THE KENNEDY YEARS

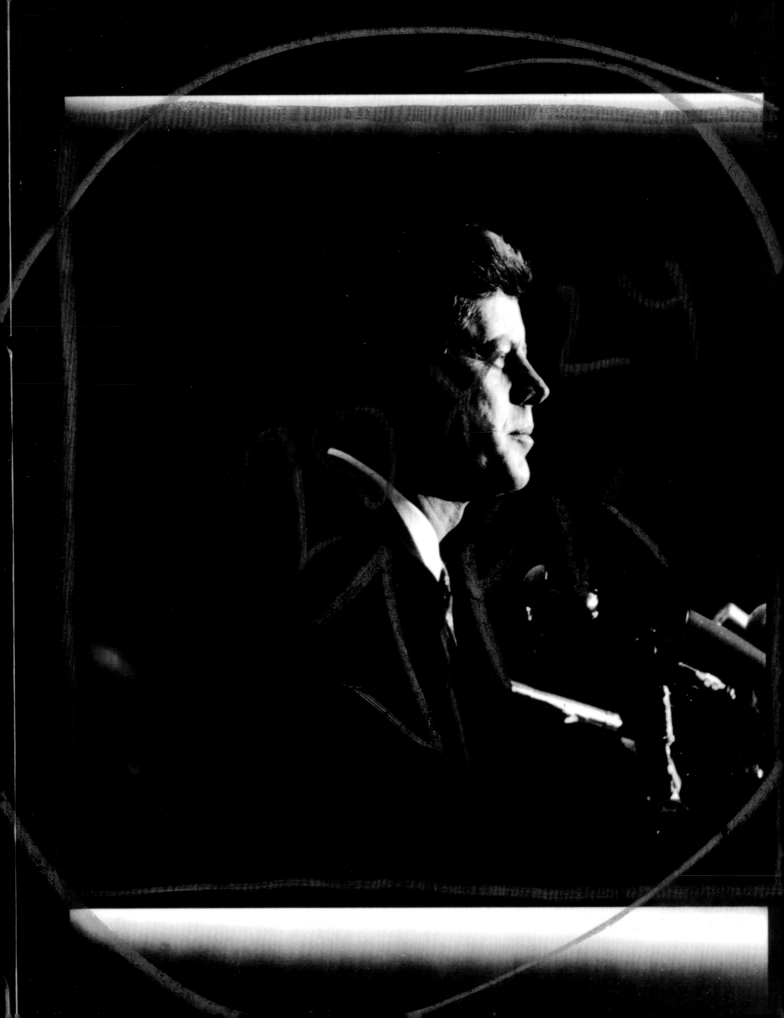

Andrew –
hope you enjoy
the book! I know we
share a love for the
Kennedy family.
Paula

THE KENNEDY YEARS

A MEMOIR

Jacques Lowe

With a preface by
Thomasina Lowe

RIZZOLI
NEW YORK

New York · Paris · London · Milan

First published in the
United States of America
in 2013 by
Rizzoli International
Publications, Inc.
300 Park Avenue South
New York, NY 10010
www.rizzoliusa.com

Originally published in the
United Kingdom as *My
Kennedy Years* in 2013 by
Thames & Hudson Ltd,
181A High Holborn,
London WC1V 7QX

My Kennedy Years © 2013
Thames & Hudson Ltd,
London

Photographs and archive
source material © 2013 the
Estate of Jacques Lowe

Text compiled, organized,
and edited by Peter Warner
© 2013 Thames & Hudson Ltd,
London

Designed by
Adam Brown_01.02

2013 2014 2015 2016 /
10 9 8 7 6 5 4 3 2 1

ISBN: 978-0-8478-4173-8

Library of Congress Control
Number: 2013933349

Printed and bound in China by
C & C Offset Printing Co. Ltd

Frontispiece:
John F. Kennedy, 1960.

Page 6: Jacques Lowe,
self-portrait on the
Caroline, the airplane used
in the early days of the
presidential campaign.

Page 8: Robert F. Kennedy
with his son Michael, 1958.

Publisher's Note

A long-held ambition of Jacques Lowe's daughter Thomasina,
this posthumous memoir has been pieced together from a variety
of first-person sources. The most important of these are several
previously unpublished oral histories that Jacques Lowe taped
before his death in 2001. In addition, the memoir utilizes gallery
talks and speeches that Lowe gave at the openings of exhibitions
of his work, several of which were video-taped. It also draws on
previously published works by Jacques Lowe as well as stories that
he related to his family. All of these sources have been compiled
and edited to form a more or less chronological narrative with
the addition, where necessary, of a modest amount of historical
background or context. Although obvious factual errors relating to
dates and places have been corrected, we have tried to preserve the
informal tone of Jacques Lowe's reminiscences.

Contents

Preface by Thomasina Lowe 6

Prologue 8

1 Meeting the Senator 10

2 Engaging the American People 24

3 Winning the Nomination 66

4 Campaigning for the Presidency 118

5 Taking the Oath 170

6 The White House 184

7 RFK and Me 204

8 On the World Stage 220

Epilogue 252

Index 254

Acknowledgments 256

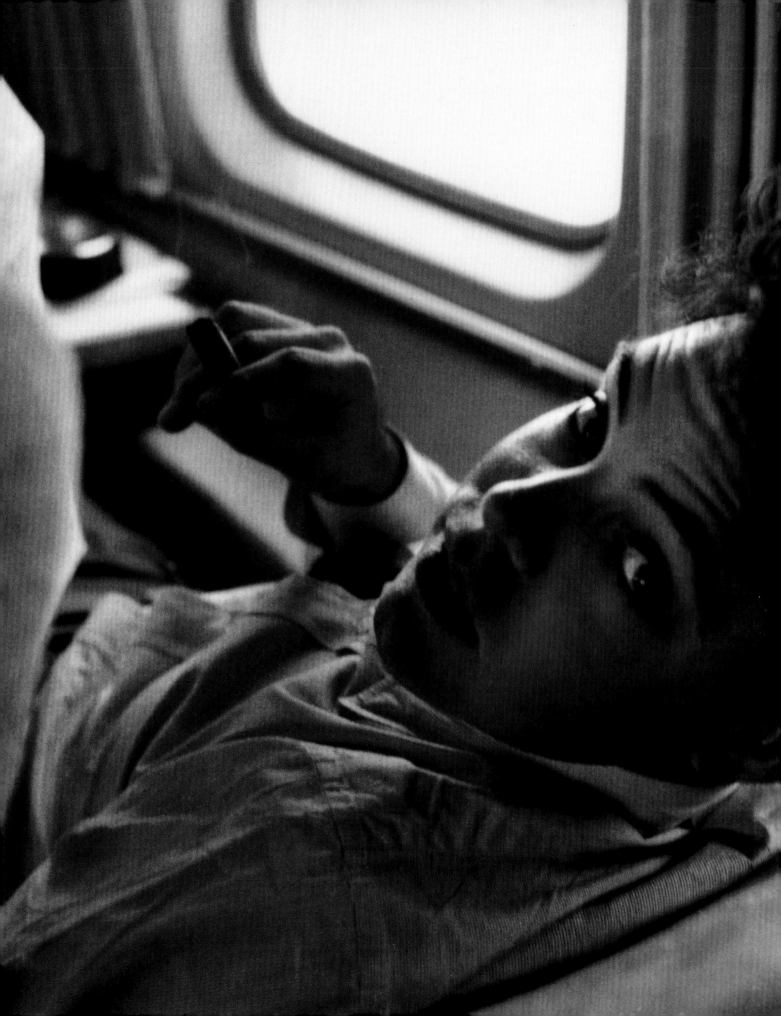

In New York, on the morning of September 11, 2001, I was faced with a moral dilemma unlike any that I had confronted before. As I became aware of the scale of destruction taking place a few blocks from my father's loft, I asked myself, Do I save myself or my father's precious negatives, depicting one of the greatest statesmen of the modern era, and located in a vault at Five World Trade Center?

Before he had died on May 12, only four months previously, my father had entrusted me to safeguard his archive of photographs of the 35th President of the United States of America, John Fitzgerald Kennedy, and I now carefully considered whether to rush down to the World Trade Center or to save myself. In my mind's eye, I could see my father running down Broadway against the flow of traffic with just one aim: to rescue his negatives. I have no doubt that he would not have paused for thought; every fiber in his body would have propelled him to that safe in order to retrieve its irreplaceable contents. There would have been no choice for him.

Fate dictated that the decision was not his to make but mine. I chose to look after my own safety, but I am still haunted by the dilemma in which I found myself that day.

Subsequently, I campaigned to retrieve whatever might be left of the negatives. Under piles of rubble a safe was eventually discovered, strangely intact. However, when it was opened, it was clear that the negatives had been destroyed. From the ashes that I held in my hand that morning, I have tried to rebuild my father's archive. Thanks to modern technology, all of my father's choice prints, stored in his loft, have been scanned and preserved, along with all the contact sheets, which became an invaluable record of his work after the negatives were lost.

More than ten years after that grim day in New York, the publication of this book stands as a testament to the possibility of rebirth in the aftermath of almost inconceivable horror.

Thomasina Lowe

Preface

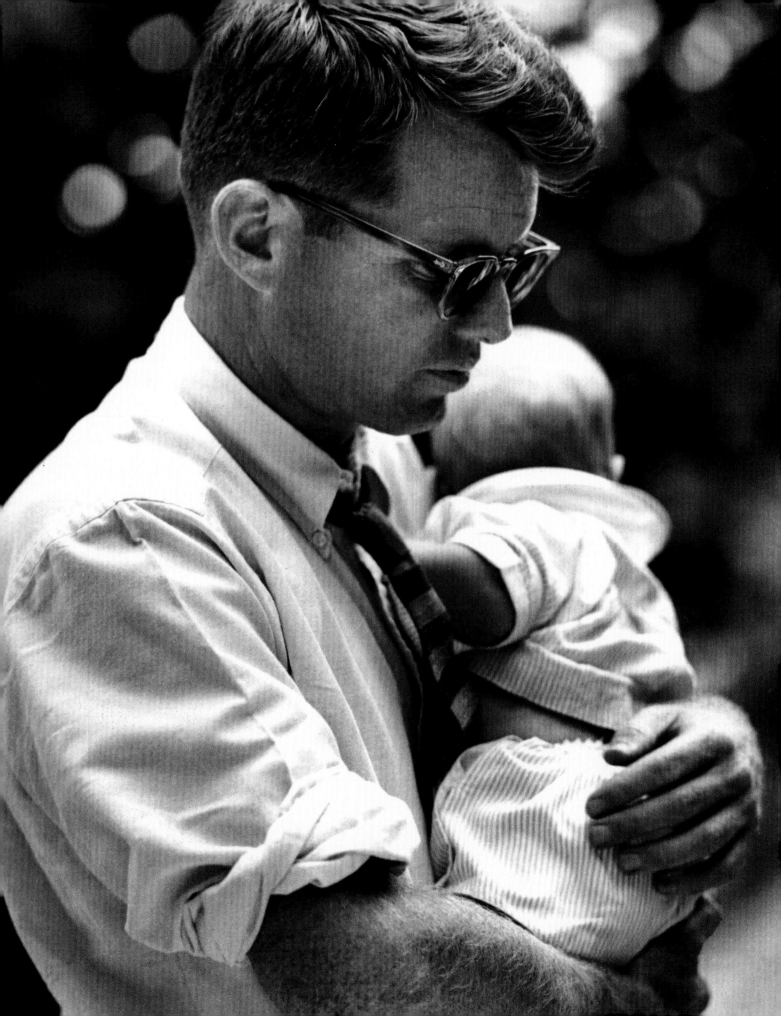

I was working in my studio in New York one evening in early September 1958. It must have been well gone midnight when the phone rang. A strangely familiar but slurry voice asked,

"Is this Mr. Lowe?"

"Yes," I said cautiously.

"This is Joe Kennedy speaking."

I was sure someone was playing a prank on me; Joseph Kennedy was an almost mythic figure at the time, far more famous than any of his sons. I said,

"Well, if you're Joe Kennedy, I'm Santa Claus."

"No, no, no. This is Joe Kennedy. Today's my birthday and Bobby gave me those pictures you took of his family. They are the greatest photographs I have ever seen."

Now I knew it was Joseph Kennedy and it was clear he had celebrated his birthday with a few drinks.

"Those pictures are the most wonderful birthday present I've ever had. I want you to promise me you'll photograph my other son."

"Which one is that?" I asked.

"Jack. Will you call me at my office in two days?"

I agreed, mainly to be polite and to get him off the phone. When I called two days later, I expected that Joe would have forgotten all about me. To my surprise he invited me to come up to Hyannis Port.

And that is how my great adventure with the Kennedy family began.

Prologue

My early life had already had its share of adventures by the time I met the Kennedys. I was born in Germany to a German father and Russian Jewish mother in 1930. When the Nazis began to hunt for Jewish children in the schools, I was hauled out of school and my mother and I spent the war years in hiding. After several difficult postwar years, we finally emigrated to the United States in 1949. I was 19 years old and had not attended school since I was 9.

When I was still in Germany, I saw the movie *Foreign Correspondent* with Joel McCrea as an intrepid trench-coated journalist and it made a big impression on me. (I have seen it at least ten times since then.) I had always been interested in photography and combined with my very romantic notion from the movies, photojournalism was a natural way to go. I got into the business by first becoming an assistant to several photographers, including the well-known portrait photographer Arnold Newman. While still an assistant, I was one of the winners of a contest that *Life* magazine sponsored for young photographers. I decided that meant I was a genius and I went off on my own.

How I survived the first two years financially is still a mystery to me, but then I began to get assignments and eventually I became quite successful while still quite young. It was a great era for photojournalism. Besides *Life*, there was *Look, Colliers*, the *Saturday Evening Post, Time, Coronet*, and *Paris Match.* Once they assigned you to a story, you could be given anywhere from eight to twelve pages to tell it. So it was very satisfying in terms of creative energy as well as financially. One of the journalists I worked with was Pierre Salinger. We did a story on the Hungarian Revolution for *Colliers* that never ran because the magazine suddenly folded. Before coming to *Colliers*, Pierre had been working on an investigative piece about the Teamsters union and when Robert Kennedy became majority counsel for the Senate Committee on Government Operations, whose subcommittee was investigating labor racketeering, I introduced Pierre to Bobby.

1

Meeting the Senator

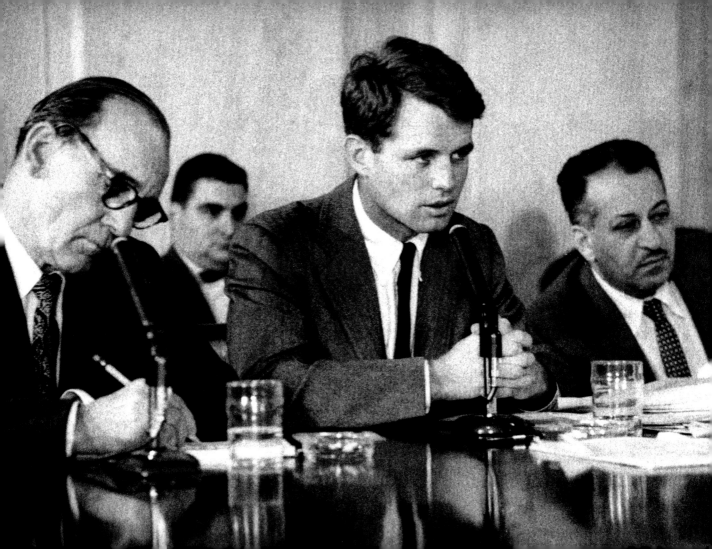

Page 10: Jacques Lowe was 28, and a successful photojournalist, when he met John F. Kennedy.

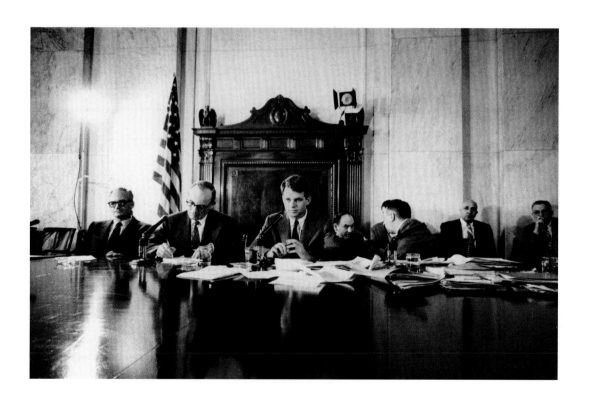

Washington, DC, 1956

Despite his youthful appearance, Bobby earned his reputation as a relentless prosecutor when he was counsel to the Senate committee investigating labor racketeering. Lyndon Johnson, then Senate Majority Leader, always greeted Bobby as "Sonny Boy," and their relationship only got worse.

I had come to Bobby's attention through a curious circumstance. His role as chief counsel had made him a minor celebrity in Washington and three different magazines separately commissioned me to photograph him. All three sessions took place during one week in 1956. By the time I showed up for the third session, Bobby thought I represented the entire magazine business and on the spur of the moment he invited me to his home for dinner. We became friends and I began to spend weekends at Hickory Hill, his house in McLean, Virginia. Bobby's home was a photographer's paradise: a happy madhouse, what with his then five children plus assorted dogs, cats, ducks, and donkeys, along with football games and the swimming pool. Occasionally, I brought my daughter Victoria with me, who had a great time. "Daddy," she said after one visit, "there are more cookies and toys at the Kennedys' than we have all year in New York."

Because I always had my camera with me, I took a lot of photographs at Bobby's—all quite casually with no plan in mind. After about a year, I wanted to thank Bobby for his hospitality. I went though all the photographs I had taken at Hickory Hill to select the best images. I printed up one hundred and twenty-four 11 × 14s and sent them to Bobby as a gift. He thanked me profusely and a few days later asked me if I would make another set.

"That's a lot of photographs," I said. "What are you going to do with them?"

"My father's birthday is coming up and I want to give them to him as a present."

I printed a second set of images for Bobby and then forgot all about the birthday present until two months later when I received my late-night call from Joe Kennedy.

I did not get off to an auspicious start with Jack Kennedy in Hyannis Port. He was running for re-election to the Senate, and had just been on the road for ten days. He had returned to Hyannis Port for a weekend of rest before going back on the road for five days. The last person he wanted to see was a photographer, especially since his father had informed him about me only that morning. So there he was, dressed in a suit, white shirt and tie because his father told him to, when he would much rather have been in casual clothes. I don't think I ever saw him again in a suit and tie on the Cape until the day he was elected President. I wouldn't say he was surly, but he was icily polite. As for me, let's say I was not very impressed with the Senator. Jackie was much more welcoming. She asked me some technical questions about photography—which film to use in certain situations—and made herself

and Caroline, who was then less than a year old, completely available to me. Once we started the session, Caroline's presence helped the Senator to relax a bit and the first of my well-known Kennedy pictures came out of that session, the one in which Caroline has her mother's pearls in her mouth. I also took some portraits of Jack alone to use as posters for his campaign.

After the session, I stayed for lunch and dinner. Kennedy remained distant, speaking mainly about how difficult it was to campaign. He had just been in Boston and he said it was hard in Irish neighborhoods since he wasn't really an Irishman. I think he meant that he was looked on as the patrician son of a wealthy family. I didn't understand why he had to work so much; after all he was a shoo-in for re-election in Massachusetts. But, as I was soon to realize, he already had his eye on the presidency and nothing less than a landslide in Massachusetts would do. The next day I went back to New York, developed the film and sent the contact sheets and my bill. I wasn't overly happy with the images and when I didn't hear anything further I figured I had bungled the job.

Several weeks later, I received another midnight call, only this time Jack Kennedy was on the phone. "I'm in New York. Can you come see me tonight because I'm leaving in the morning." He was staying in a building on Park Avenue that was owned by Joseph Kennedy.

I got dressed and took a cab over there. When the door to their apartment opened, there was Jack Kennedy wearing nothing but a towel. He had just emerged from the shower. From down the hall I heard water splashing. Jackie was in the bathtub. "Is that Jacques?" she yelled out. "Oh, those wonderful pictures!"

For the next fifteen minutes I sat with Jack while he apologized for his behavior in Hyannis Port. He recalled how distant and almost rude he had been and explained that he had been on the road and was tired and out of sorts. He produced the contact sheets I had sent. Under the circumstances, he said, the pictures were phenomenal. We spread the contacts out on the floor and I got down on my hands and knees to sort through them while Jack stood above me, still just wearing a towel. We chose several to use for various political purposes and one that became the family Christmas card.

That was the first time that Jack made a positive impression on me, thanks to his charm, good manners, and informality. Politically speaking, I was an Adlai Stevenson Democrat, and I thought of Jack as a kind of playboy Senator who hadn't sponsored much legislation and was better known for courting and marrying a beautiful young woman. I knew his father had great ambitions for Jack; but I had yet to see Jack's own sense of purpose.

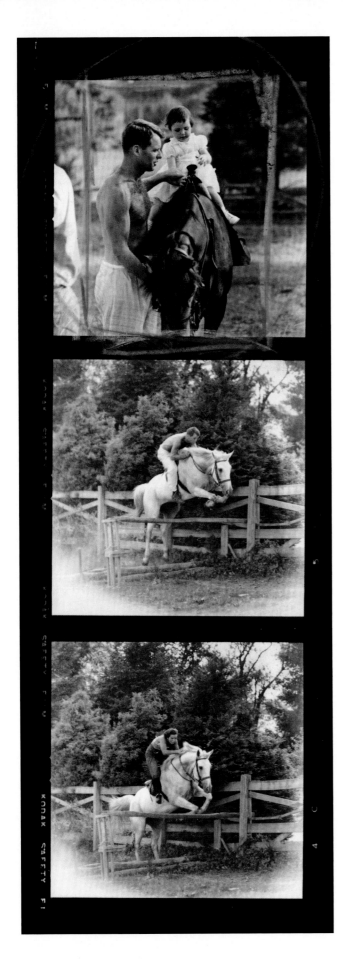

Hickory Hill, 1958

Jacques always had his camera ready when he visited Hickory Hill, Bobby and Ethel's home in McLean, Virginia. The couple loved to compete—whether as captains of opposing touch football teams or in horse jumping. But Bobby was also a tender and attentive father. Here he comforts his son David.

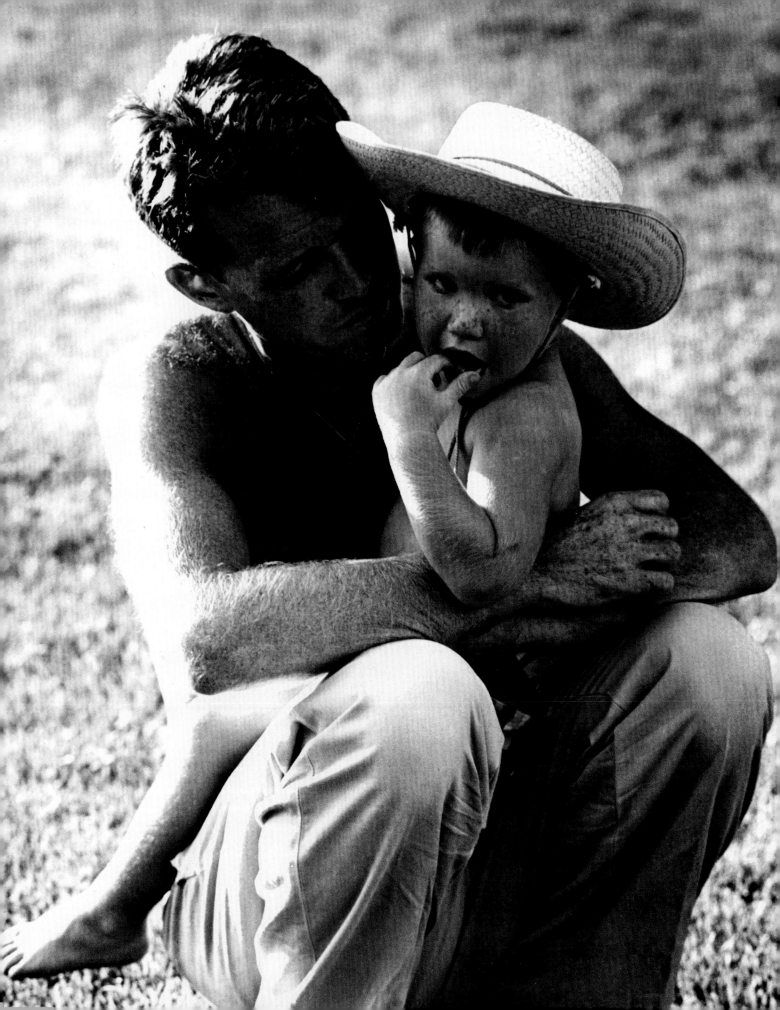

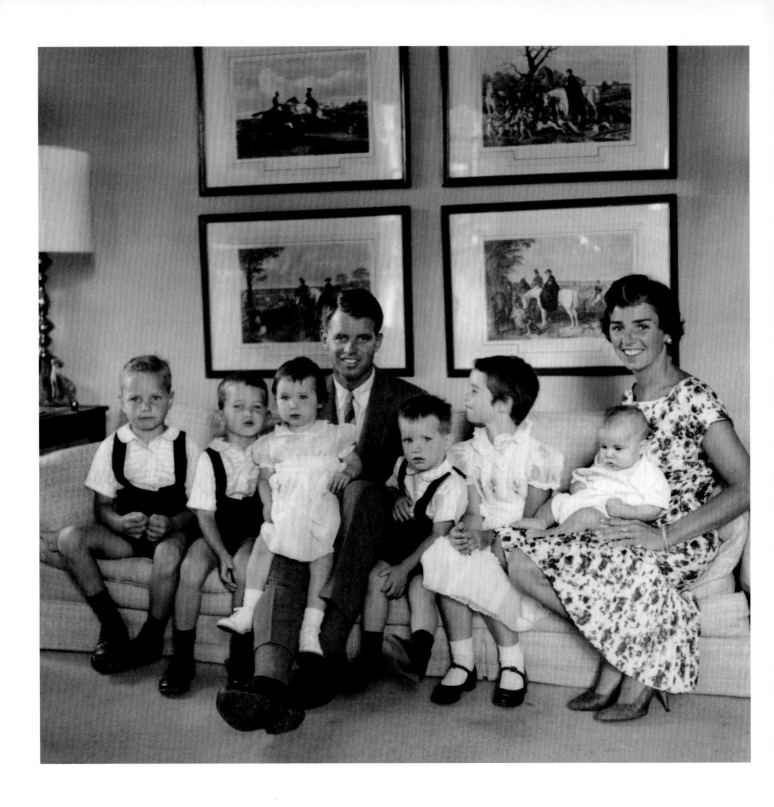

Jacques took many group portraits of Bobby and Ethel's burgeoning family. From left, the children are Joe II, Bobby Jr., Courtney, David, Kathleen, and Michael.

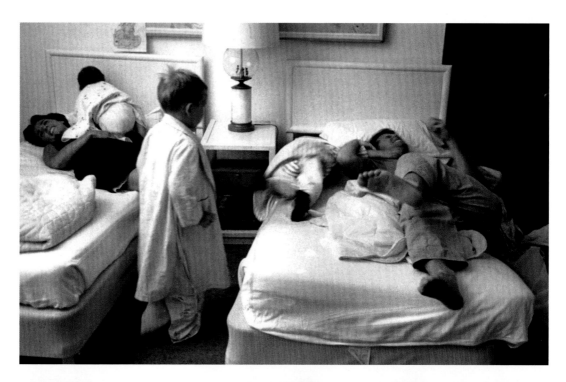

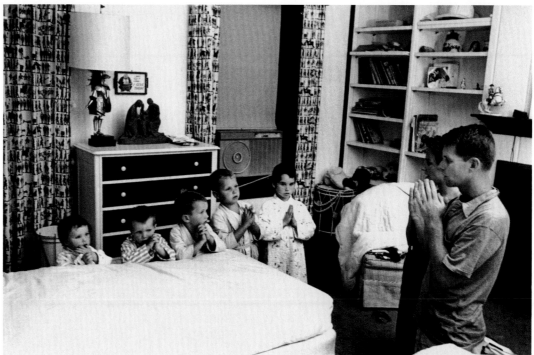

Years later, Robert Jr. would say that Jacques was present "when I woke up and in our house when we went to bed." Bedtime often included horseplay with the parents as well as prayers.

Hyannis Port, Late Summer 1958

Jack was a reluctant subject at Jacques' first photo session with him in the late summer of 1958 at Hyannis Port and posed quite stiffly. Joe Kennedy, who had set it all up, insisted that his son wear a suit. Joe and his granddaughter Caroline provided Jacques with a more intimate shot.

"Joe Kennedy was a very tough customer though charming if you were in with him. I'd hate to have been one of his enemies."

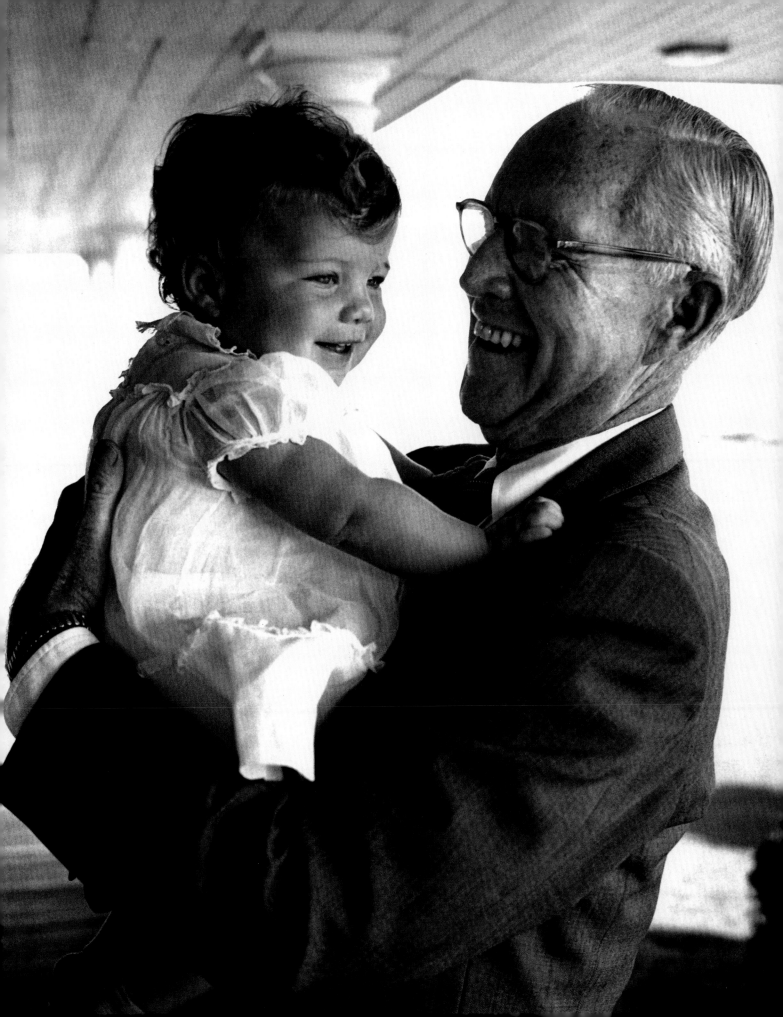

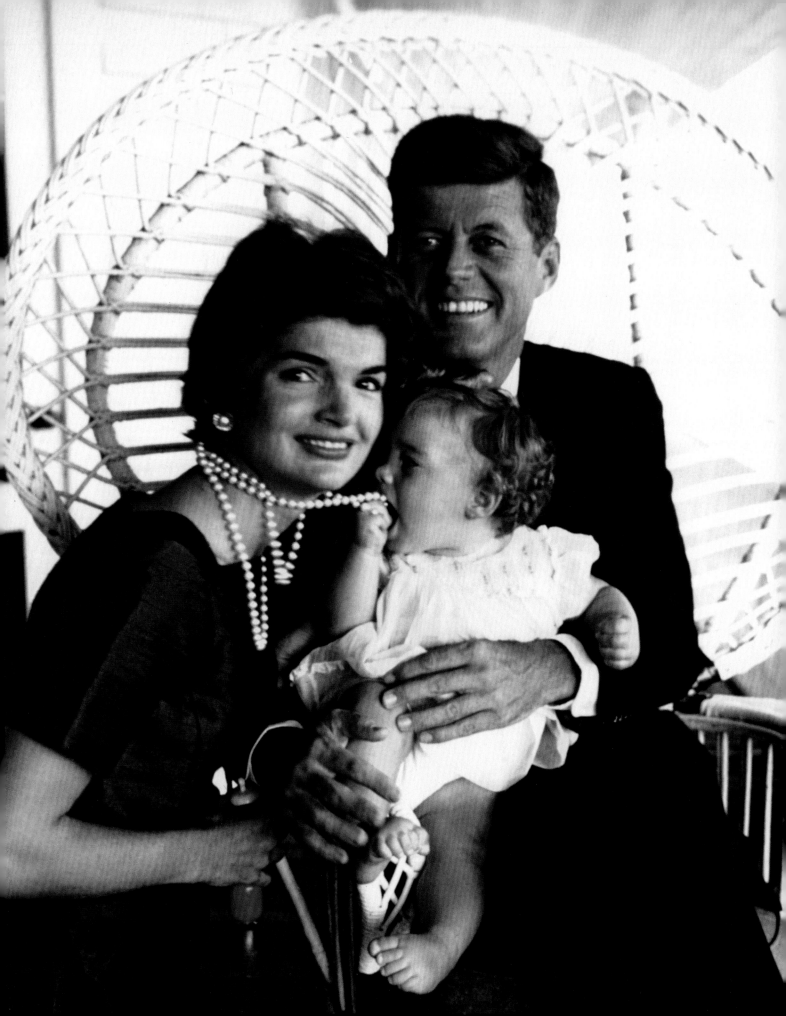

After Jackie and Caroline joined the photo session, Jack relaxed. When Caroline began to suck on Jackie's pearls, Jacques got his first famous image of the Kennedys. For the family Christmas card, Jackie chose the photograph marked with 7 xs, but she asked Jacques if he could replace the image of Caroline with the one from the contact marked with 2 xs.

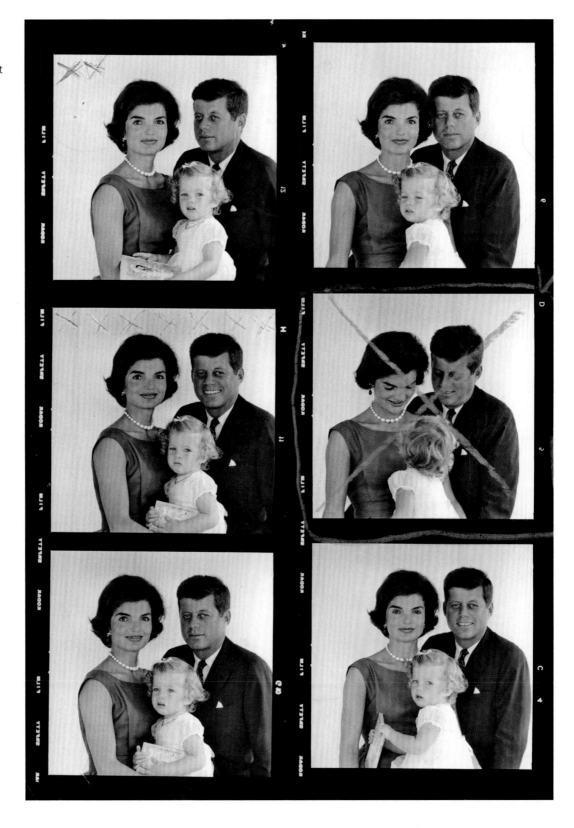

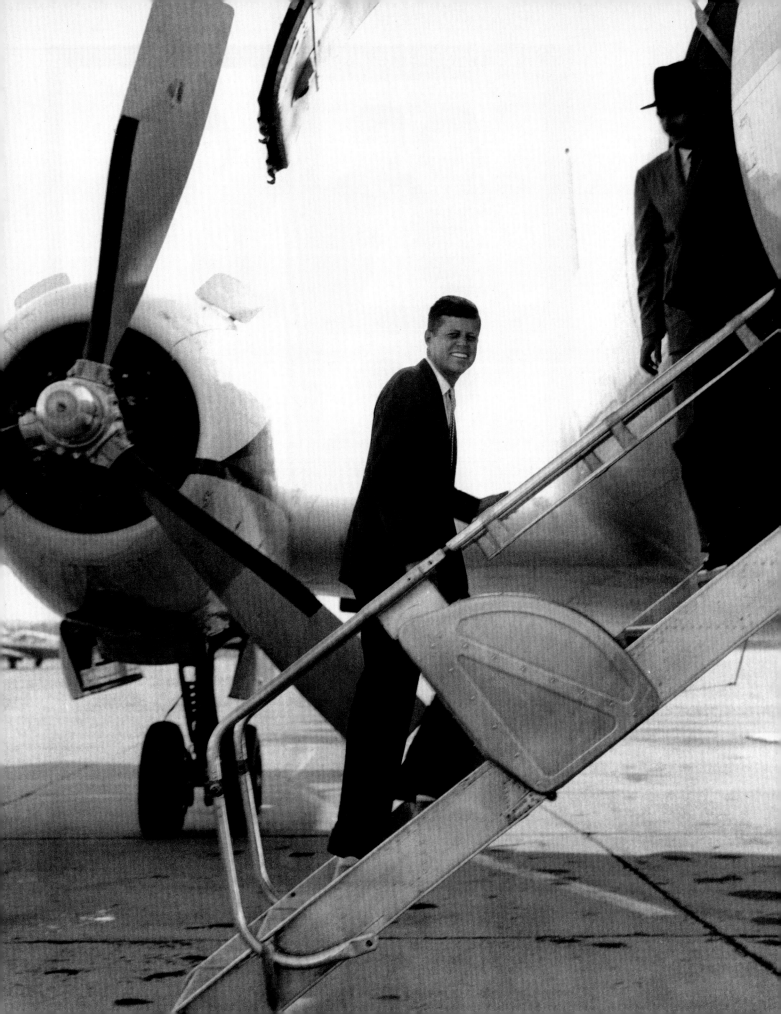

A few weeks later Jack Kennedy won the Massachusetts election in a landslide and suddenly he was a political star. Just as he planned, he was being talked about as a serious contender for the Democratic nomination in the 1960 presidential election. I got a call from Jack's brother-in-law Stephen Smith, who ran the early campaign before Bobby got fully involved. He invited me down to Washington, to a somewhat anonymous suite in the ESSO building. Smith explained that Jack was going to run in the primaries. They would need a photographer from time to time to cover his events. Was I interested? Of course I was.

"What are you going to charge me?" he asked. We agreed on $150 a day, plus expenses, and that was the only conversation about money we ever had.

Well before the formal primary season began in the spring of 1960, Jack's traveling and speaking schedule had accelerated. I would receive a call from Steve Smith. Could I go to Nebraska for a couple of days? I would head out to the Butler Aviation terminal at LaGuardia Airport where Jack and Steve and a few others would be waiting in a leased plane and we'd take off. It seemed very informal and unscripted. I'd ask Steve: "What kind of pictures do you want? Action shots? Portraits? What are you going to use them for?"

"It's up to you," he'd say. 'I know we need pictures but you're the artist.'

I'd send Steve contact sheets from each trip and a bill and I'd get paid, but nothing much was done with the images. The Nebraska trip was for a barbecue with Democrats who were there to look Jack over. The speeches by the local politicians were quite longwinded but Jack seemed to impress the crowd. One of the images that I captured that day eventually became the campaign poster and was ubiquitous during the run-up to the election.

Of course, in those early days Jack was not known nationally, and some of his appearances were not very impressive. After Nebraska, we took a trip to Oregon. When we landed in Portland, just three supporters

2

Engaging the American People

Page 24: Boarding the *Caroline* for an early campaign trip, Waiting at the top of the stairs is Dave Powers, a member of Jack's "Irish Mafia" group of aides who stayed with him from his first run for Congress through his presidency.

met his plane. Another time, I found Jack, Jackie, and Steve Smith sitting in a diner in a small town in Oregon, alone and unrecognized. Occasionally, Jack was stung by the lack of attention. On that same Oregon trip, in Coos Bay, I met Jack outside a union hall after he had made a speech to a small and somewhat hostile group of dockworkers.

"What did you think of that speech?" he asked.

"I wasn't exactly overwhelmed by their response to your candidacy."

"Well, those sons of bitches, they hate everybody anyway. You just have to do what you can do and that's the end of it."

No matter how small or hostile the audience, Jack always dressed in a suit and spoke very directly and straightforwardly. Although he was not yet completely at ease when he spoke, there was no cornpone posing or pandering and he never talked down to an audience. He was a kind of patrician egalitarian in the way he connected with people. I remember an occasion when he was interviewed by a disc jockey in a little town out West, somewhere in the Dakotas, as I recall. The disc jockey made a disparaging remark about Charles de Gaulle, whom Jack admired. It would have been easy to let the remark go by, but Jack had just read an installment of de Gaulle's autobiography and he refuted the disc jockey by quoting verbatim from the book. Jack was a speed-reader who seemed to retain almost everything that he read.

Between trips I also spent some time photographing Jack and Jackie in Washington. They had a lovely town house on N Street in Georgetown. Jackie had decorated it elegantly but not ostentatiously. Nor was their social life ostentatious. They entertained with a lot of small dinners. As for guests, they preferred newspapermen to politicians–people like Walter Lippmann, James Reston, and Joe Kraft. Ben Bradlee, then the Washington bureau chief of *Newsweek*, was also a frequent visitor. Although Jackie would later become very reluctant to expose her children in the media, she was more open in those days, though still cautious. I took some wonderful pictures of her playing with Caroline in their Georgetown home. No matter what mood Jack was in, he always perked up if I asked him to pose with Caroline.

Where photography was concerned, I sometimes found myself caught between Jack and Jackie. The point of my job was to place my photographs in the media where it would do the most good to get him elected President. At one point *Vogue* wanted Jack to pose for some pictures, which Jackie much favored. But Jack said to me, "To hell with them. What am I going to do with three hundred thousand Republican

ENGAGING THE AMERICAN PEOPLE

ladies?" Instead, *Modern Screen*, with a circulation of five and a half million, got the pictures. When the issue came out, Jackie was furious. Though Jack okayed it, I was the one who got the blame.

I also had a run-in with Joe Kennedy, a very tough customer, though charming if you were in with him. He asked me to photograph Teddy's wedding to Joan Bennett in November 1958. I didn't really like the idea of being a wedding photographer and I told Joe that there wasn't anything I could do for him that anyone else couldn't. The conditions for taking good photographs would be very limited what with TV lights going on and off and other photographers' cameras flashing away. But Joe forced me to name a price so I said two thousand dollars, thinking this would discourage him, but it didn't. The wedding was a circus, with TV and newsmen all over the lot, even jumping out from behind the altar. It was hard to get a good shot without a few other photographers in the picture. When the TV lights went on, I would adjust my camera but then they'd suddenly go off and my picture would be dark. Just as I feared, the pictures weren't very good. Joe said he hated them and refused to pay me.

"I'm sorry," I said, "but that's not the game we're playing. I told you I didn't want to do it, that the pictures wouldn't be good, but you insisted and agreed to pay me two thousand dollars, so that's what you owe me." He apologized, said I was perfectly right, and he paid me.

By September 1959 the interest in Jack Kennedy had begun to increase. The crowds were larger and there were more journalists covering the pre-primary events. Now we had a leased airplane called the *Caroline* and the trips were longer and more frequent. Instead of two days a week, I was now away four days a week. Yet it was still quite informal. There was no person handling security. If there were spare seats on the plane, no one minded if I brought along a friend or two. The California trip in the late fall was my first indication that Kennedy might be gaining real momentum. At Mills College in Oakland, I could see Jack was beginning to connect with his audience, even when the students asked tough questions about his religion, which he never ducked. Although I was a Stevenson supporter, I was beginning to see how Jack had learned to speak to people while Stevenson talked *at* them.

Omaha, Nebraska, 1959

On Jack's first unofficial campaign trip, to Omaha, Nebraska, he attended a barbecue with local Democrats—state senators, party workers, and farmers—who were already in his camp. Even then, Kennedy and his advisors had very specific assignments for these supporters. Before the event kicked off, Jack held a press conference.

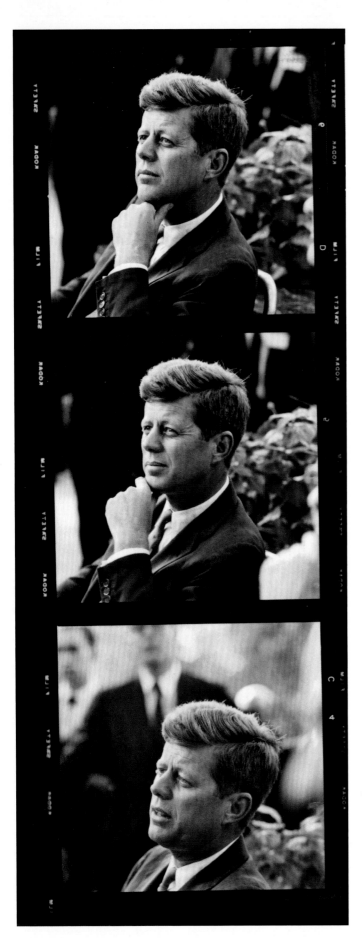

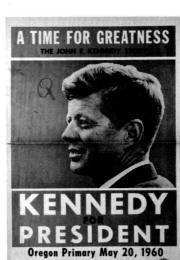

A TIME FOR GREATNESS
THE JOHN F. KENNEDY STORY

KENNEDY
FOR
PRESIDENT
Oregon Primary May 20, 1960

"One of the images that I captured that day eventually became the National Campaign poster and was ubiquitous."

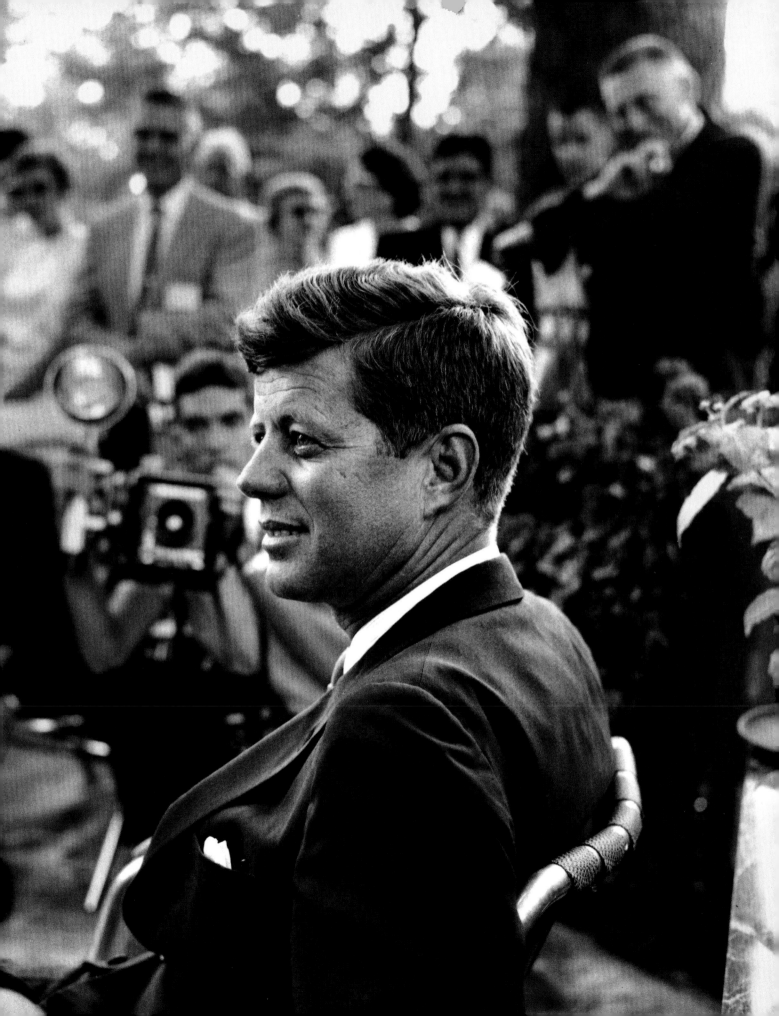

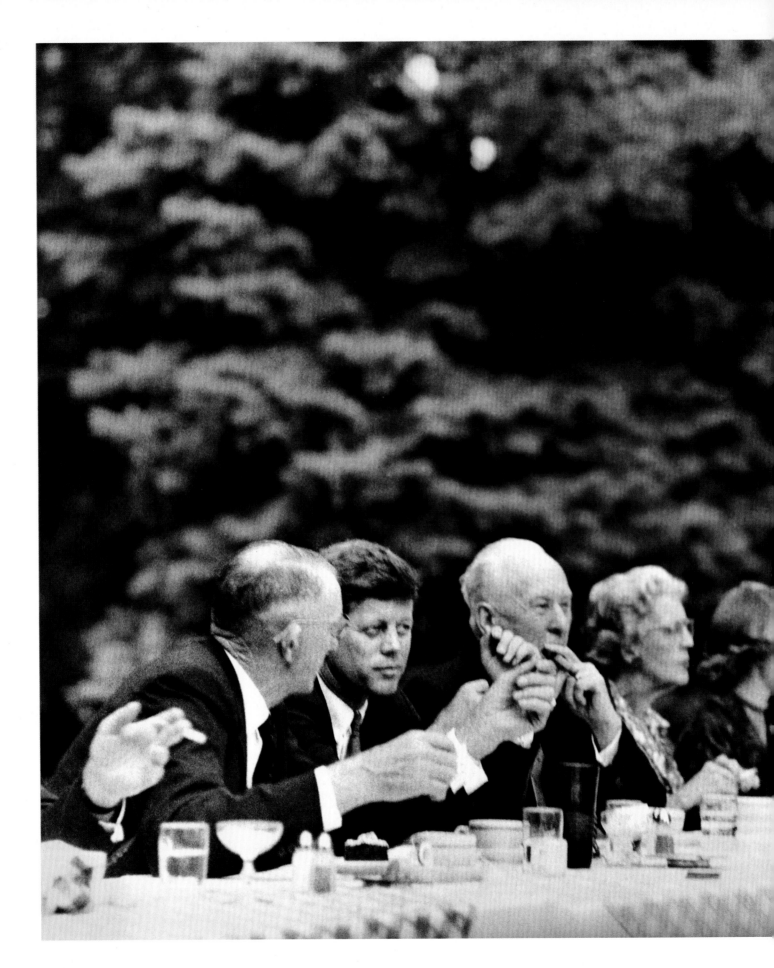

Eating chicken and meeting Democrats at the barbecue in Omaha. Although Jack had not evolved his full set of rhetorical flourishes at this stage, his characteristic stance with both hands in his jacket pockets was already on display.

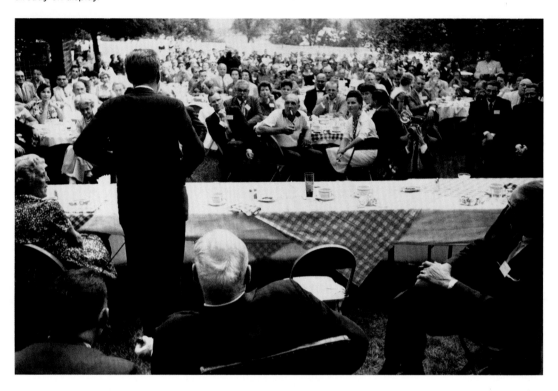

"He never talked down to an audience...his listeners went away occasionally uplifted, occasionally unimpressed, but never patronized."

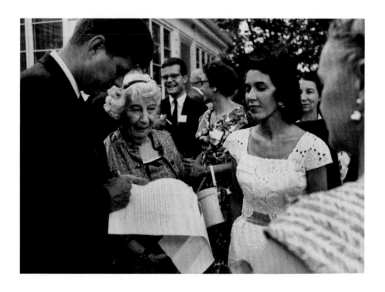

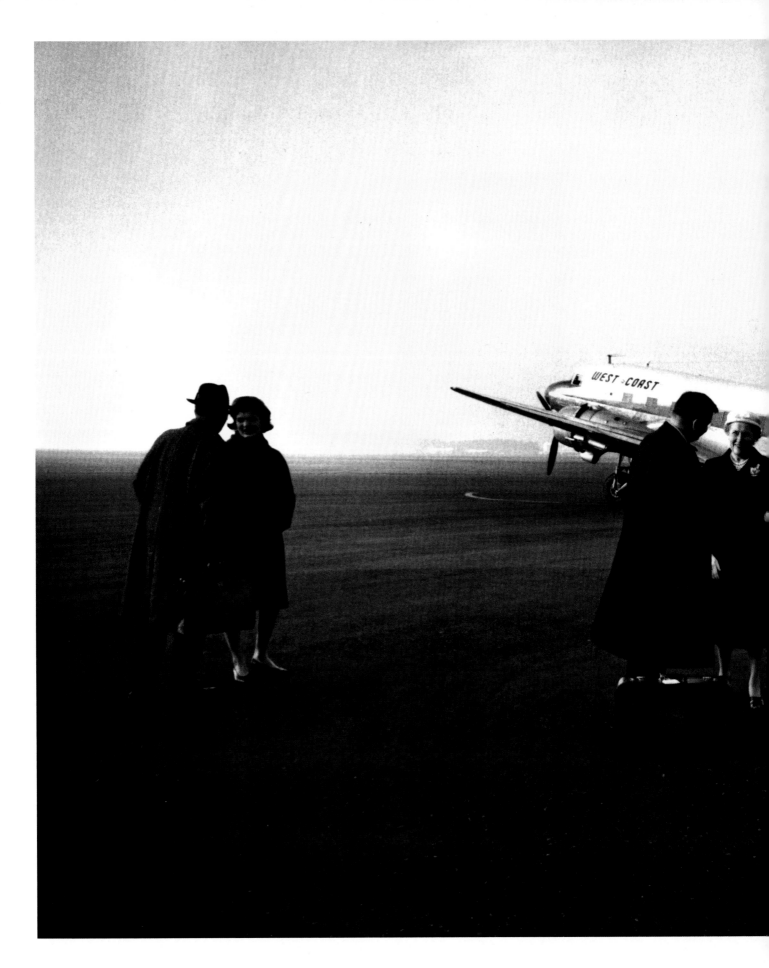

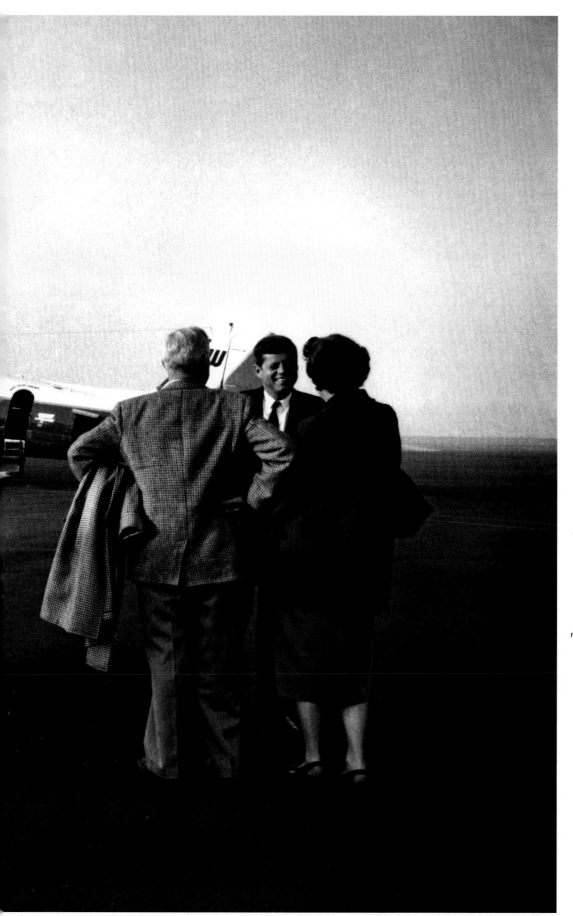

In the period of the "undercover" campaign, there were no huge crowds to greet the presidential hopeful. Here Jack, Jackie, and two of their team are met by a tiny reception committee led by Congresswoman Edith Green (center).

"Jack opened the book to the photograph of his arrival at the Portland airport on a bleak day in 1959 when just three supporters were there to meet him. 'Maybe nobody remembers that day,' he said, 'but that's why it's my favorite picture.'"

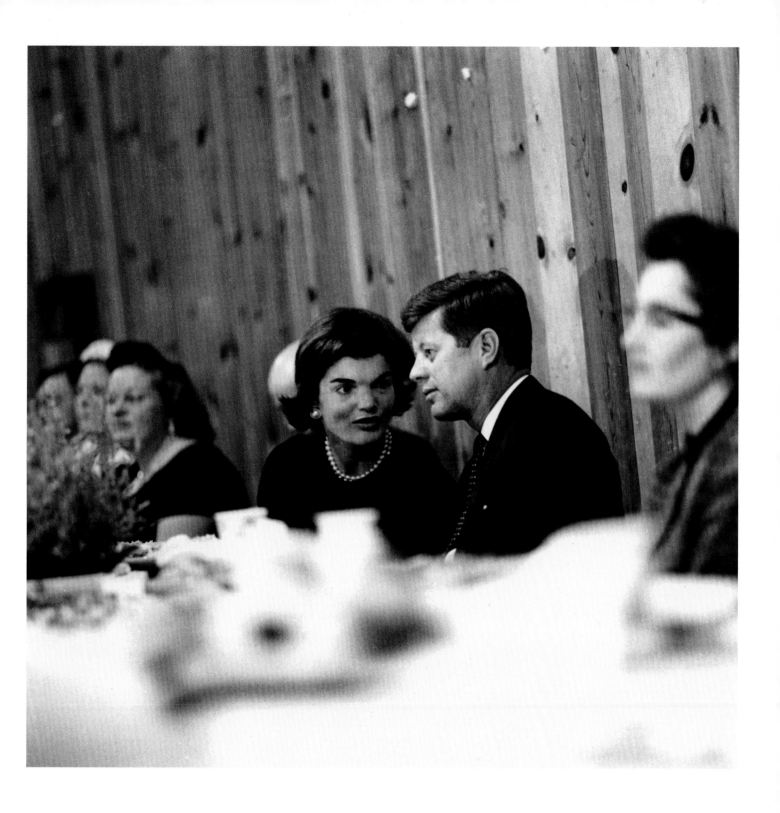

Pendleton, Oregon, 1959

Attending local fundraisers was an important way of building grassroots support. In these early days, Jack relied on Jackie to help keep his spirits up through endless speeches and dinners.

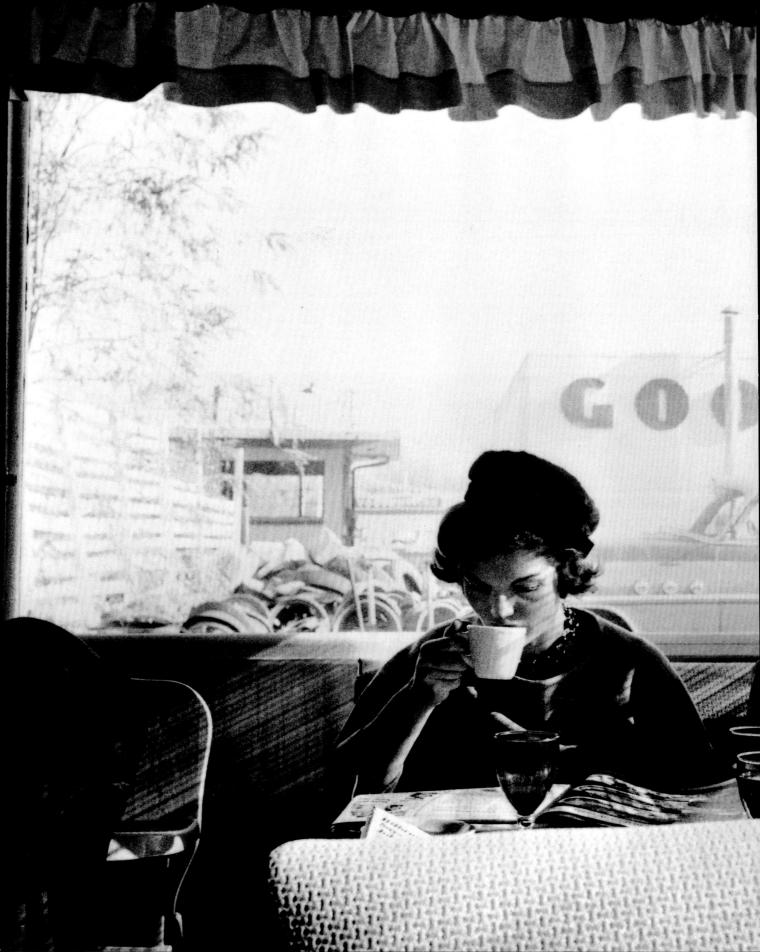

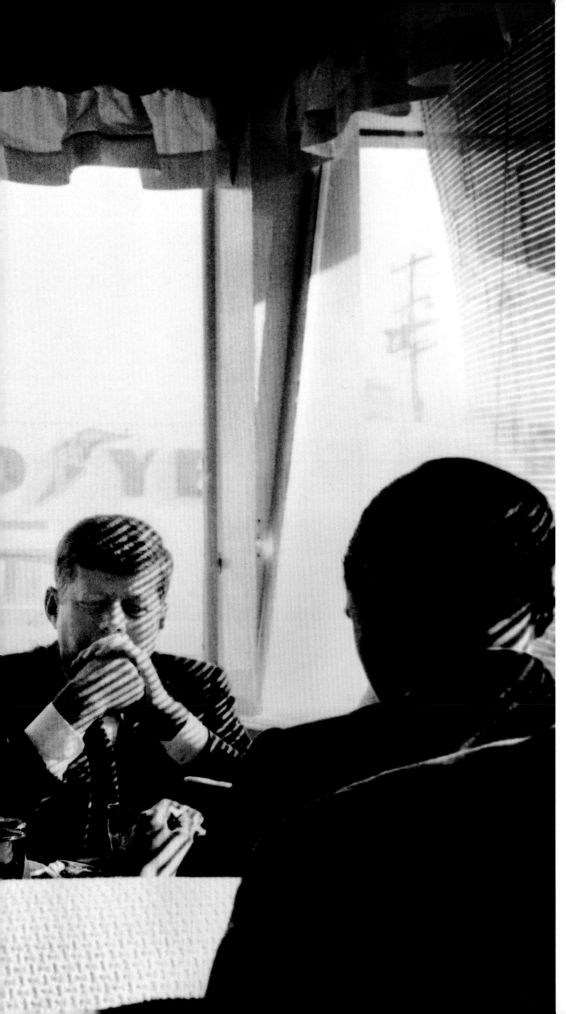

After spending the night in the Let 'Er Buck motel in Pendleton and attending Sunday morning Mass, Jack, Jackie, and Steve Smith have breakfast. Such anonymity would be impossible just a few months later.

Coos Bay, Oregon, 1959

At a union hall, the turnout was minimal and the audience unfriendly. Jackie did her best to warm up the longshoremen.

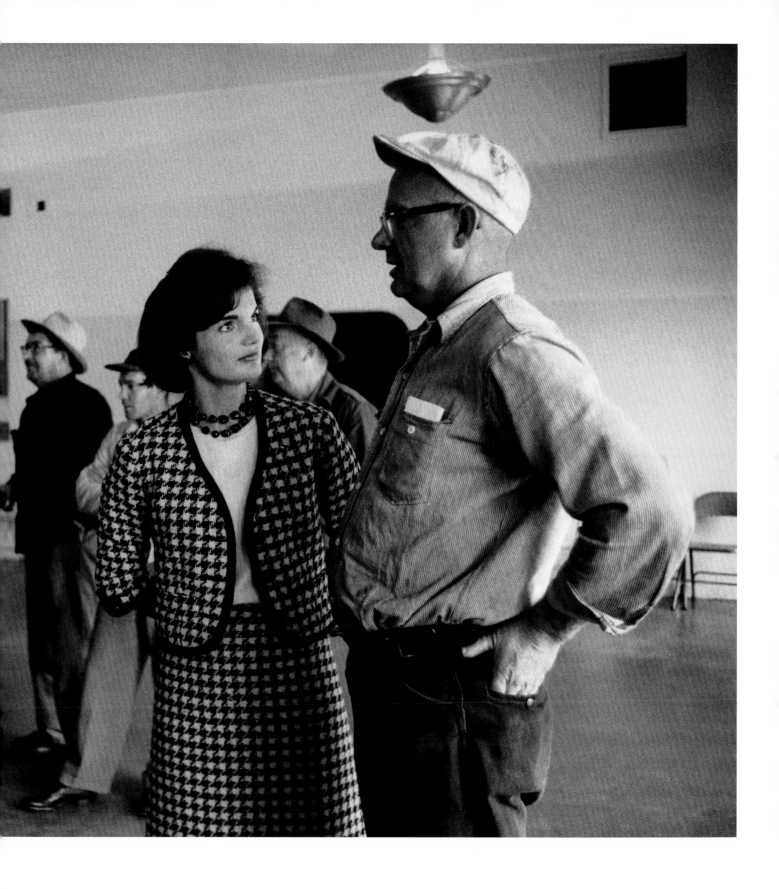

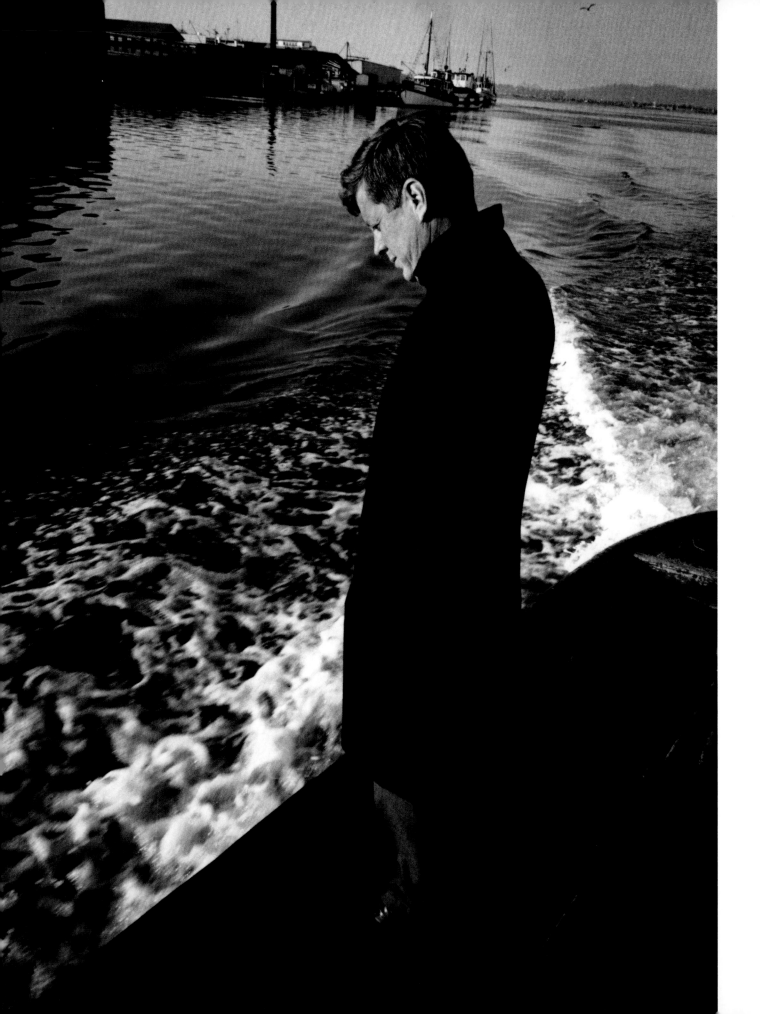

After his disappointing reception in the union hall, Jack wandered out to the docks in a somewhat disconsolate mood.

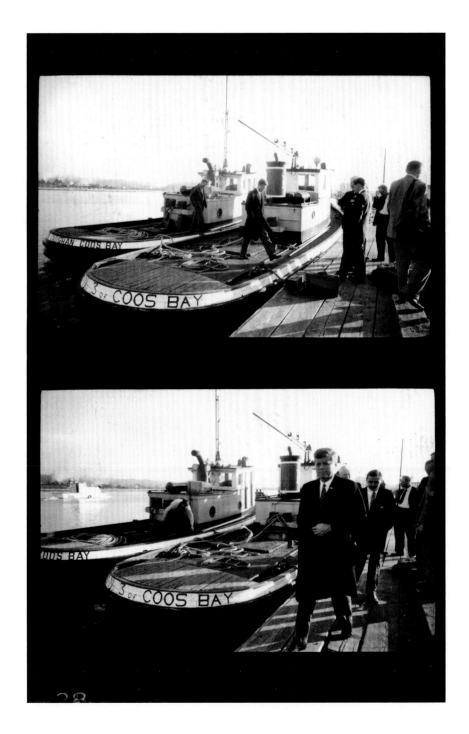

"There are few
 lonelier ordeals
 than the pre-primary
 campaign of a
 Presidential hopeful."

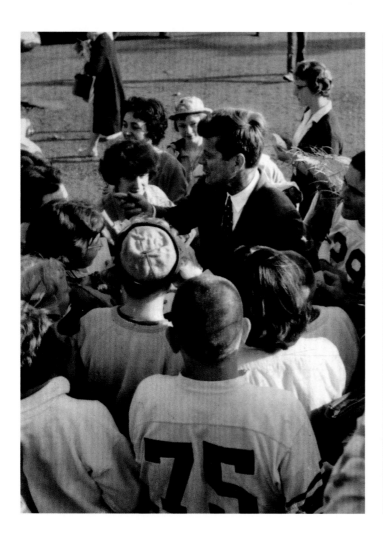

"Kennedy often spoke at high schools, partly because his early 'campaigning' was theoretically nonpolitical and mostly because he couldn't get other speaking dates. There wasn't a vote to be had among those kids, but when a candidate made a good impression on them, their parents were the first to hear about it."

The high-school students of Coos Bay, Oregon, responded to Jackie's star power and were keen to obtain her autograph after Jack had spoken to them.

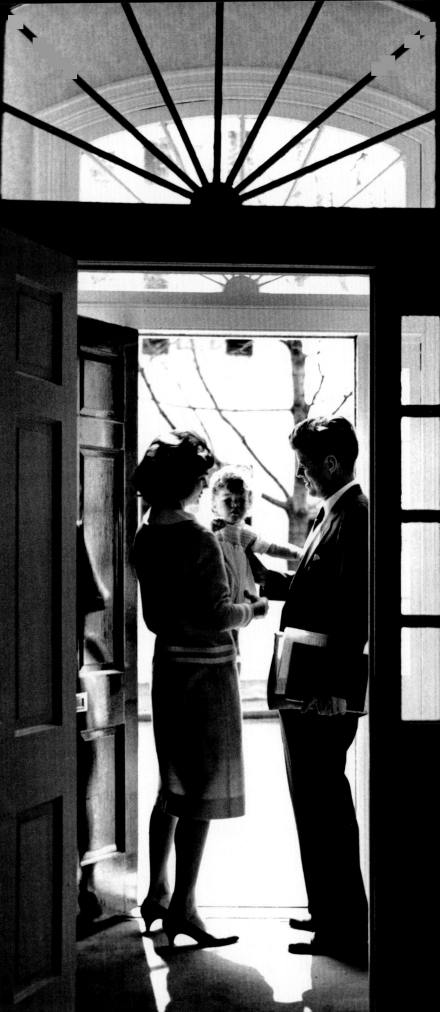

Washington, DC, 1959

As he leaves his house in Georgetown to go to the office, Jack says goodbye to Jackie and Caroline. The Senator's nickname for his daughter was "Buttons."

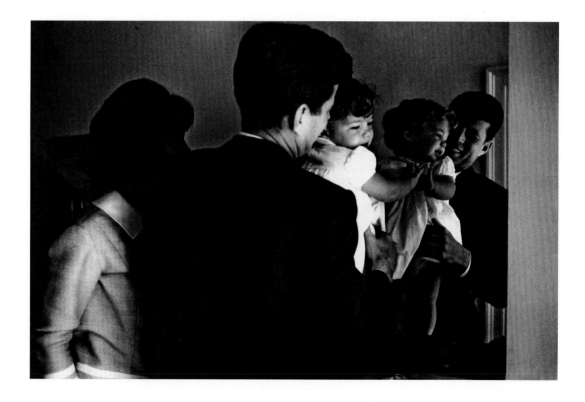

"No matter what mood Jack was in, he always perked up if I asked him to pose with Caroline."

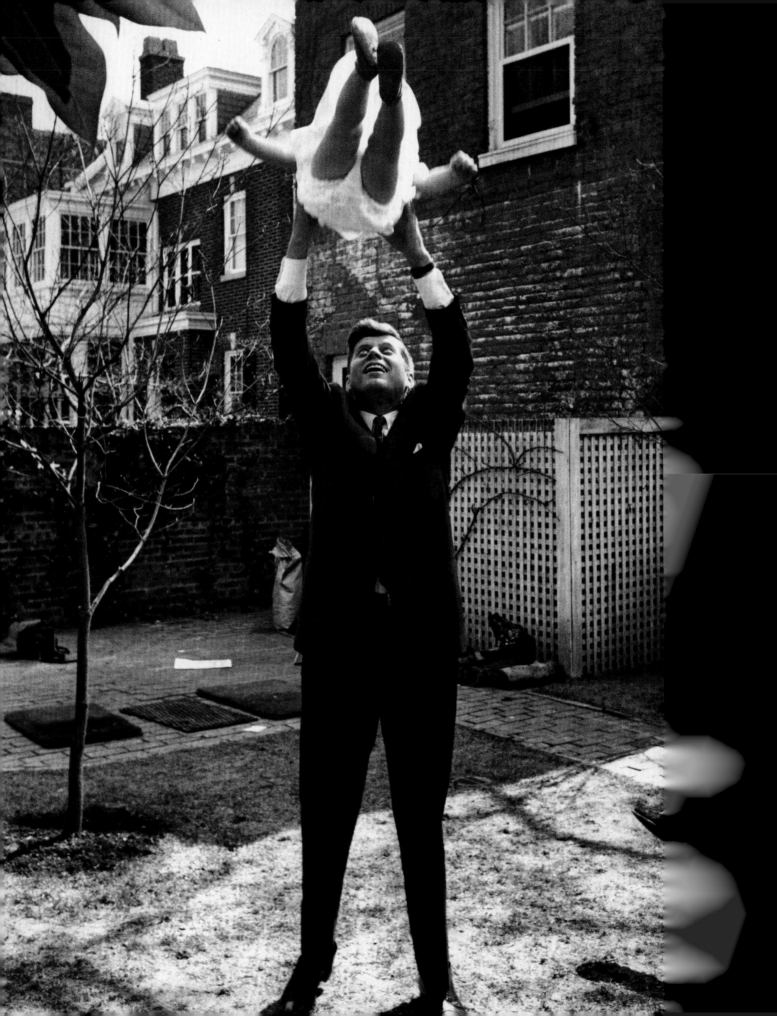

During the early campaigning of 1959, trips were interspersed with work in Congress and life at home in Georgetown. In a later television interview, Jackie observed that Caroline "loves the backyard and her plastic pool...[but] knows enough to leave when men are talking business." Once the primary season began, Jack would be on the road almost constantly.

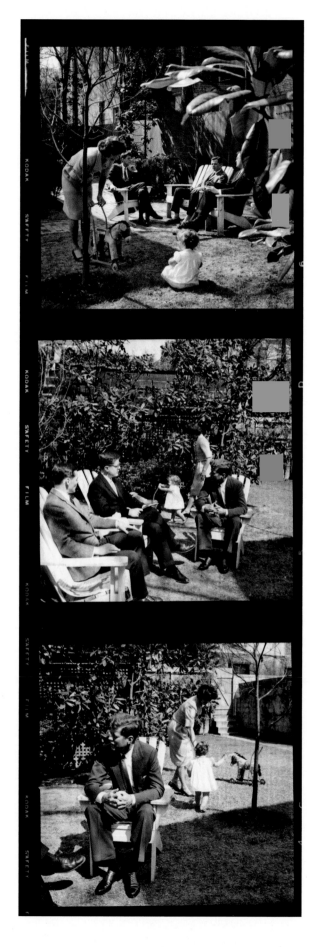

"Although Jackie would later become very reluctant to expose her children in the media, she was more open in those days, though still cautious."

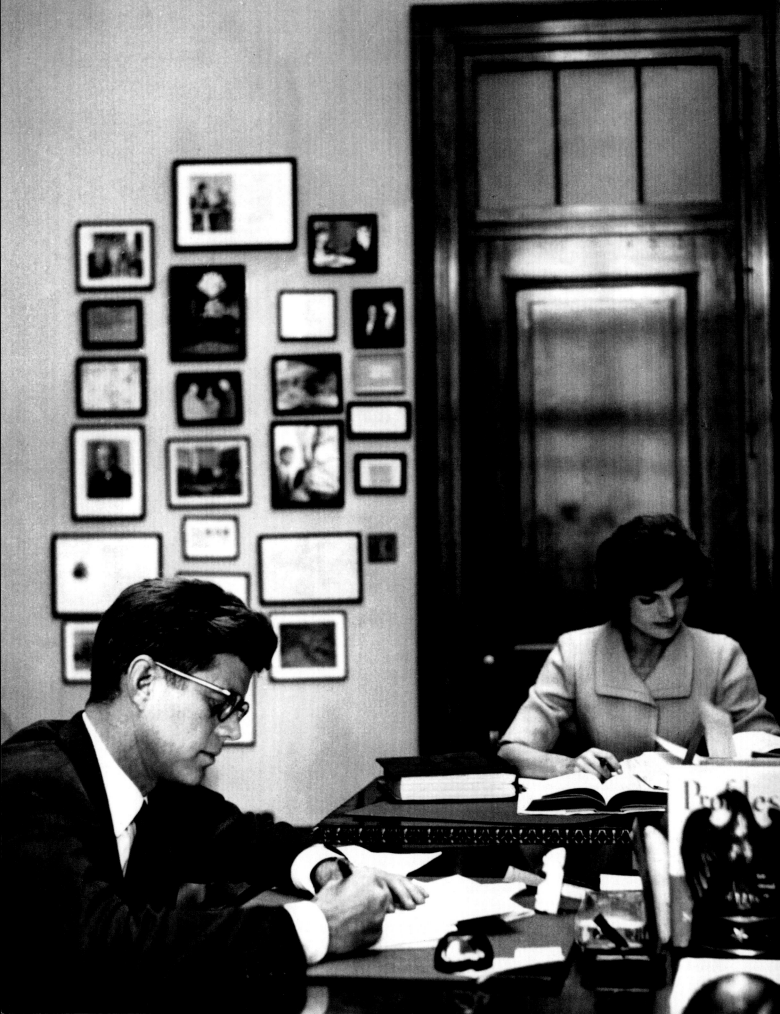

Jack's Senate office. When she had time, Jackie helped her husband with research for his speeches, including translating material written in French. Later, Jack would avoid being photographed wearing glasses. The Senator's informal style meant that he was frequently interrupted by visitors, such as this delegation of union officials.

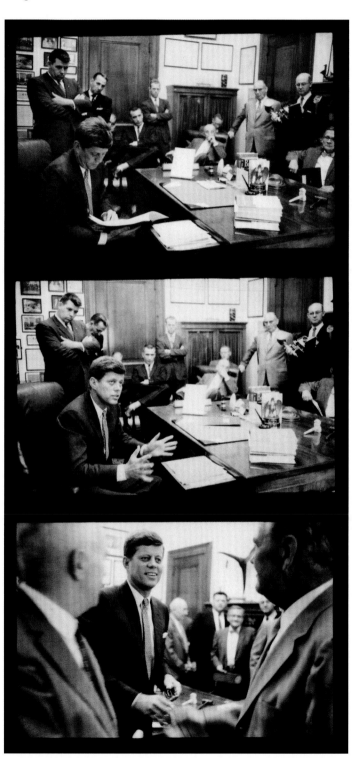

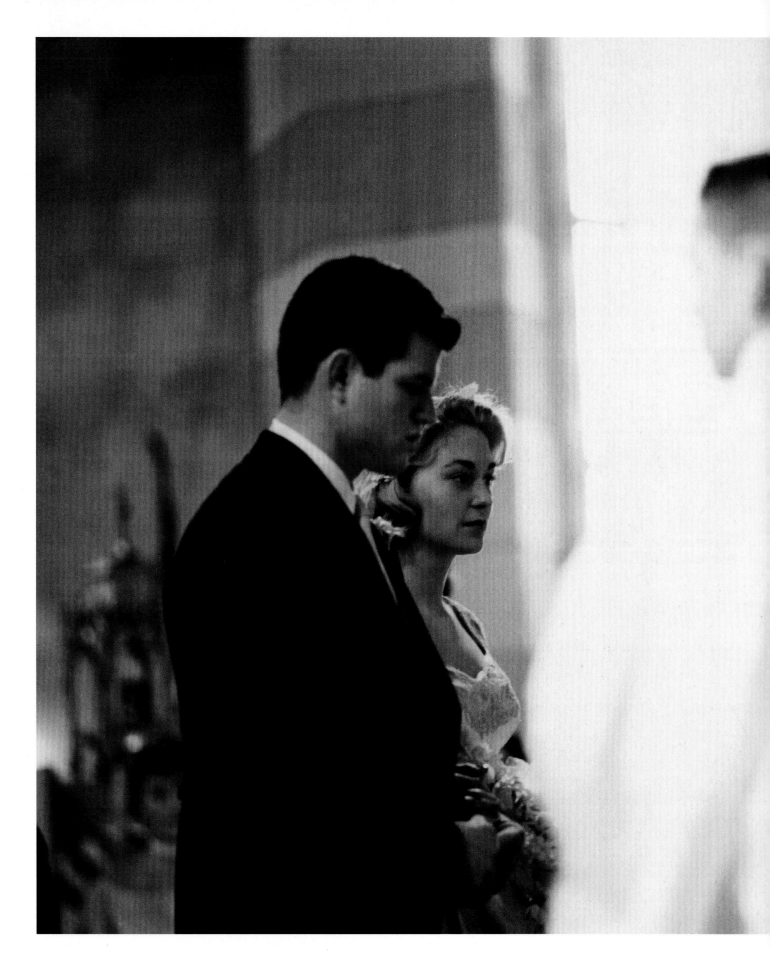

Bronxville, New York, November 1958

Presided over by Cardinal Spellman, the wedding of Edward Kennedy and Joan Bennett was a huge tabloid newspaper event. The reception was held at the Bronxville Country Club with the whole Kennedy clan in attendance. Earlier that month, Jack had been re-elected to the Senate.

"The wedding was a circus, with TV and newsmen all over the lot, even jumping out from behind the altar. It was hard to get a good shot without a few other photographers in the picture."

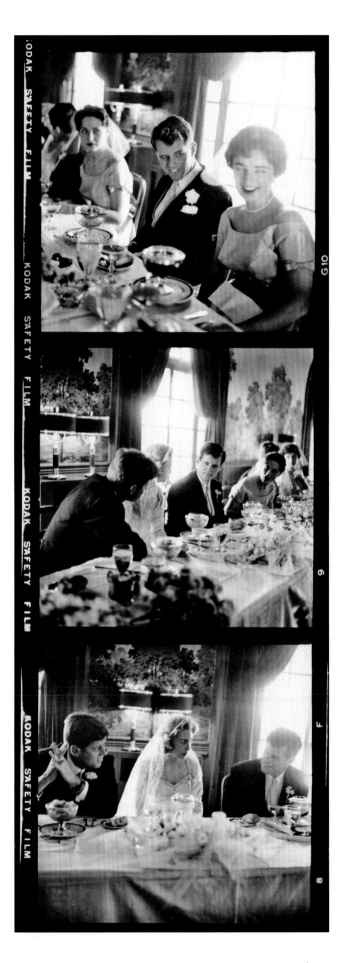

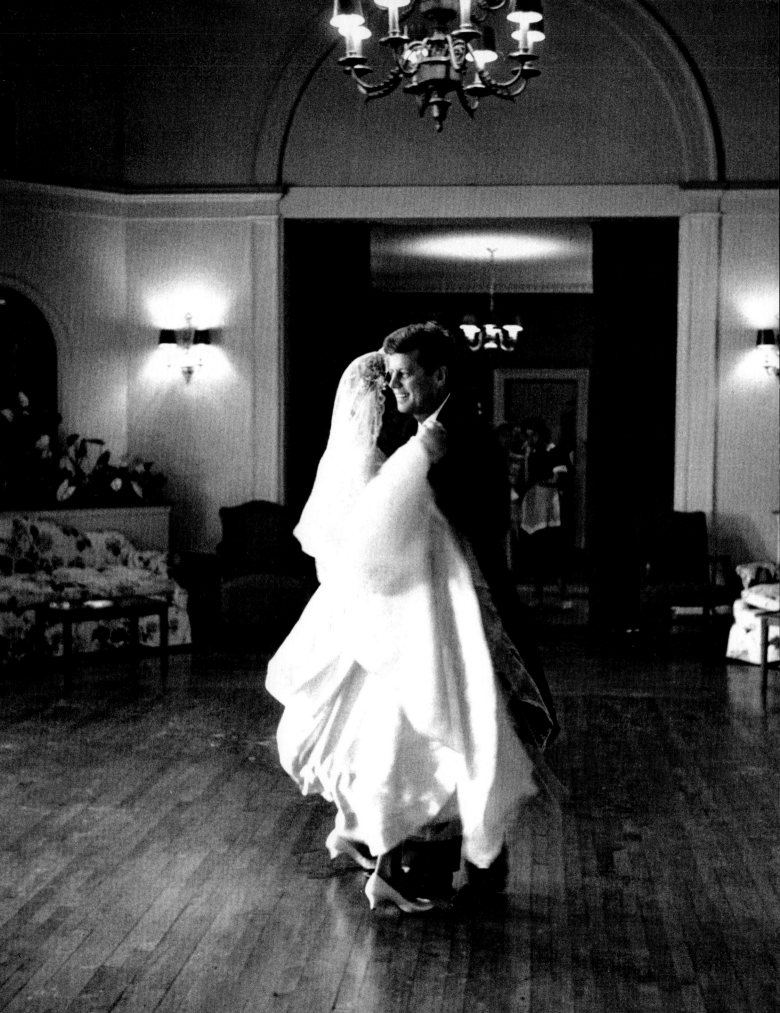

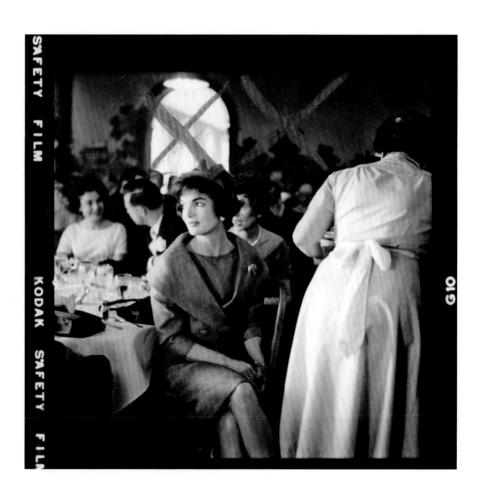

Jacques did not wish to be a wedding photographer and thought the conditions made it impossible to get good images, but he dutifully captured Jack taking the bride for a spin on the dance floor. The image of Jackie gazing away pensively was more to Jacques' liking.

On the Campaign Trail

From September 1959, the team
used a leased Convair called the
Caroline. After Jack announced
his candidacy in January 1960,
the team of advisors, speechwriters,
and press people grew larger.

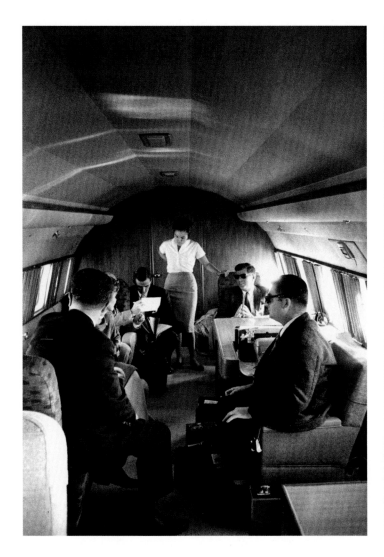

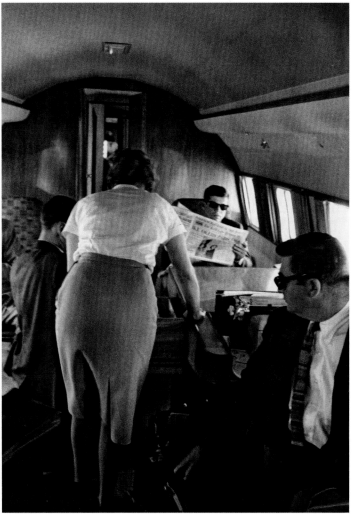

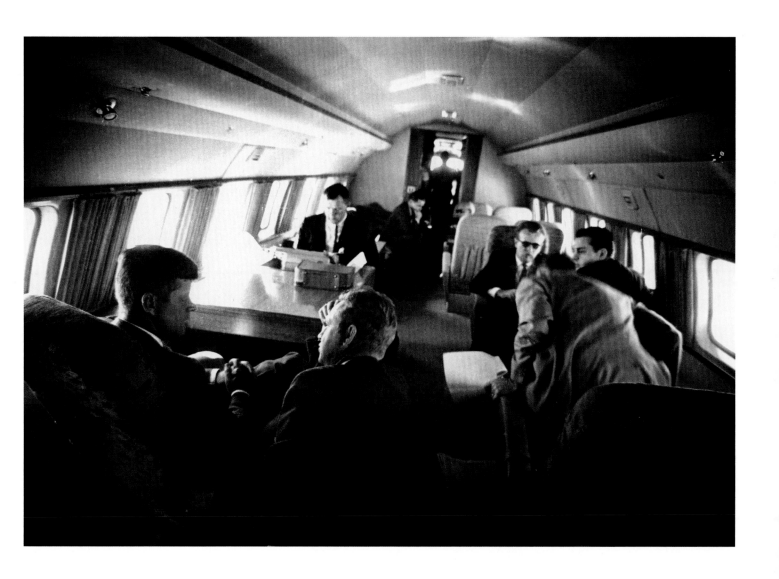

"He was always well briefed by his aides on the territory he was entering. On the plane he would read the local newspapers—in those days his name was on the inside pages—while downing his regular campaign diet of clam chowder, steak, and an occasional Heineken's beer."

When she could, Jackie accompanied Jack on his early trips and her assistance ranged from presiding over tea parties with elderly ladies to attending farm-equipment auctions. Later, during the election campaign itself, she was pregnant with John Jr. and made fewer appearances.

Here she is reading Jack Kerouac's *The Dharma Bums*, which had recently been published. Jackie took care not to overdress though she always looked stylish—the check suit was by the French designer Bob Bugnand—and never changed her manner to pander to voters.

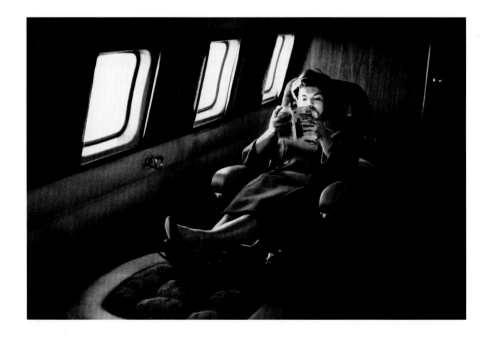

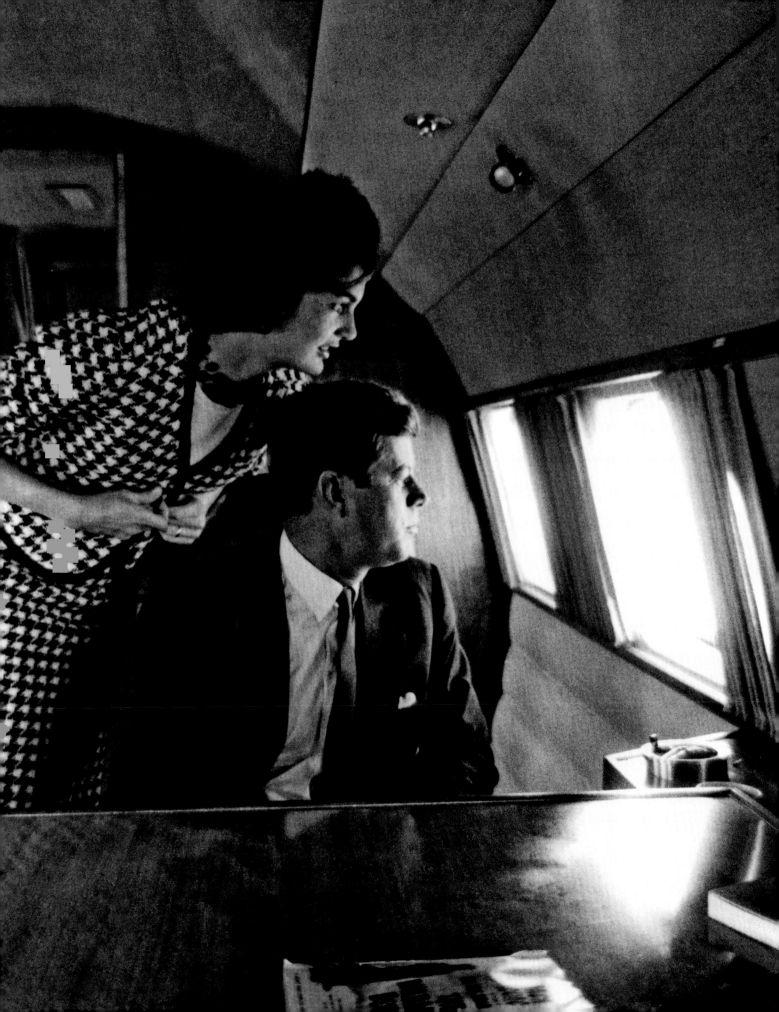

Oakland, California,
October 1959

At Mills College, a well-known
women's college, Jacques noticed
that the Senator was now more
comfortable with using his hands
for emphasis and was talking
persuasively to the young women
and occasional male graduate
student. He felt that the visit was
a turning point.

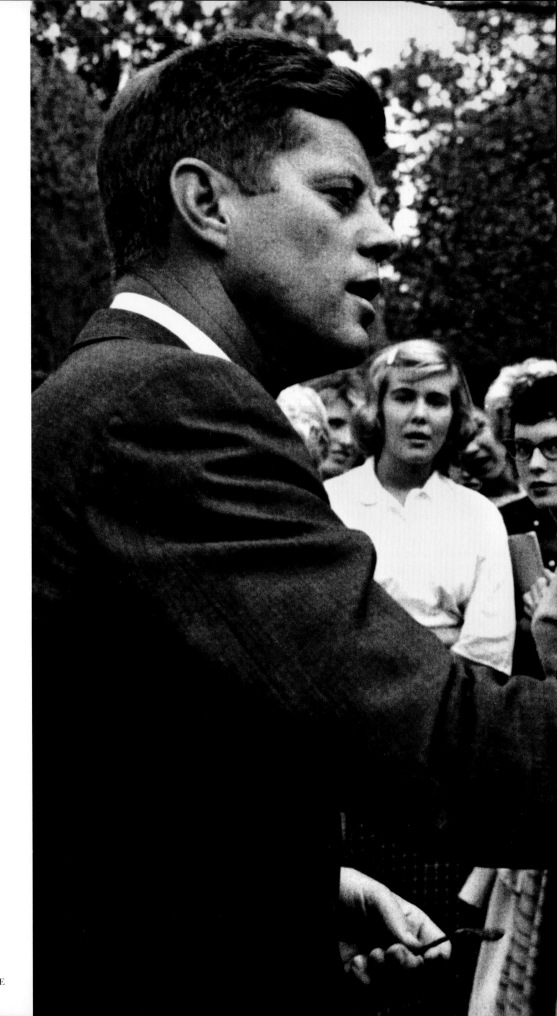

"At Mills, they listened intently, threw probing and candid questions at him, and got replies that were just as candid and hard-hitting."

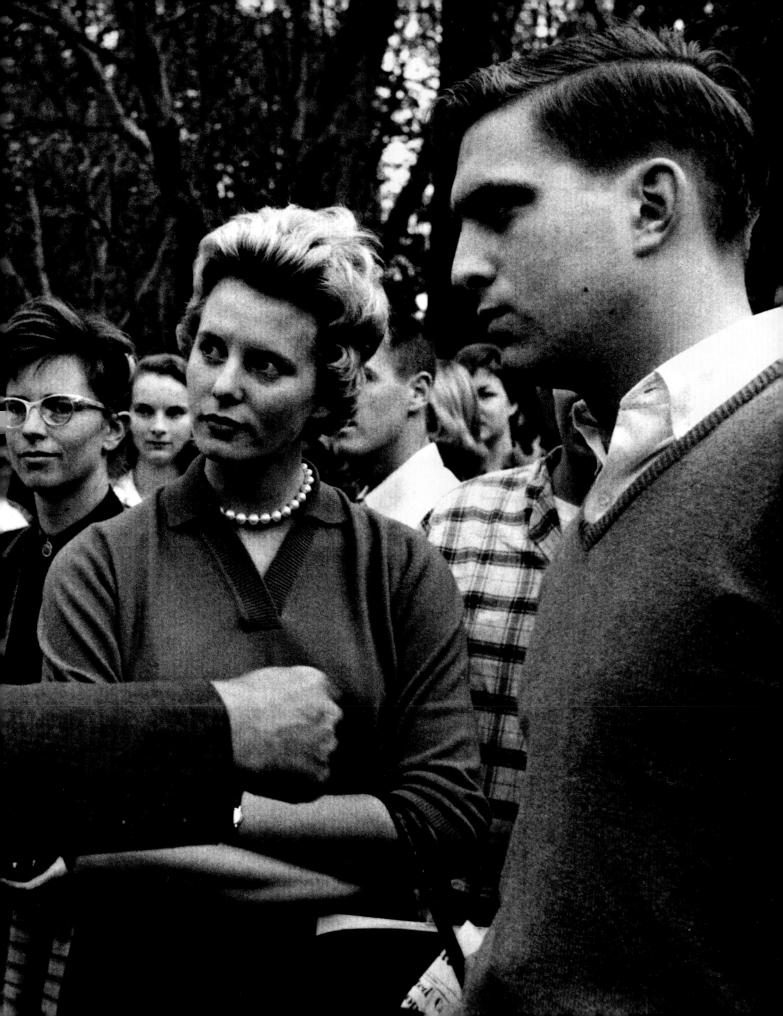

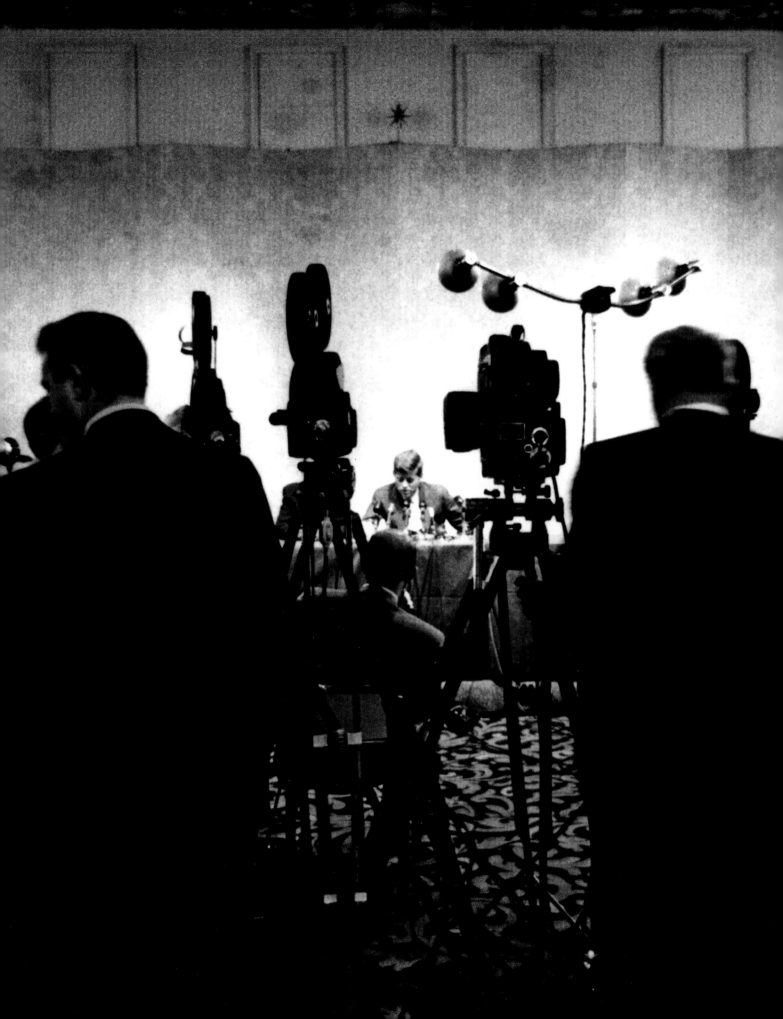

On January 2, 1960, John F. Kennedy officially announced his candidacy for the Democratic Presidential nomination. At that point everything changed. Kennedy's rivals for the nomination included Adlai Stevenson, Lyndon Johnson, Hubert Humphrey, and Stuart Symington, all men with experience and reputations while people thought Kennedy was too young and too Catholic. Usually candidates entered just a few primaries but Kennedy's strategy was to compete in every primary or state Democratic convention so he could roll into the Democratic National Convention in Los Angeles with overpowering momentum. Winning primaries would dispel the conventional wisdom that American voters would not accept a Catholic as President; if he could beat better-known and more experienced candidates it would prove he was more electable.

Jack's first major opponent, Minnesota Senator Hubert Humphrey, was expected to do well in the primary of his neighboring state of Wisconsin. Bobby was so concerned about Humphrey's popularity there that he initially urged Jack to avoid that state. If Jack lost in Wisconsin, Bobby reasoned, he would be knocked out of the race at the very beginning. But Jack felt he had to be bold to win and Joe supported him. If Jack ducked the tough battles the party would never accept him. Once the decision was made, the entire family pulled together.

Jack won strongly in Wisconsin but the state's large number of Catholics, who voted overwhelmingly for Kennedy, meant that the religious question was not really answered. He next went up against Humphrey in West Virginia, where Catholic voters were less than 5 percent of the population. Here, Humphrey, a true liberal who had fought bigotry all his life, had the support of anti-Catholic bigots such as the Ku Klux Klan and other fringe groups. At first, West Virginia was very difficult; the crowds were small and not especially friendly. But Jack worked hard for every vote. If we came across any coal miners, Jack would pose for me with them and then ask me to send each of them a copy of the image. He never forgot to check up on me.

3

Winning the Nomination

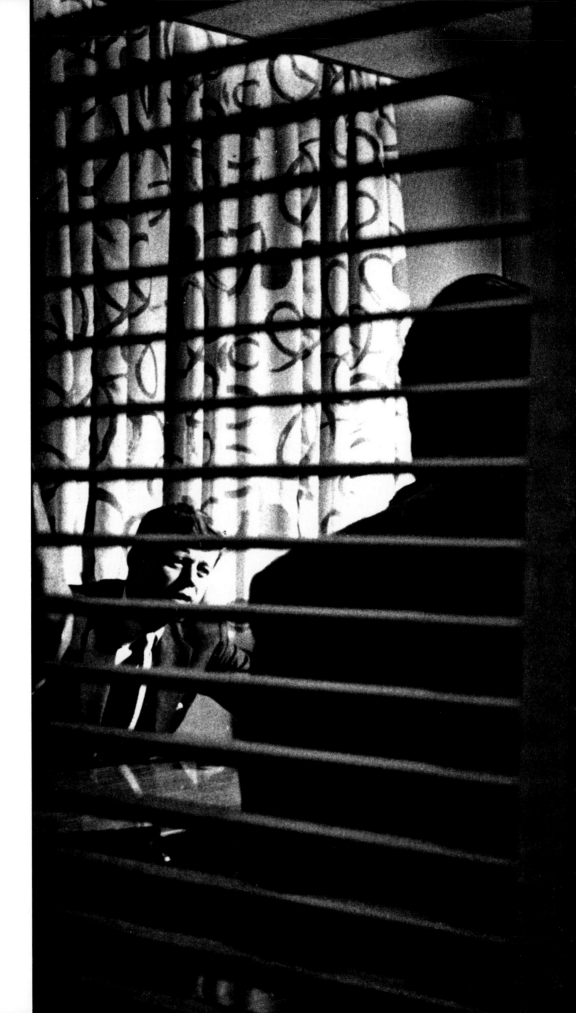

Page 66: "I am announcing today my candidacy for the Presidency of the United States," Jack declared on January 2, 1960, to a Senate Caucus Room filled with press and some three hundred friends and supporters.

Chicago, Spring 1960

Once the primary campaign began in earnest everything happened on the fly. Here, at a Chicago airport stopover, Jack convenes an impromptu meeting before flying on to Wisconsin.

Wisconsin, April 1960

Wisconsin was the first big primary test, where Jack took on Hubert Humphrey almost on the Minnesota Senator's home territory, and beat him decisively, capturing 20½ of the state's 31 convention votes.

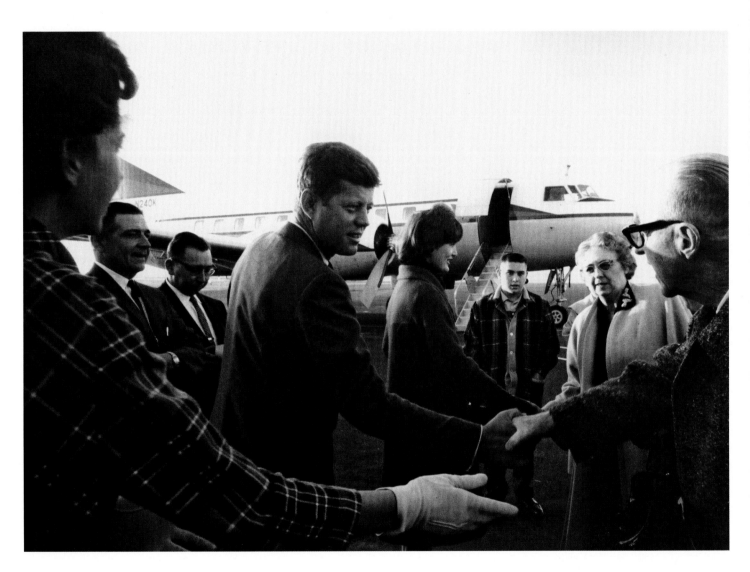

"Wisconsin started on a lonely level, a search for hands to shake and nonexistent votes to influence. Nobody seemed to care, few were willing to listen, no enthusiasm was apparent."

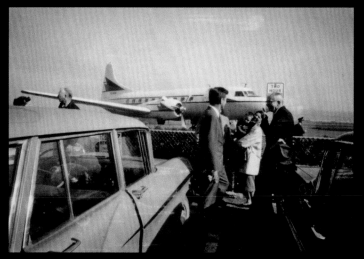

West Virginia, April 1960

The West Virginia primary, which took place in early May, became the make or break contest where Jack would have to prove that his Catholicism was not an impediment. This was the issue, not poverty or unemployment. After a slow start, the crowds became enthusiastic and Humphrey's campaign faltered. The picture (right) taken in Charleston became one of Jack's favorite images.

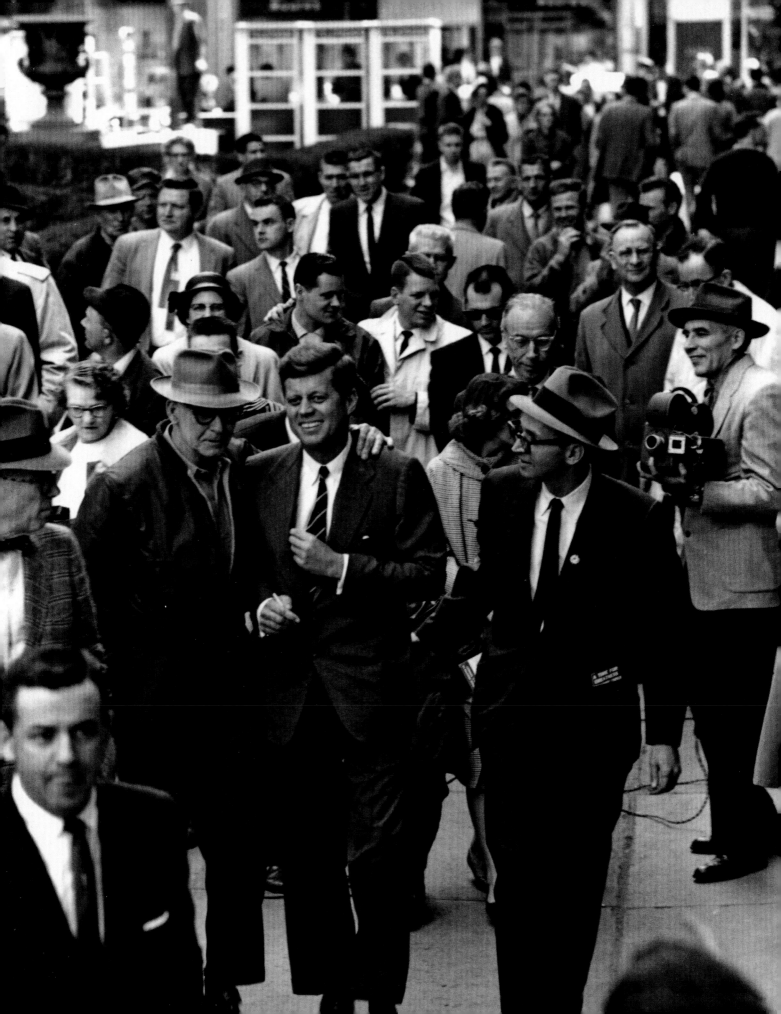

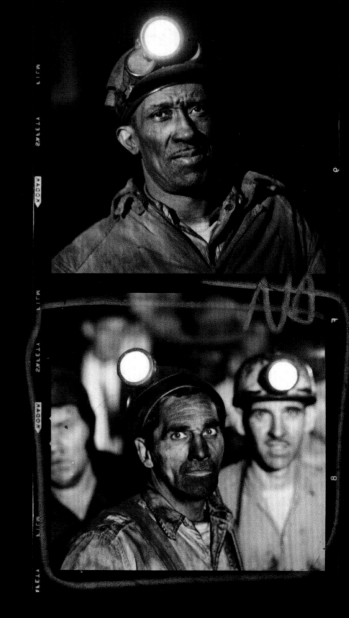
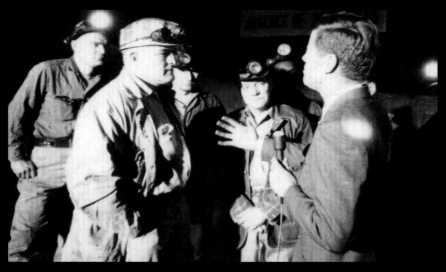

Less than 5 percent of the population of West Virginia was Catholic and Jack took every opportunity to shake the hands of potential voters to convince them that his religion should not hinder them from voting for him.

Overleaf: By the time the primary campaign in West Virginia drew to a close it was clear that Jack would score a major triumph. His victory was so overwhelming that Humphrey dropped out of the race for the nomination.

"Jack worked hard for every vote in West Virginia. If we came across any coal miners, Jack would pose for me with them and then ask me to send each of them a copy of the image. He never forgot to check up on me."

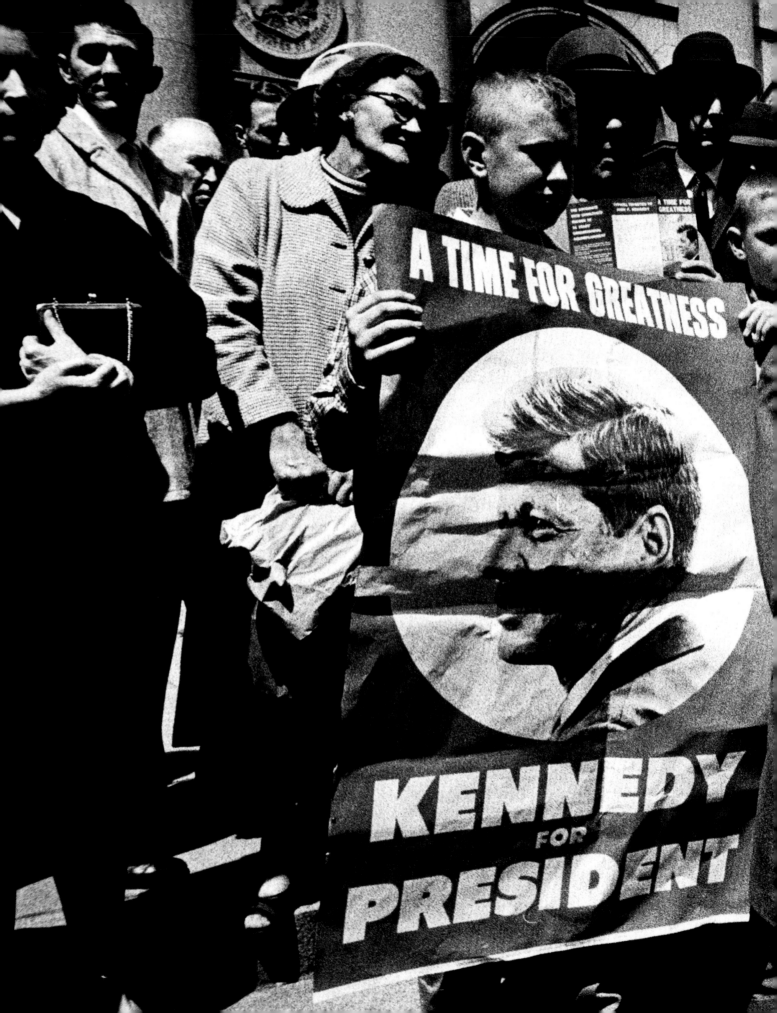

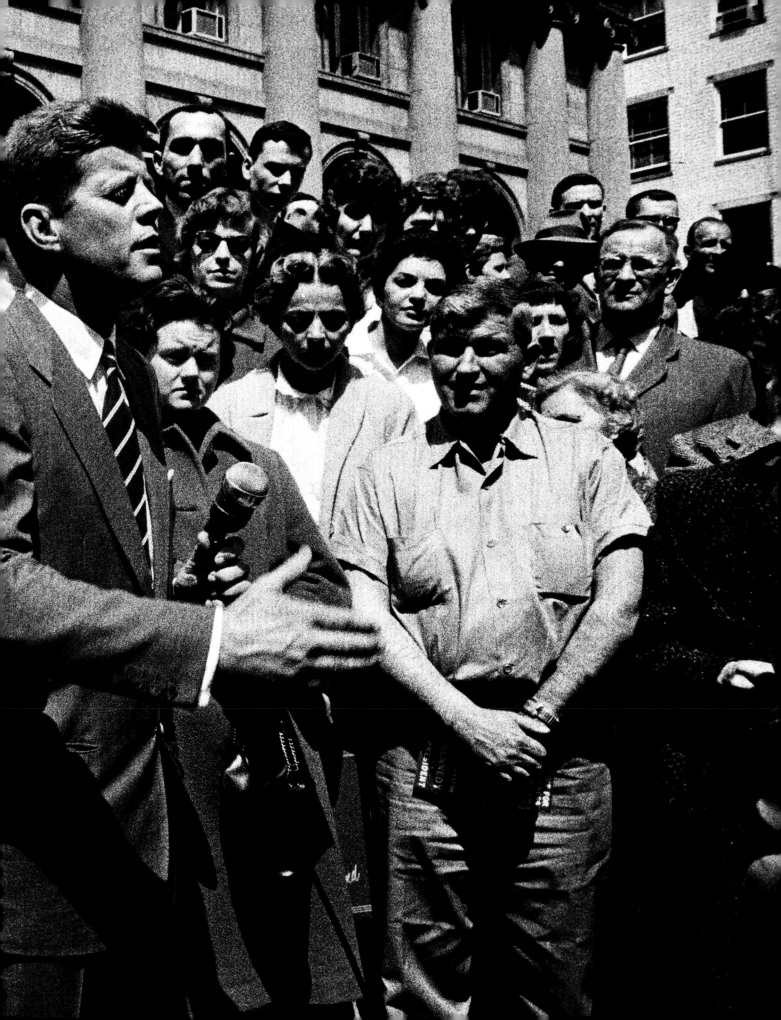

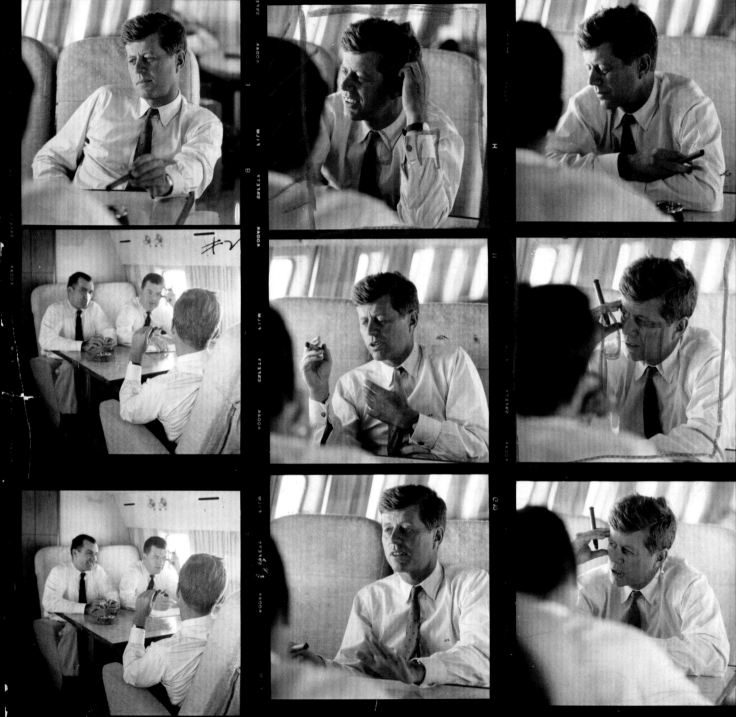

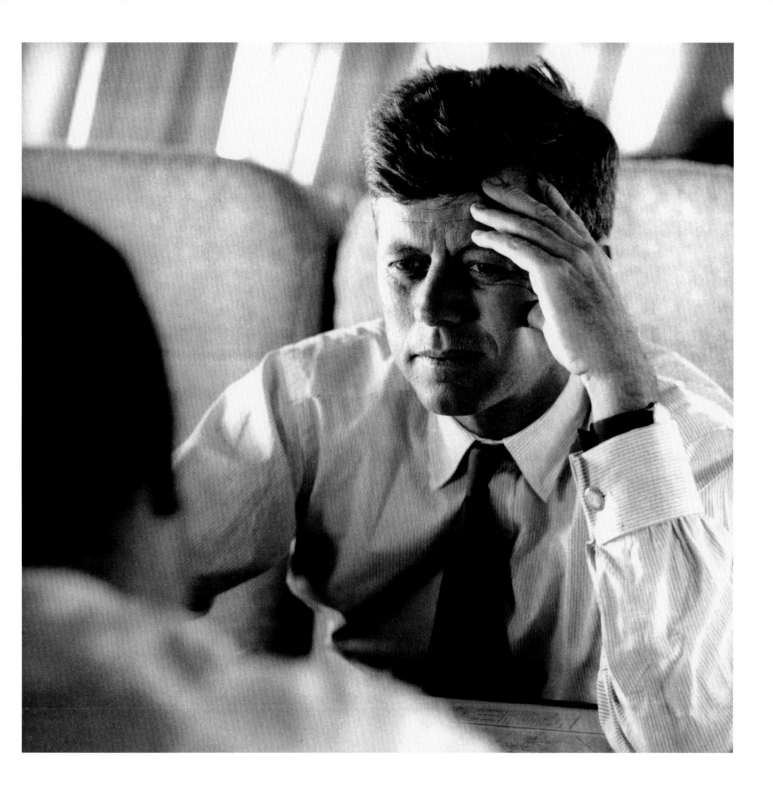

**Towards Nebraska,
Spring 1960**

Leaving West Virginia on the
Caroline, Jacques captured Jack
in a confident and relaxed mood.

California, 1960

The growing importance of celebrity culture in American politics was underlined when Frank Sinatra, Shirley MacLaine, and Dean Martin provided the entertainment at a Jefferson-Jackson Day dinner—a traditional Democratic Party fundraiser.

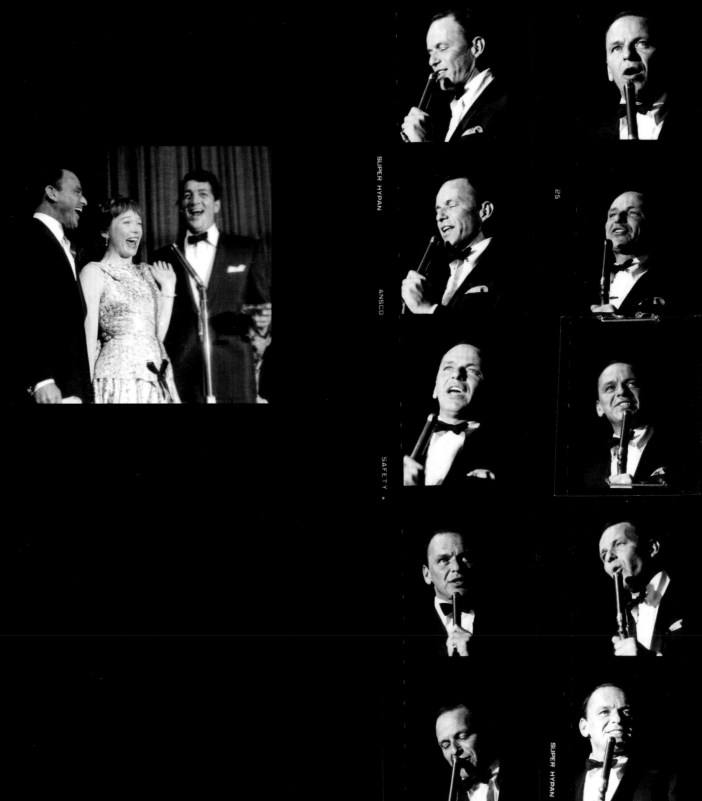

Jackie was pregnant for much of the campaign and was mainly active in the early days. But there she was in West Virginia one afternoon, gamely letting herself be evaluated by the high-society ladies of a small town as if she was a horse. The Kennedy family machine was in full swing by now; they simply overwhelmed the somewhat disorganized Humphrey campaign. Bobby was campaign manager and Jack's closest, most trusted advisor; Steve Smith was in charge of the finances; Teddy, who was the coordinator for the Western states, was also on the scene; and the Kennedy sisters were everywhere. Humphrey began to feel a little defensive. On one telecast he said:

"The Kennedys are everywhere but I have a family, too. Muriel, come on up here and show yourself to the folks. Muriel, where are you?"

After some time, his wife, Muriel, finally made her way up.

"And then there's my son. Bob, where are you?"

When Bob finally appeared, Hubert said:

"What have you been doing for the campaign Bob?"

"I've been handing out 'Humphrey for President' literature."

"And what's happening?" his father asked.

"Nobody wants the stuff," Bob said.

Most importantly, it was in West Virginia that Jack discovered that if he addressed the Catholic issue with his characteristic directness, voters would be reassured. Although some of his advisors wanted him to avoid the issue, Jack felt he had to confront it. The Kennedy campaign even paid for a state-wide telecast two days before the election in which he affirmed his belief in the separation of Church and State. The vote was a landside for Kennedy.

It was hard to dislike Humphrey personally, and when the result was in and Humphrey dropped out of the race, Bobby put his arms around him and assured him there was no animosity. The Kennedy campaign began to feel like a bandwagon. As we bounced around the country, from primary state to primary state, I noticed that Jack was careful to touch base with powerful Democratic leaders such as Governor David Lawrence of Pennsylvania and Mayor Daley in Chicago, always with his eye on the convention, where these men would have a lot of delegates under their control.

I was now on the road seven days a week. At first I had sent my contact sheets to Steve Smith or his designated person; they would mark the images they wanted and send them back to me and I'd print them. With the increased demand, I began to make my own selection and print them

and let the Kennedy people choose the ones they wanted to use. Finally, as we got closer to the convention, I developed each day's photographs in a portable dark room, selected the useful images myself, and sent them to the Democratic headquarters in each of the fifty states plus about one hundred key television stations. I was also providing images for small rural newspapers that didn't employ photojournalists. I was turning out hundreds of pictures every night as we rolled from Wisconsin to West Virginia, California, and Illinois on our way to the convention.

In early July, just before the convention began, we had a short break and I flew to Hyannis Port to take color portraits of Jack and some family portrait pictures. Jack was keyed up, at once happy yet nervous. The primaries had gone well but he still had to face Lyndon Johnson in Los Angeles. At one photo session, I told Jack I didn't like his necktie and we exchanged ties. He admired my tie and said I must be making a lot of money.

"If I am, it isn't from the Kennedy campaign," I said. Later, someone plagiarized that photo and sold it to a European magazine where it appeared on the cover. Because Jack was wearing my necktie, I was able to prove my ownership of the image and get paid for it.

Before I left Hyannis, Jack asked me if I was coming to the convention. I told him I was.

"Good. Let's take some great candids there." Little did I know how right he would prove to be.

The previous Democratic Convention, in 1956, was where Kennedy began his march to the presidency. The speech he made putting Adlai Stevenson's name in nomination made him a strong candidate for the Vice Presidential nomination, though all the doubts about a Catholic candidate were also on the table. A number of politicians (including Jack and his new assistant Ted Sorensen) made the case that a Catholic on the ticket would help Stevenson. But many others thought a Catholic would drag Stevenson down. Stevenson and some of his advisors were initially open to Kennedy as a running mate but the hostile reaction of some of the party leaders (many of whom were themselves Catholic) persuaded him to turn the Vice Presidential nomination into an open election. On the third ballot, Estes Kefauver beat Kennedy. Although Kennedy never forgave Stevenson for his indecisiveness, the Kennedy luck prevailed in the end. Dwight Eisenhower and Richard Nixon overwhelmed Stevenson and Kefauver, but at least Jack (and his Catholicism) was not blamed for bringing down the ticket.

Now, as we rolled into the 1960 convention in Los Angeles, the Kennedy strategy looked good: Jack had won all the primaries he had entered and was in the strongest position. Our headquarters, along with almost everyone else, was the Biltmore Hotel. The candidates all had lobby displays with pretty girls in costumes parading around handing out buttons and car stickers. The Kennedy people were giving out PT-boat tie clips. And there was a constant stream of visitors who wanted to speak to the candidate or the campaign manager, or anyone remotely connected to the campaign. The activity was non-stop and chaotic. Back in Hyannis, Jack had asked me to stick close to him at the convention but it wasn't easy. With the help of Steve Smith, I managed to fight my way into his suite. But every time Jack left the suite he was swallowed up by masses of people who were desperately trying to get close to him. If I didn't manage to wedge myself into the elevator with him, shoving other people aside if necessary, I wouldn't be able to find him for several hours.

There was still a sentimental attachment among some delegates to Stevenson, but Jack, having placed Stevenson's name in nomination in 1956, had some hope that the former presidential candidate would return the favor in 1960, which would solidify his support among liberals. Stevenson would not give up, but aside from a prolonged demonstration on the convention floor, he made little impression. The only serious contender was Lyndon Baines Johnson, the powerful Senate Majority Leader.

By now the Kennedy organization was an efficient machine. In addition to Bobby Kennedy and Steve Smith, there was Lawrence O'Brien, manager of Jack's re-election landslide to the Senate, who had a file on every delegate at the convention; Pierre Salinger dealt with the press; other key roles were played by Sargent Shriver, Kenny O'Donnell, and Ted Sorensen. Ted Kennedy did such a great job as coordinator for the Western states that Lyndon Johnson was startled to discover he was pretty much denied the vote of those delegates.

I had become such a ubiquitous figure in the Kennedy team that when Lyndon Johnson spotted me across the crowded convention floor, he walked all the way over and shook my hand. "Hi, Junior," he said and then walked away. Johnson probably didn't know exactly who I was but he already knew he had been completely outplayed by the Kennedy team and he didn't want to miss any bets with the Kennedys as far as his future was concerned.

On the convention floor, I had the uncanny experience of seeing a photograph I had taken of Jack reproduced on hundreds and hundreds of placards, which our supporters waved frantically as the balloting began. When the first ballot commenced, I was standing with Larry O'Brien who was holding his tallies of where Kennedy stood with each delegation. He was convinced Kennedy would win on the first ballot with 762 votes, one more than a bare majority. At the very end of the balloting Wyoming put Kennedy over the top, giving him a total of 806 votes. Everyone started screaming and yelling. Ted Kennedy grabbed the Wyoming banner and started waving it.

The Vice Presidential nomination was the big surprise and that is how I got some of my most famous candid images. Stuart Symington, Senator from Missouri, was Jack's original choice. Although there was a certain logic to the idea of having Lyndon Johnson on the ticket–he could deliver Texas and help in the South–no one imagined that Jack would offer the nomination to him and no one thought that Johnson, the most powerful Senate Majority Leader in history, would accept.

I arrived in Jack's suite in the Biltmore Hotel at eight in the morning just as Jack phoned Lyndon Johnson to request the meeting where he would feel Johnson out about the Vice Presidential nomination. For the rest of that extraordinary day I stayed on the scene as the process played out in a series of meetings. Bobby, who detested Johnson, went back and forth a number of times between Jack's suite and Johnson's, which was two floors below. I was there when Bobby and Jack had it out about choosing Johnson. When it was all finally worked out and time to seal the deal, there were just the three of us in the room–LBJ, JFK, and me. Johnson poured himself a healthy drink. Then Bobby came into the room and stood silently by, regarding Johnson with a look of deep suspicion. Only with hindsight, and because of the assassination, can we see just how much history flowed from that moment, from the great progressive legislation that Johnson passed to his tragic and disastrous conduct of the war in Vietnam.

That night I had dinner with Clay Felker, then an editor at *Esquire*, Norman Mailer, and Peter Maas, who was writing for *Look*. When I casually mentioned that Lyndon Johnson was going to be the next Vice President they nearly fell off their chairs. Then they ran for the phones. I sold my story that night to *Look* magazine who couldn't believe I was in the room taking photographs. They gave me several pages and Jack Kennedy himself wrote the captions! It was a real coup for me.

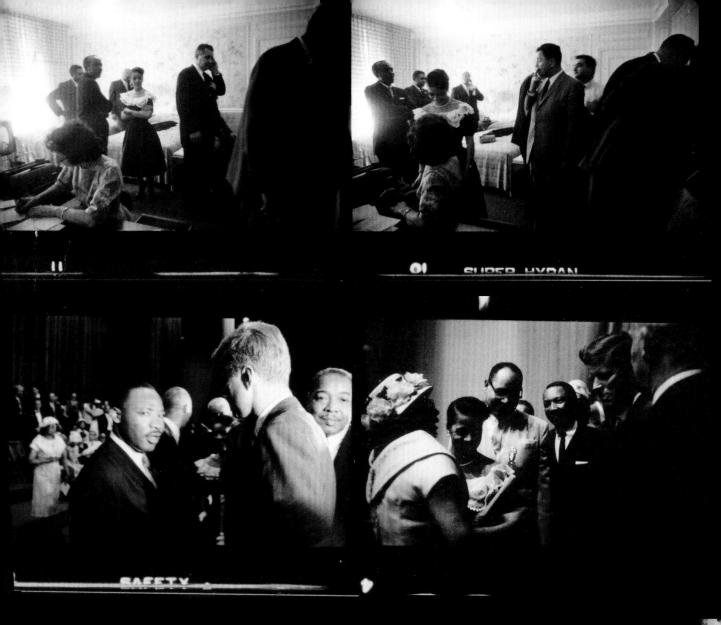

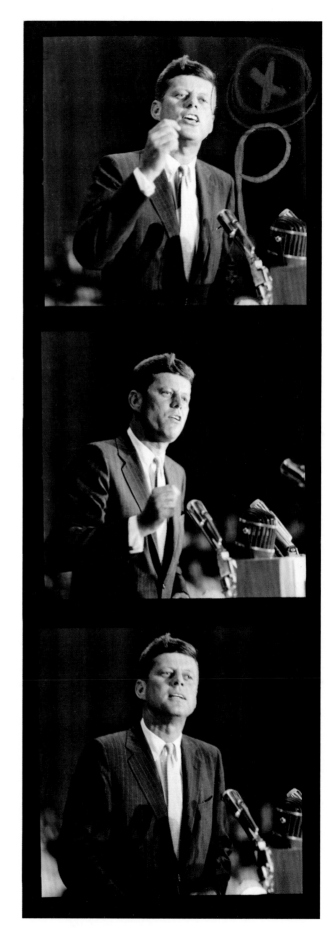

Los Angeles, July 1960

On July 10, the day before the Democratic National Convention got underway, Jack addressed a NAACP rally at the Shrine Auditorium in Los Angeles. It had been organized to press for the inclusion of a strong civil rights statement in the party's platform.

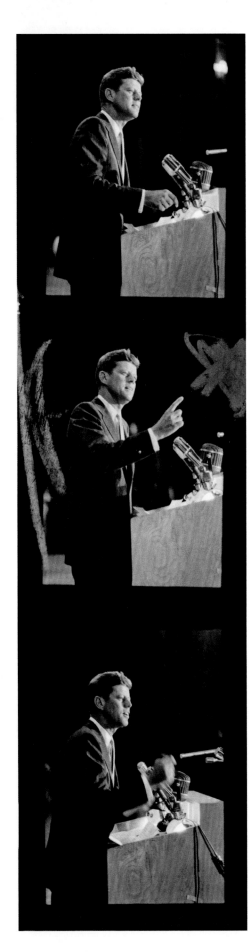

Jack's speech was received politely at the NAACP rally. Lyndon Johnson, Jack's strongest rival for the nomination, had also agreed to speak, but sent a representative instead. When Johnson's name was mentioned, the boos and jeers brought the rally to a standstill for several minutes. Only Hubert Humphrey was cheered.

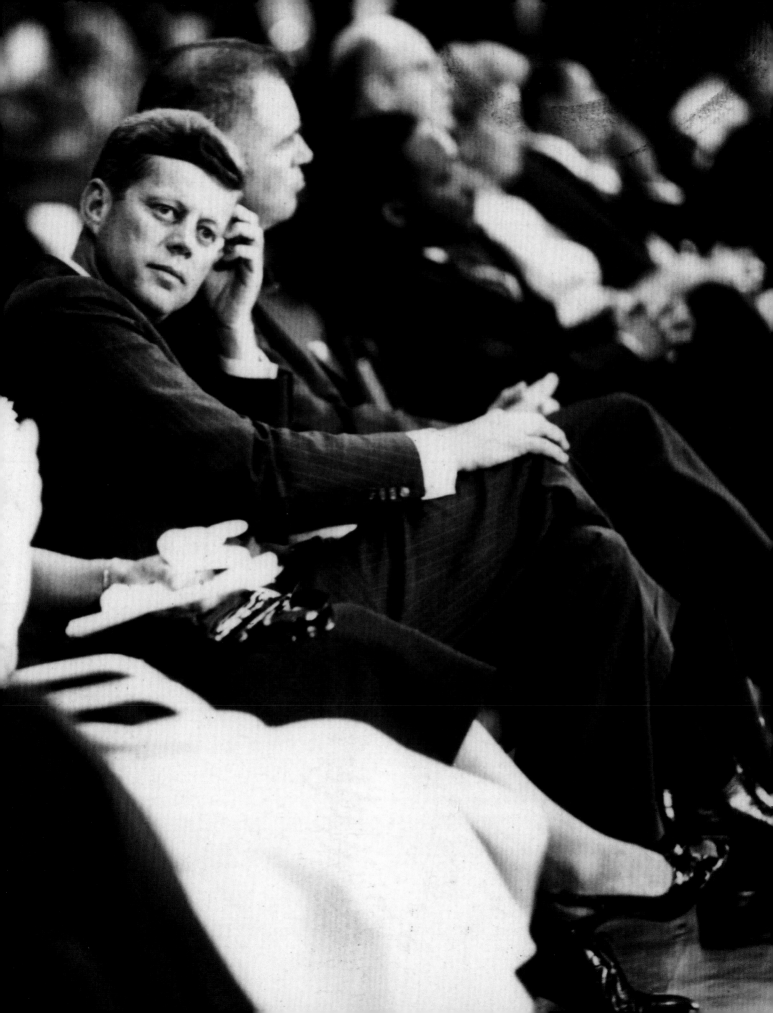

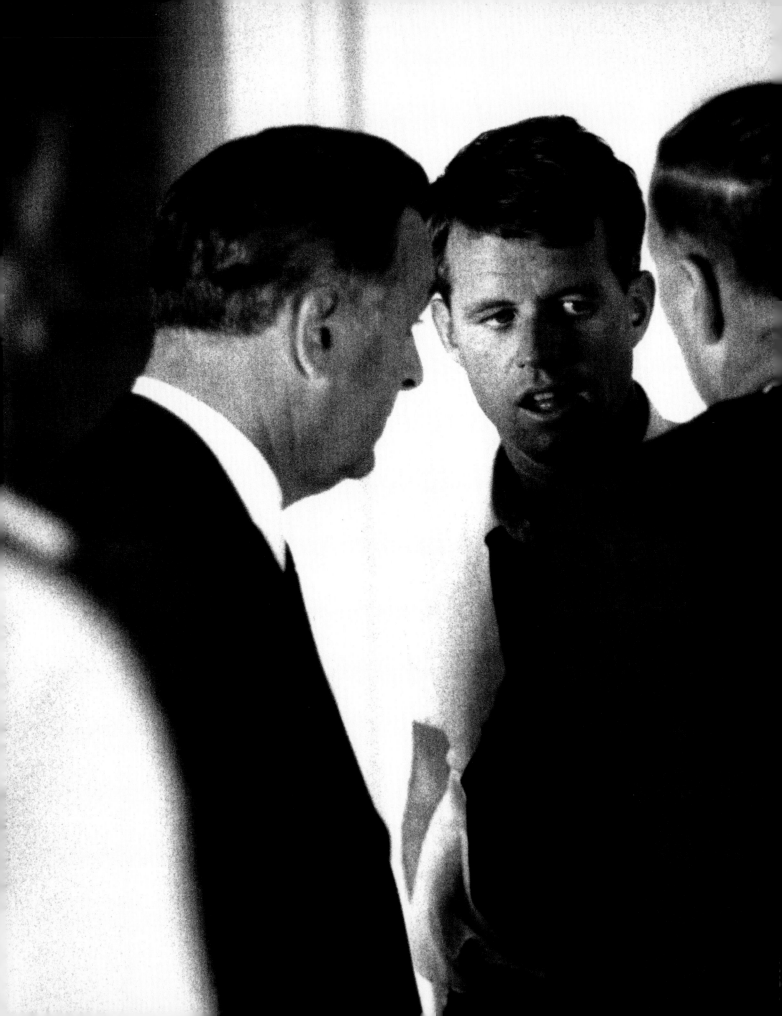

The Kennedy command center for the Democratic National Convention was in suite 9333 at the Biltmore Hotel, Los Angeles. Lyndon Johnson's suite was 7333, two floors below. When it came time to negotiate with Johnson over his selection as the Vice Presidential candidate, Jack, Bobby, and LBJ used a back staircase between the floors to avoid the press and other politicians.

Overleaf: Before the convention was fully underway, there was a constant round of meetings with politicians and delegations to shore up support. Jacques thought that one of the most frightening aspects of the convention was the fickleness of the delegates.

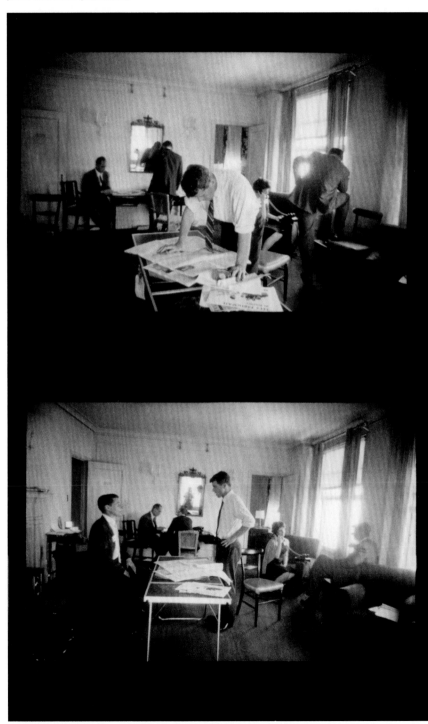

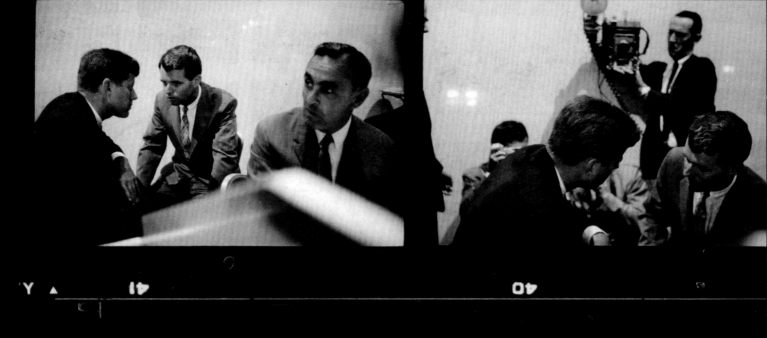

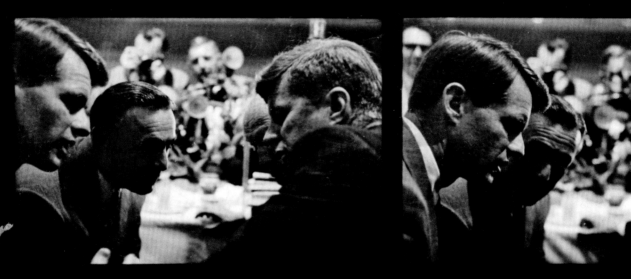

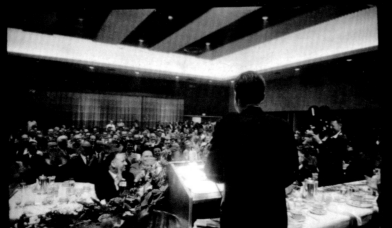

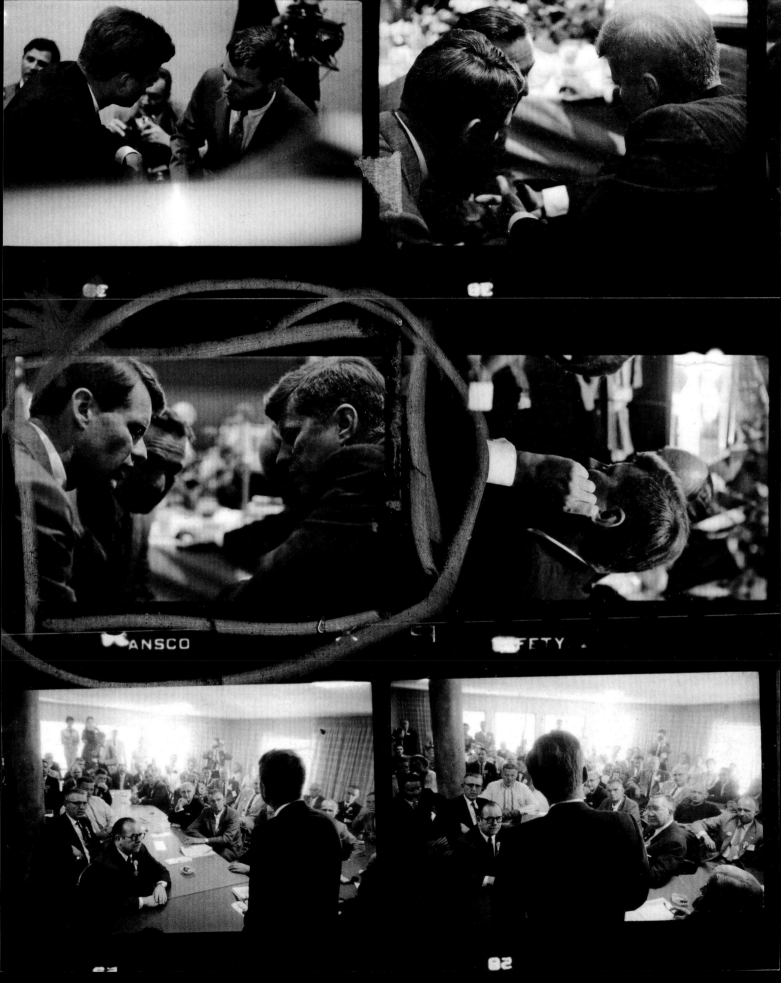

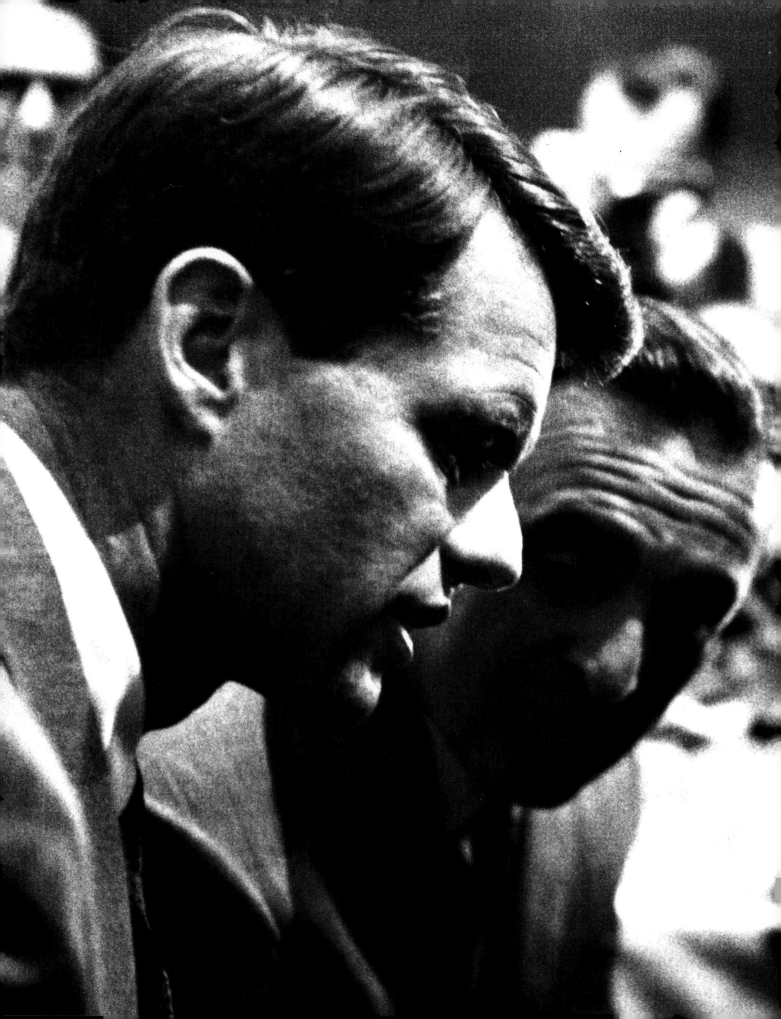

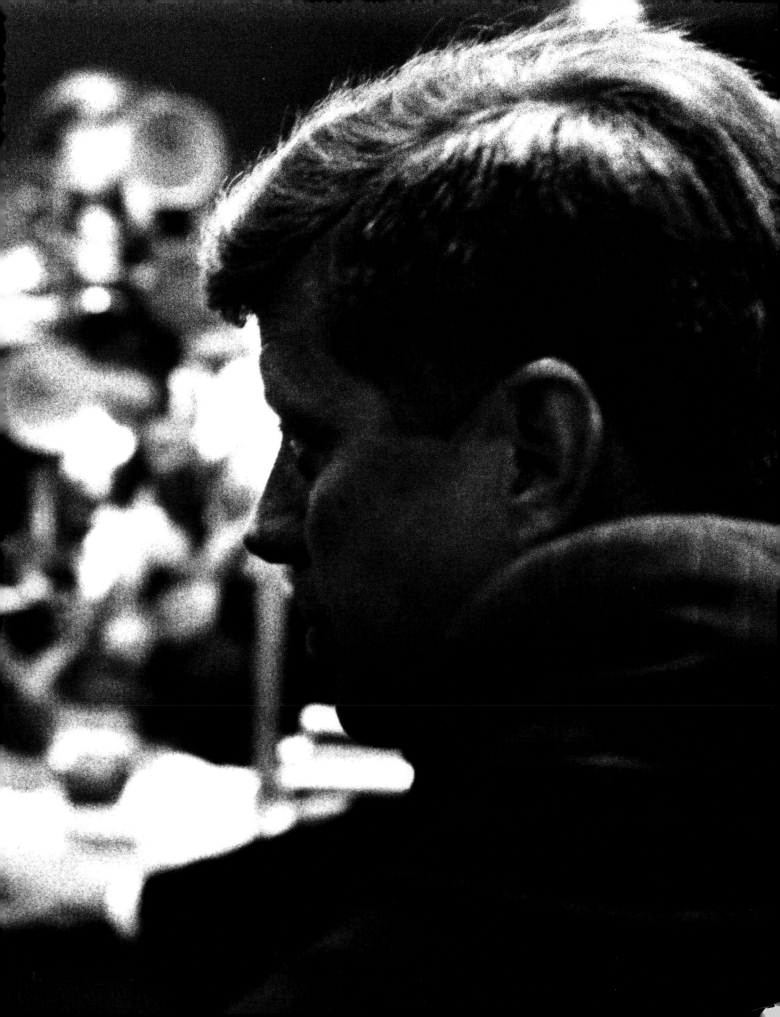

Pages 94–95: Governor Abraham Ribicoff of Connecticut was one of Jack's earliest and strongest supporters. He had placed Jack's name in nomination for Vice President in 1956.

On Tuesday, July 12, Senator Eugene McCarthy placed Adlai Stevenson's name in nomination and there was a large and raucous demonstration in his favor, though it did little to advance his candidacy. Meanwhile, Jack accepted a challenge from Lyndon Johnson to debate with him before the Texas delegation. Johnson expected to demolish his rival for the nomination but most people felt that Kennedy, employing his charm and humor, easily bested the Texan Senator.

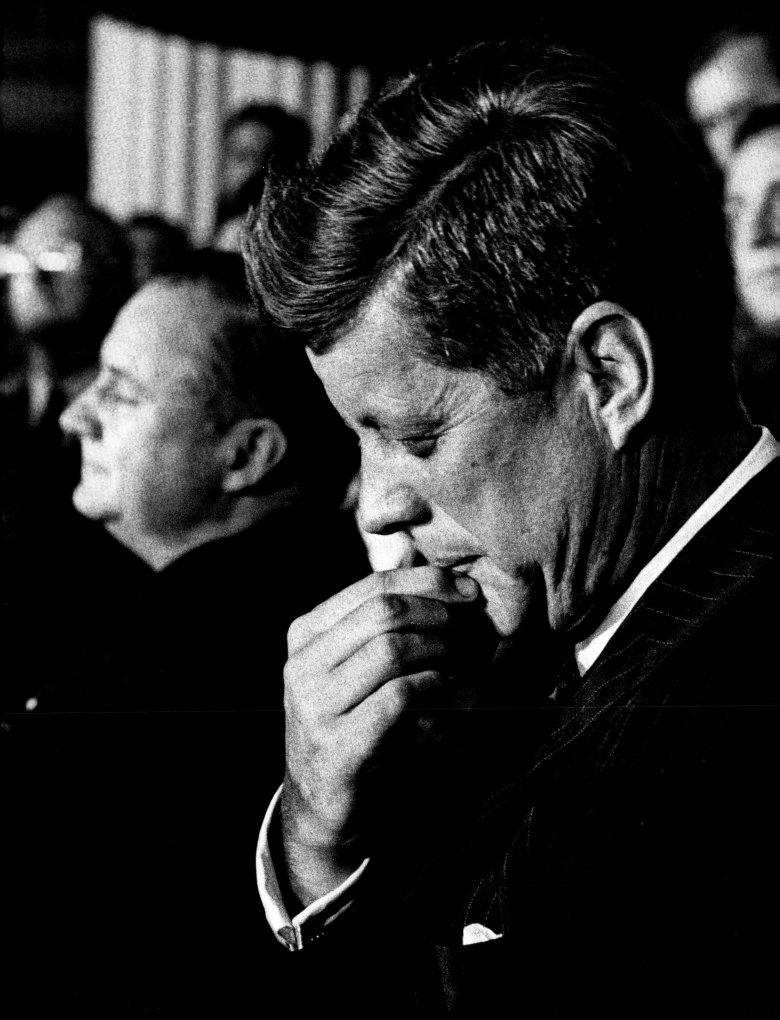

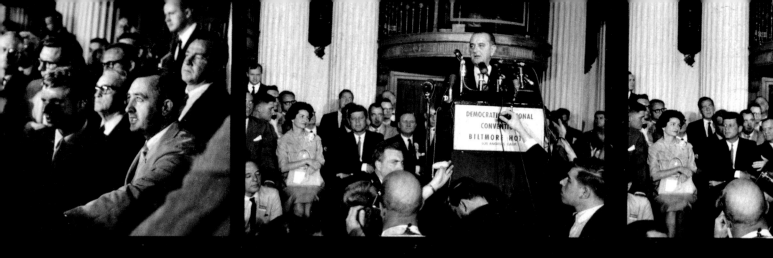

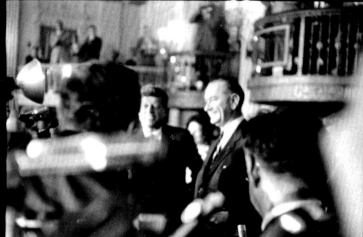

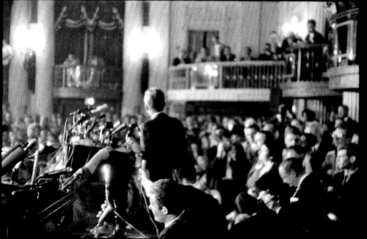
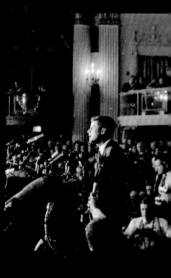

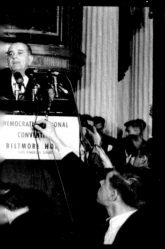
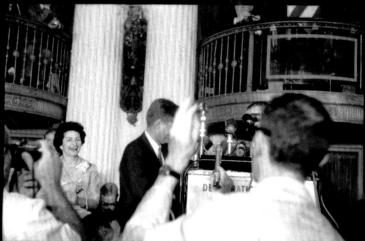
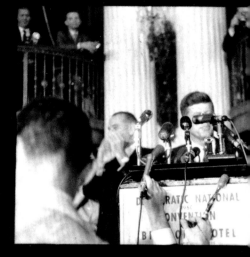

17

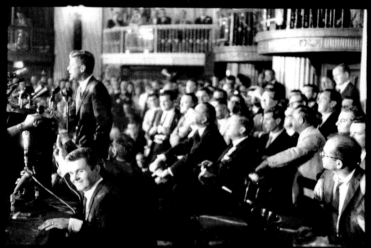
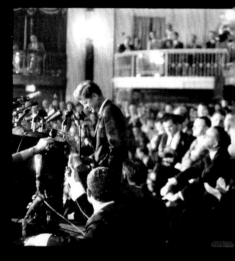

62

82

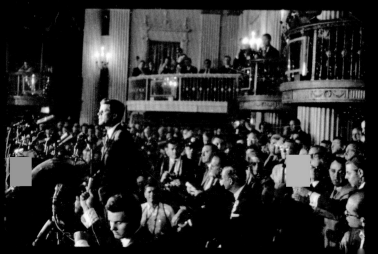
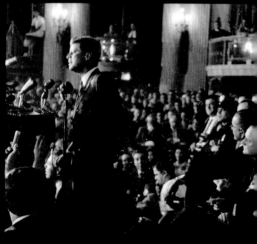

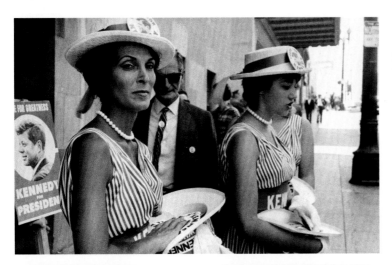

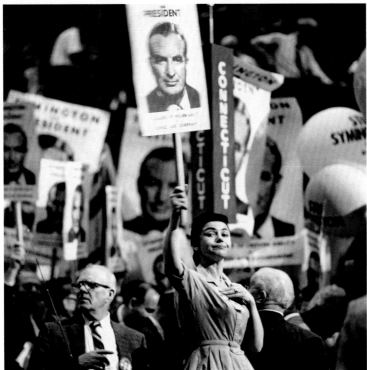

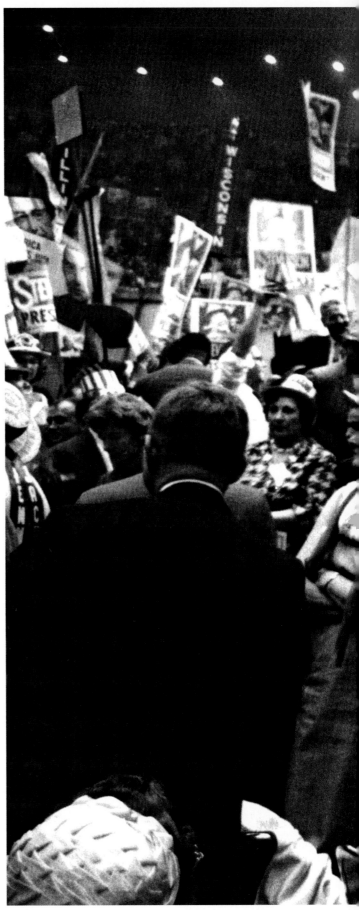

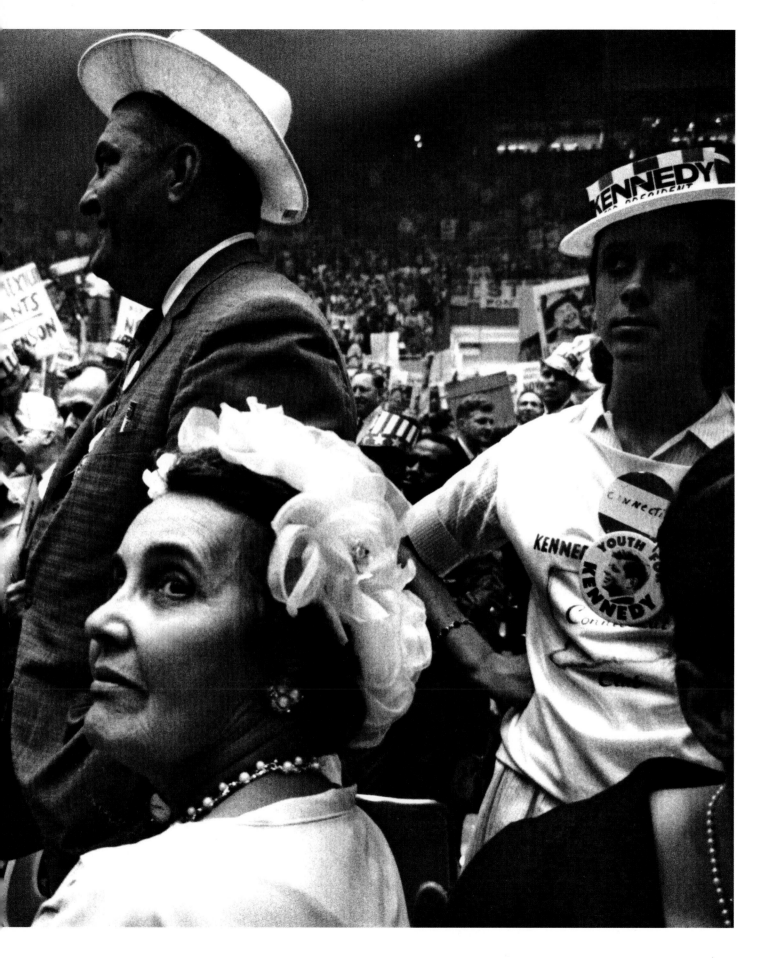

After the nomination of Kennedy as the Democratic Party's candidate for the presidency was made unanimous, the convention delegates waited until Jack—in a break with protocol—came to the Los Angeles Memorial Sports Arena to thank them. In the early hours of Thursday morning he ascended the dais and, with the state standards gathered below him, made a brief speech while everyone cheered—or wept.

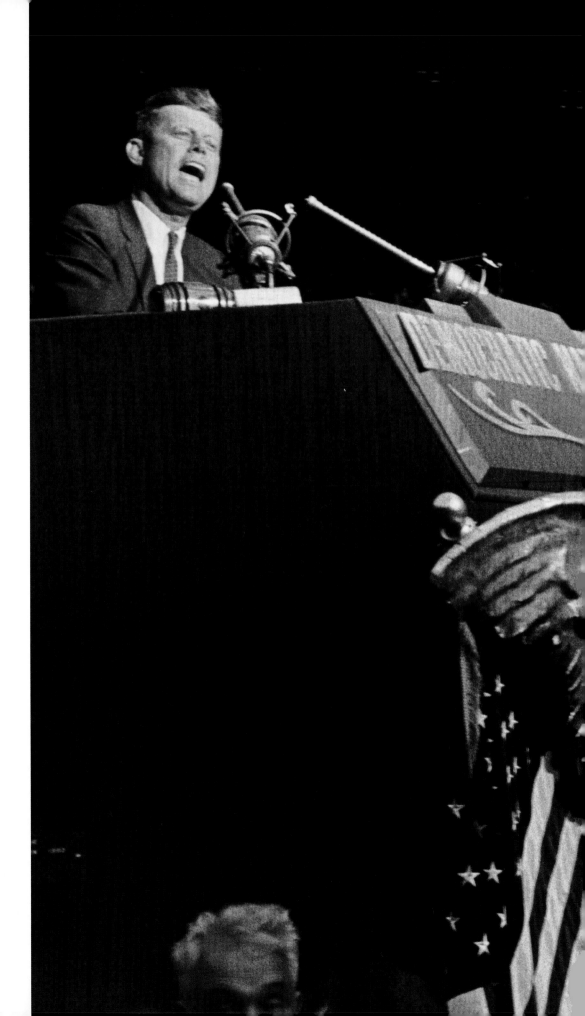

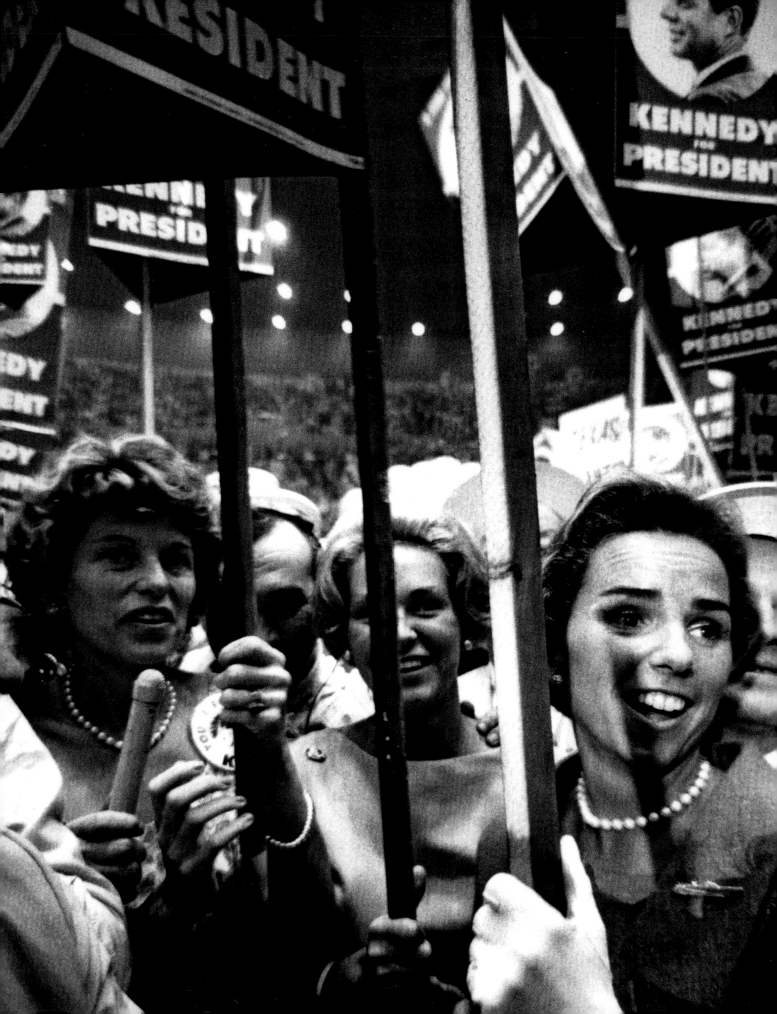

Three Kennedy women—
Eunice Kennedy Shriver,
Joan Bennett Kennedy, and
Ethel Kennedy—on the floor
of the convention. The next
day, Jack savored the headline
announcing his victory as the
Democratic Party's nominee.

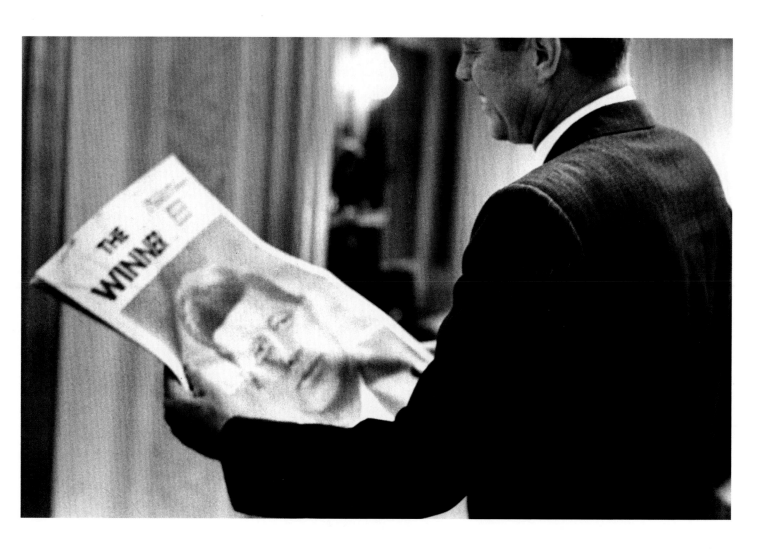

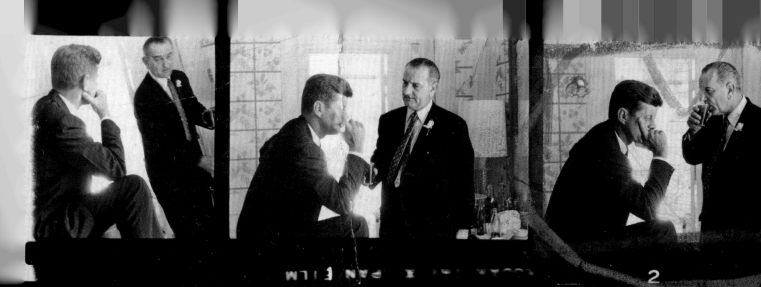

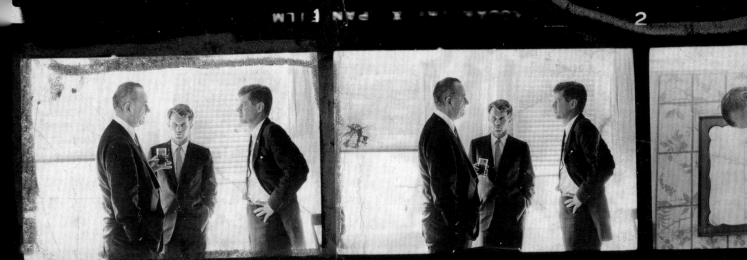

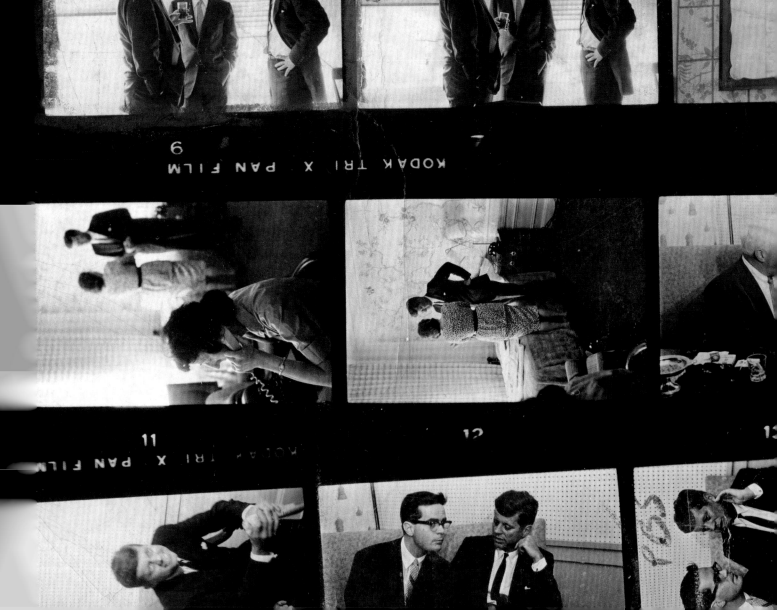

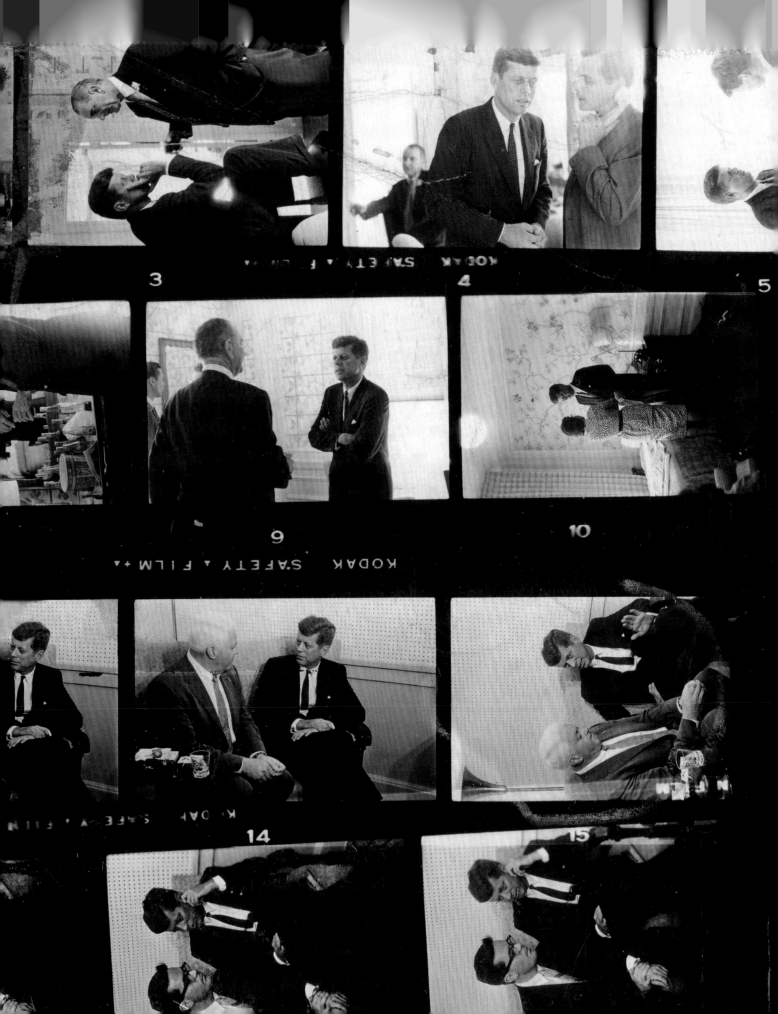

Pages 106–111: In an extraordinary series of meetings over the morning and afternoon of July 14, Jack, Bobby, and Lyndon Johnson work out the details of putting Lyndon Johnson on the ticket as the Vice Presidential candidate. Often Jacques was the only other person in the room when Bobby and Jack discussed the issue. Bobby was known to harbor an intense dislike for Johnson and the feeling was mutual. Many years later, referring to the image on the right, Jacques said "the silhouette is when Bobby and Jack have it out about the Lyndon thing." Jack also encountered fierce resistance to Johnson from the liberal wing of the party.

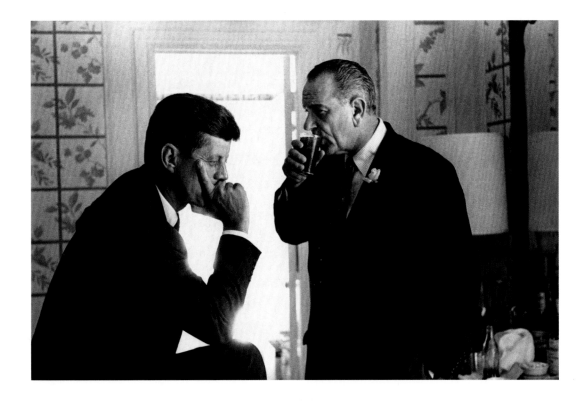

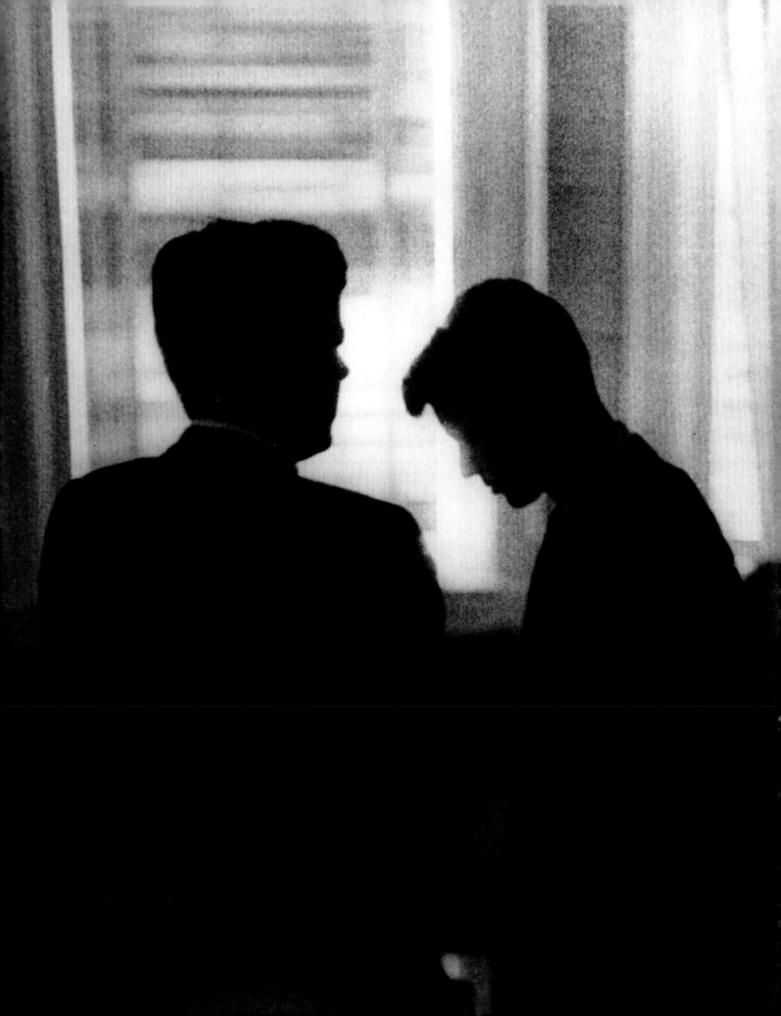

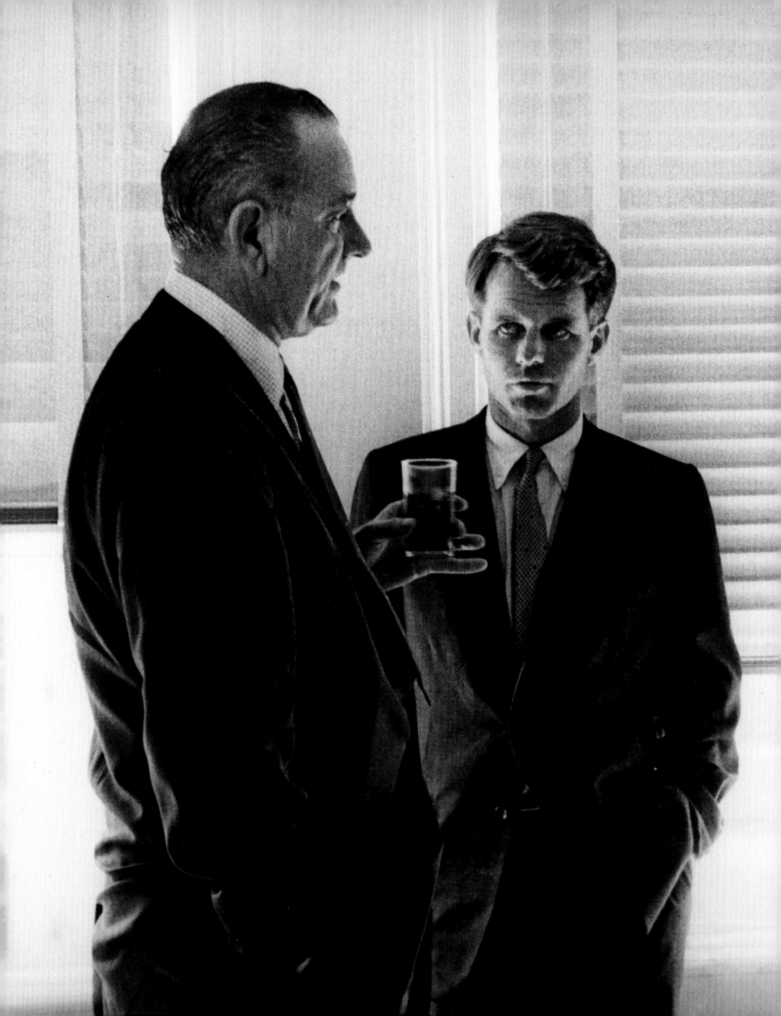

"When it was all finally worked out and time to seal the deal, there were just the three of us in the room—LBJ, JFK, and me. Johnson poured himself a healthy drink. Then Bobby came into the room and stood silently by, regarding Johnson with a look of deep suspicion."

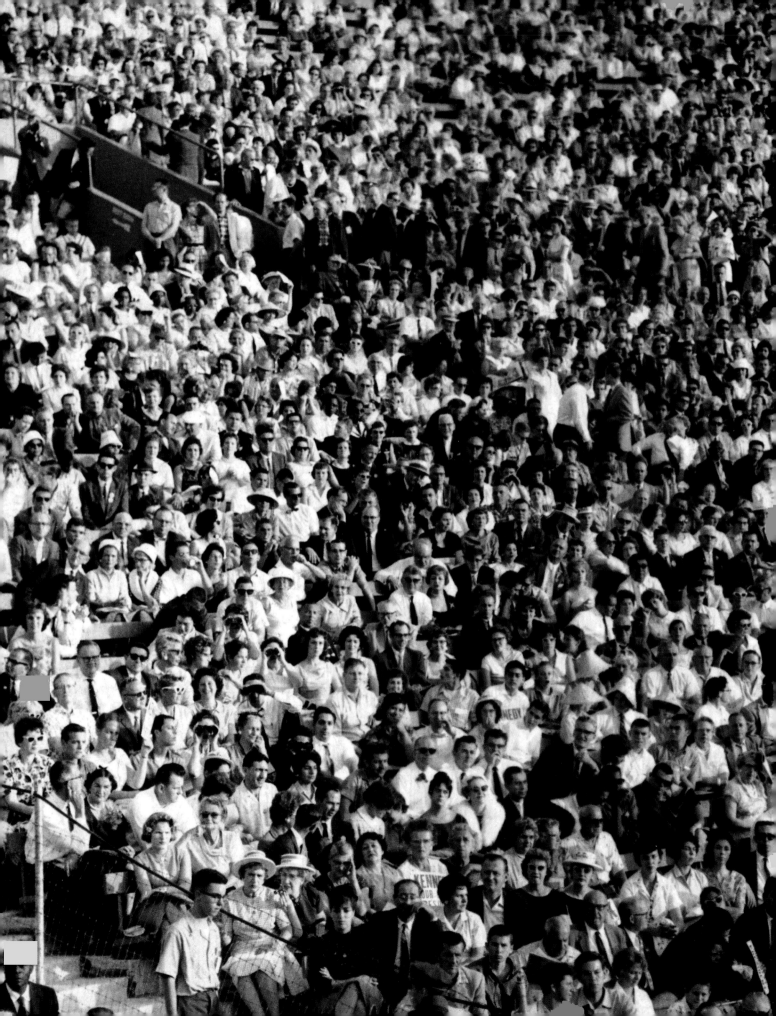

The final act of the convention, at the Los Angeles Coliseum on July 15, was the Democratic Party's massive celebratory show of unity. Before a capacity crowd of 100,000, and late in the evening after all his competitors and all the major figures in the party had spoken, John F. Kennedy accepted the nomination and announced: "The New Frontier is here...Beyond that frontier are the...unsolved problems of peace and war, unconquered pockets of ignorance and prejudice, unanswered questions of poverty and surplus."

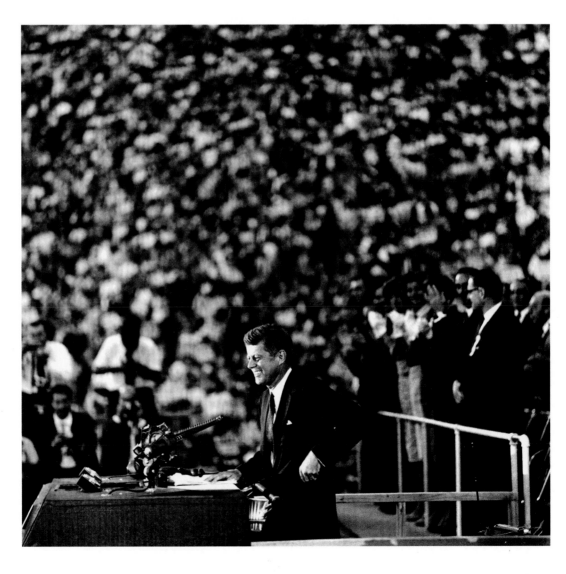

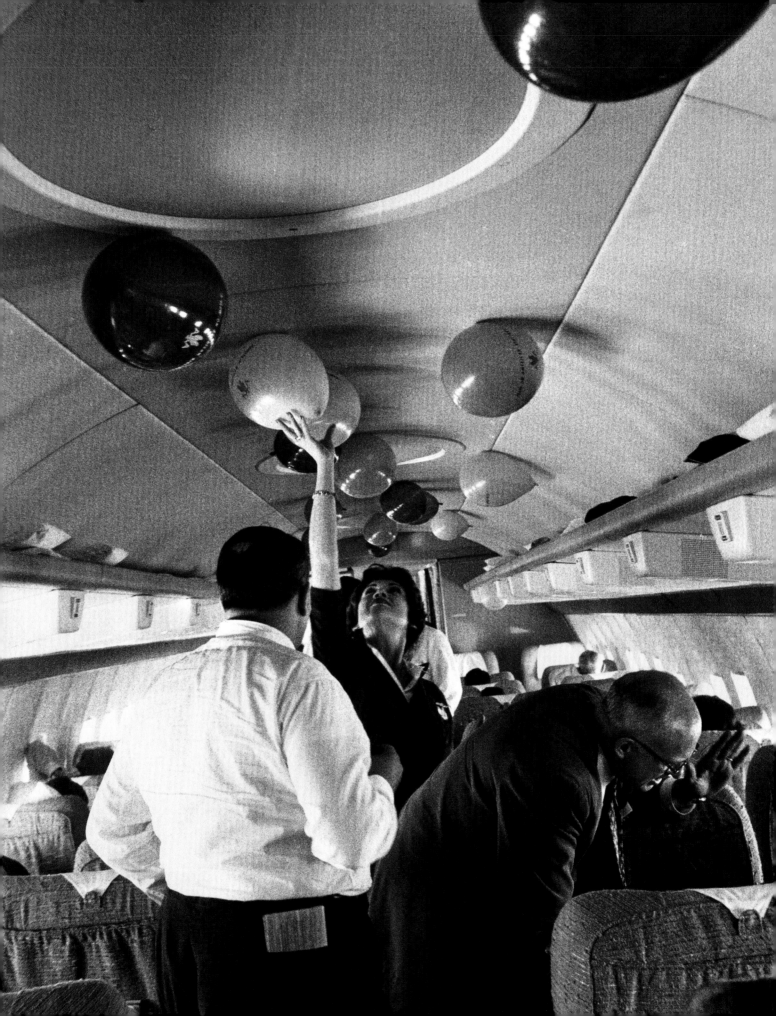

Flight to Boston, July 1960

On July 17, Jack, his family, and entourage left Los Angeles on the *Kennedy Special*. The balloons added to the celebratory mood while Ethel found a quiet place to read to her children and Jack talked with his nephew Bobby Jr.

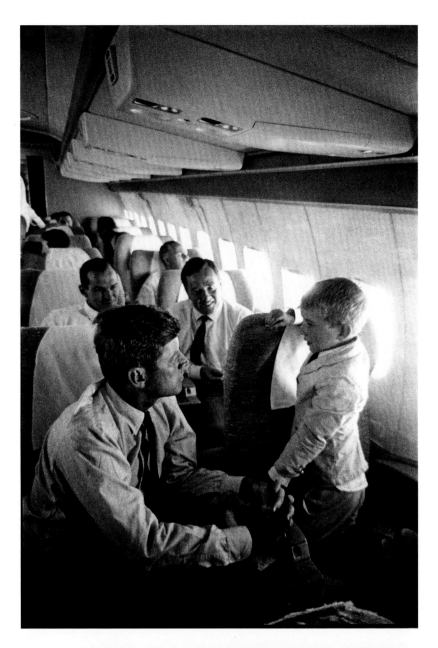

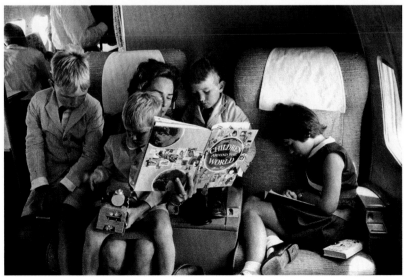

Boston, July 1960

When the Kennedy team arrived back in Boston from the convention, some 15,000 people and four bands had assembled at the airport to greet Massachusetts's favorite son. It was an indication of what the presidential campaign was going to be like.

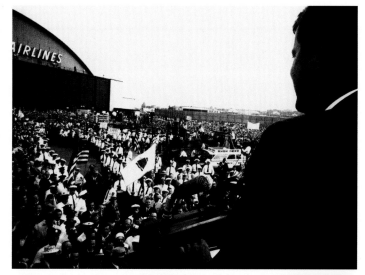

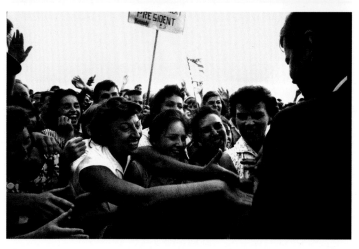

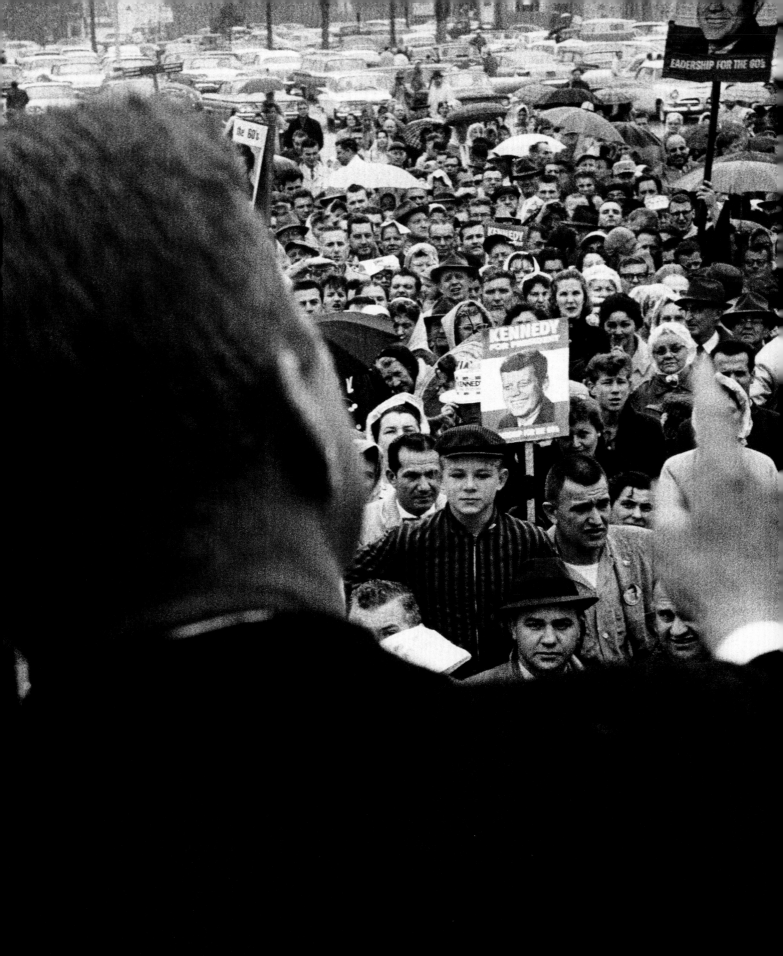

The biggest crowd we had ever drawn greeted us at the airport in Boston. Now Jack was surely Boston's favorite son. Then we all headed for Hyannis, for a brief respite of two weeks before what we knew would be three months of non-stop campaigning.

Although a lot of intense strategy planning took place in this period, it was also an opportunity for relaxation and the last chance to renew a Kennedy family tradition. The summer was the time when most of the family gathered at the Kennedy Compound in Hyannis Port. Joe Kennedy's home was called the "big house"; Jack and Bobby had smaller houses for themselves. The children were free to wander in and out of all the homes. They were typical white clapboard coastal Massachusetts houses with lots of rooms, though they were not furnished opulently. The wealth could be seen in the private yacht at anchor in the harbor, the number of smaller boats that were always available, and there was an airplane ready to go at the airport. The life they led was more boisterous than stylish. The whole family would go out on picnics—fifteen grown-ups and thirty kids, plus nurses and crew, all on the yacht. They would haul along several hampers of hot dogs and hamburgers and French fries and Coke. Jackie maintained a kind of elegant reserve. She didn't try to keep up with the constant activity—the football and softball games, pulling each other into the swimming pool—but she did go on the picnics. She would pack her own hamper with champagne, foie gras, and *oeufs à la Russe*. Jack wouldn't have touched her stuff if his life depended on it; he stuck to the hamburgers and hot dogs.

Jack was in an exuberant and playful mood that summer after the convention. I think it was his most relaxed period until the end of his life. He and Jackie had time to enjoy each other's company. I remember coming upon them as they were trying to ride a Sailfish together. Jack kept falling off his Sailfish and then, with Jackie's help, attempted to get into a tiny bathtub dinghy to go out to recover it. That innocent enjoyment of life wouldn't happen again for many more months.

4

Campaigning for the Presidency

Page 118: The presidential campaign began at a high level of energy and excitement that never let up. In four days at the beginning of September Jack flew to Maine, California, Alaska, and Michigan. Over the next two months he spoke at every kind of venue: state fairgrounds, universities, shopping centers, airports, and hotels, and on numerous occasions from the traditional electioneering platform, the rear of a train.

Hyannis Port, July 1960

The family gathered in Hyannis Port for a brief but welcome break before the campaign began in earnest.

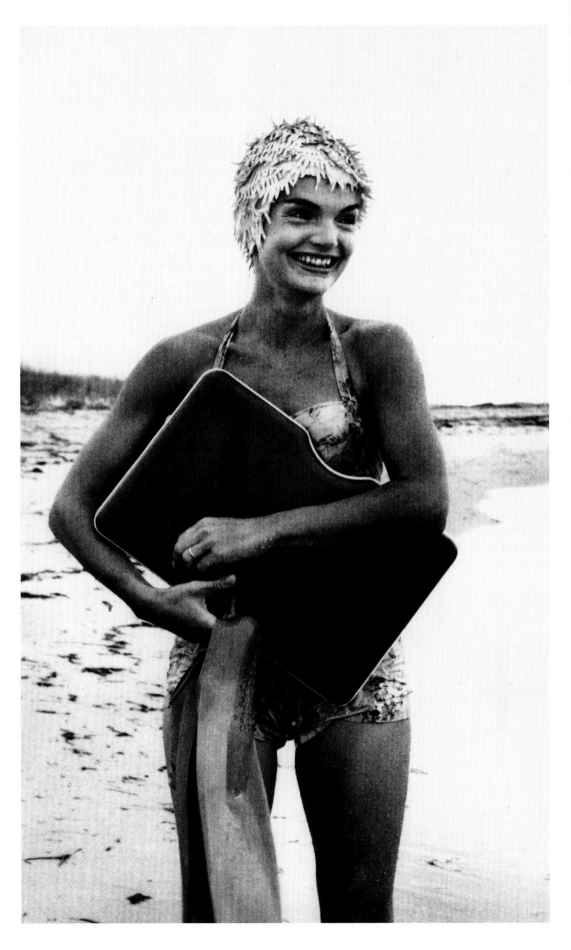

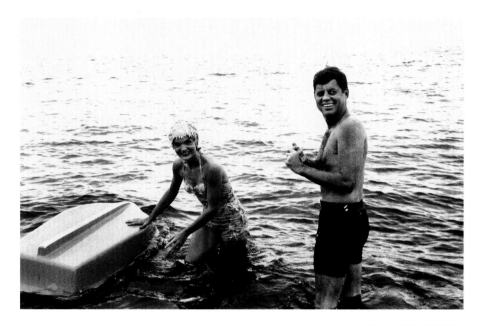

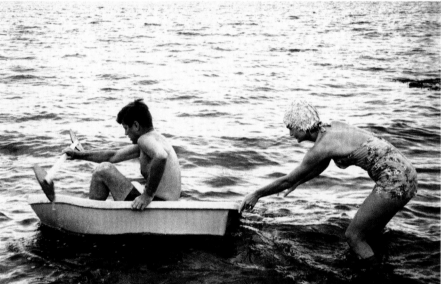

"*Vogue* was after me for years to let them run the picture of Jackie in the swimsuit and cap, which they thought was very stylish. I thought that its charm was its unstylishness and never gave it to them."

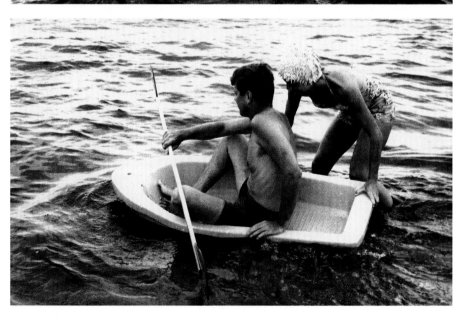

Of course, there was campaign business to be attended to as well. One morning Jackie came down to breakfast to find the leaders of the Hungarian, Polish, and Slovak societies gathered in the sitting room. She seemed a little baffled by the commotion and I asked her if I could help. "No, I'll just have breakfast on the porch," she said. On the porch, however, there was a group of Boston pols and their wives, wreathed in cigar smoke, who were delighted to greet her. When she tried the dining room, she found Jack engaged in a private conference, so she headed for the kitchen, where she discovered Pierre Salinger conducting a press conference.

While I was in Hyannis Port, I realized what unique access I had. There were no other photographers in the compound with the Kennedys, though plenty were hovering on the outskirts. All the magazines were clamoring for images of this glamorous and stylish couple. *Vogue* was after me for years to let them run the picture of Jackie in the swimsuit and cap, which they thought was very stylish. I thought that its charm was its unstylishness and never gave it to them. In Hyannis I was also able to focus on the formidable phalanx of women who would play a strong role in the campaign. There were seven of them: Joan Bennett Kennedy; Jean Kennedy Smith; Eunice Kennedy Shriver; Ethel Kennedy; Patricia Kennedy Lawford; Rose Kennedy, and, of course, Jackie. Because of Jackie's pregnancy, the other women were often drafted to stand-in for her on various trips. Jack's sister Patricia Kennedy Lawford was an especially frequent and effective campaigner.

Soon we plunged into the campaign. Jack was a tireless campaigner even though he was on the go twenty hours a day. The schedule was precisely planned from six in the morning until ten at night. The problem was that by the time ten o'clock rolled around, we were five hours behind. So we wouldn't get to the next destination until three in the morning. I would manage to get out of bed at seven, completely exhausted and barely able to function. I'd stumble outside and there would be Jack, standing in front of his motel room, fully dressed, clean-shaven, and composed, giving interviews to four or five reporters. Then he would go to breakfast where he would make his first speech of the day. After breakfast, we would head off in the general direction of the airport in a motorcade, stopping at several shopping centers on the way, where the crowds were really huge. At each stop he made a speech. We'd get to the airport, where more people would greet us and Jack would make another speech. By then it was ten thirty in the morning and it was goodbye Des Moines and hello Pekin, Illinois, where, after a speech at the airport and three more at shopping centers on the way to town, Jack would appear at a luncheon with several

hundred Democrats who had paid good money to eat cold chicken and shake his hand. Then back to the airport via a few more shopping centers.

One morning I managed to oversleep and when I awoke everyone was gone. I realized they had all left for the airport without me so I threw my clothes on and called a taxi. When I got to the airport I could see the campaign plane was already taxiing out on the runway. I scrambled up the stairs to the control tower and begged them to radio the plane and tell them to come back and pick me up. I ran back down to the apron to await the airplane. But then Jack's voice boomed out of the loudspeakers all over the airport. "Tell Lowe to go fuck himself!"

As the campaign wore on, the press corps covering him nearly doubled to six hundred. And when you went into a big city like Chicago, there would be another hundred or so reporters from the city and the local press around the state. Jack would not only make time for Mayor Daley but also touch base with all the local politicians hanging onto his coattails. They wanted to shake his hand and have their pictures taken with him, which would help them in their own campaigns; it also energized them to get the vote out for Jack. The whole atmosphere was frenetic.

Jack also had to meet with wealthy individuals who were potential donors. In those days there were no limits on what you were allowed to donate to a candidate, so the Republicans always had many more big donors, mainly in the business community, than the Democrats whose main financial support came from the unions. Of course, there was also Kennedy family money in the campaign, though it was not a bottomless supply. There's a famous story about Joe Kennedy screaming at some campaign worker in California: "I gave you the money to buy me an election. I didn't give you the money to buy me a landslide."

In the deepest, freezing cold Jack rarely wore an overcoat and he never wore a hat during the campaign. This worried the hat manufacturers of America: if other men emulated Jack, it might put them out of business. At almost every stop, some representative of the hat manufacturers of America would show up with a hat and attempt to give it to Kennedy. Some days, three hats would be delivered–homburgs, fedoras. The hat people pursued him desperately but he hated hats. People treated the "hat controversy" as an amusing distraction during the campaign but as a photographer, I understood: Kennedy had an instinctive sense for projecting an image of a youthful, athletic man. The contrast could not have been greater; Eisenhower was a sort of grandpa and Nixon, too, was part of that old-fashioned, hat-wearing world.

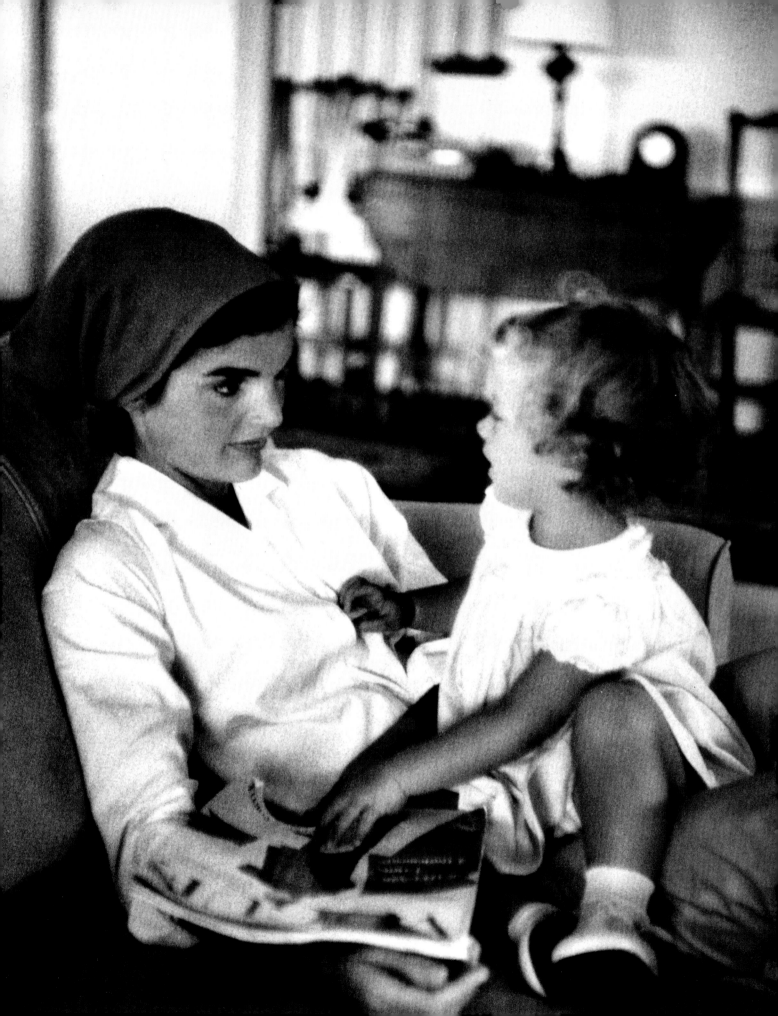

According to Jackie, "Caroline loves to mix the paints. She makes a terrible mess with them." Jackie enjoyed painting in an early American style. When Jack returned from the convention, she marked the occasion by giving him a painting. In it, Jack, dressed as an old-fashioned sea captain, stands in the stern of his boat *Victura II* ("About to Conquer") as it arrives at the dock where Jackie and Caroline are waiting with a band and a banner that reads "Welcome back Mr. Jack."

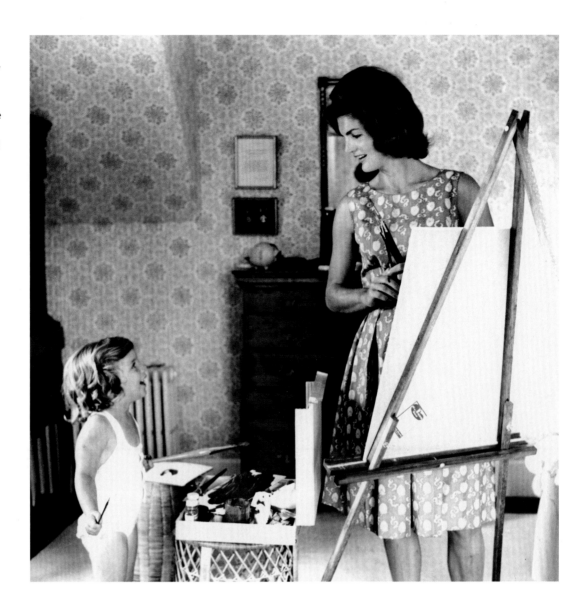

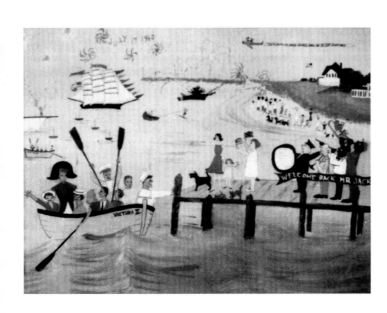

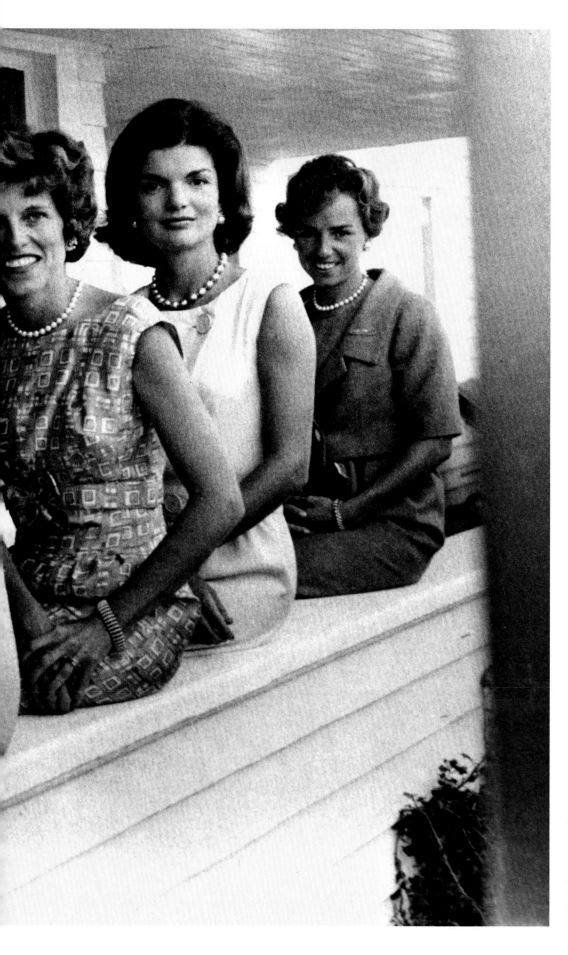

A formidable array of Kennedy women, who would work hard in the campaign, gathered at Hyannis Port. From the left, Joan Bennett Kennedy, Jean Kennedy Smith, Eunice Kennedy Shriver, Jackie Kennedy, and Ethel Kennedy.

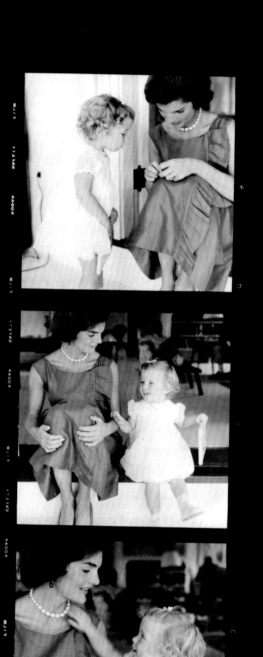
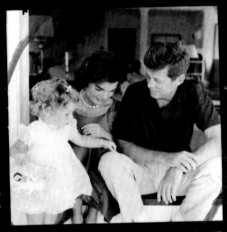
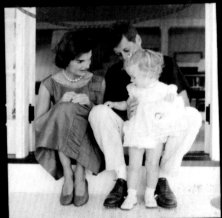
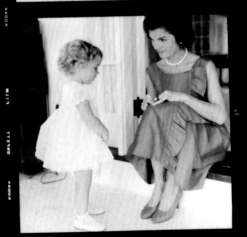

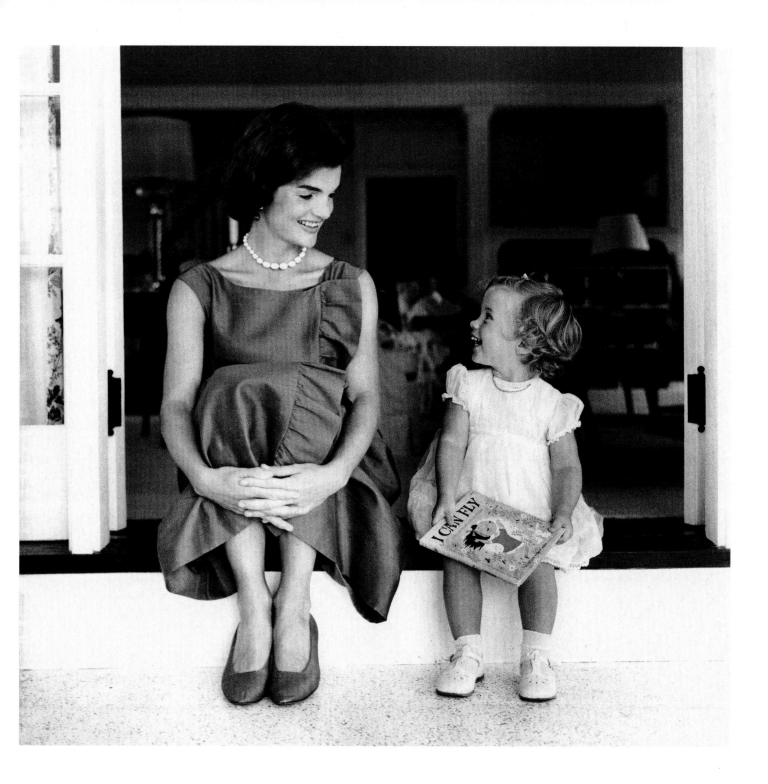

"We had just taken a family portrait for the Christmas card and Jack had run upstairs to change to go play golf—he was saying goodbye to Caroline." *I Can Fly* is a classic book of verses for children that is still in print. Jackie shared her love of reading with her children. When Caroline was 3, Jackie taught her to recite two short poems by Edna St. Vincent Millay as a surprise for Jack.

Along with being fearless about facing difficult questions, Jack also had no fear of flying. If we had to get somewhere and a pilot said, "I can't fly because of the weather," he'd say, "Either you fly or I'll get another pilot." So we'd take off and sure enough, there would be thunder and lightning and it would be pitch black at three in the afternoon. As the plane bounced around, I'd be hanging on for dear life while Jack sat there calmly reading a book or working on a speech. He was always closely involved with the writing of his speeches. He never just spoke the words that Ted Sorensen or Richard Goodwin wrote for him. At every spare moment he wrote and rewrote incessantly.

The other thing that endeared Jack to the people was his sense of humor and his light touch. When we landed at Niagara Airport, he told the crowd, "The honeymoon is over." He had a great sense of how to size up an audience and find the words that would move them. From steelworkers who were ready to boycott Russian products out of patriotism, to Iowa farmers who were interested in getting along with the Russians because they were selling grain to them, Jack knew how to push the right buttons.

His youthful image and his personal charm resonated with women of all ages. At some campaign stops there was a level of hysterical adulation that could get a little scary. In upstate New York, a blonde mother of three evaded the police detail and kissed Jack on the cheek. Mike DiSalle, the Governor of Ohio, had his coat ripped as he tried to shield Jack from his fans and another campaign worker had his pants nearly pulled off. Jack loved to plunge into crowds and he often had buttons torn from his jacket. Sometimes the long fingernails of his fans bloodied his hands. There were also young women who would simply burst into tears as he approached.

The campaign frenzy took some strange turns. One day in Peoria, a local photographer tried to force his way into our car. There was no room for him but he felt insulted. He looked at me, angrily resenting my presence, and told me he would remember me. "I'll get you," he threatened. He was a pretty big guy but I didn't pay much attention. Half an hour later, in the midst of a big crowd in front of City Hall, he attacked me from behind with a great blow to my back. I managed to fend him off by whacking him with one of my lenses. No one in the crowd paid any attention to us. They were there to see Kennedy.

Besides getting attacked, I was still processing hundreds of pictures and making sure they got to the right people. Now I also had to create pictures for campaign buttons and for innumerable Democratic brochures on special subjects—business, labor, and minority issues.

Mt. Clemens, Michigan, October 1960

After the first of the four television debates with the Republican candidate, Vice President Richard Nixon, had given Jack favorable exposure, the crowds began to swell.

"Sometimes people stood in perfect silence while he spoke. It wasn't hostility; it bordered on reverence. This was particularly the case where there were minority or immigrant populations. They had come to see a great American who, they felt, cared about them and their problems."

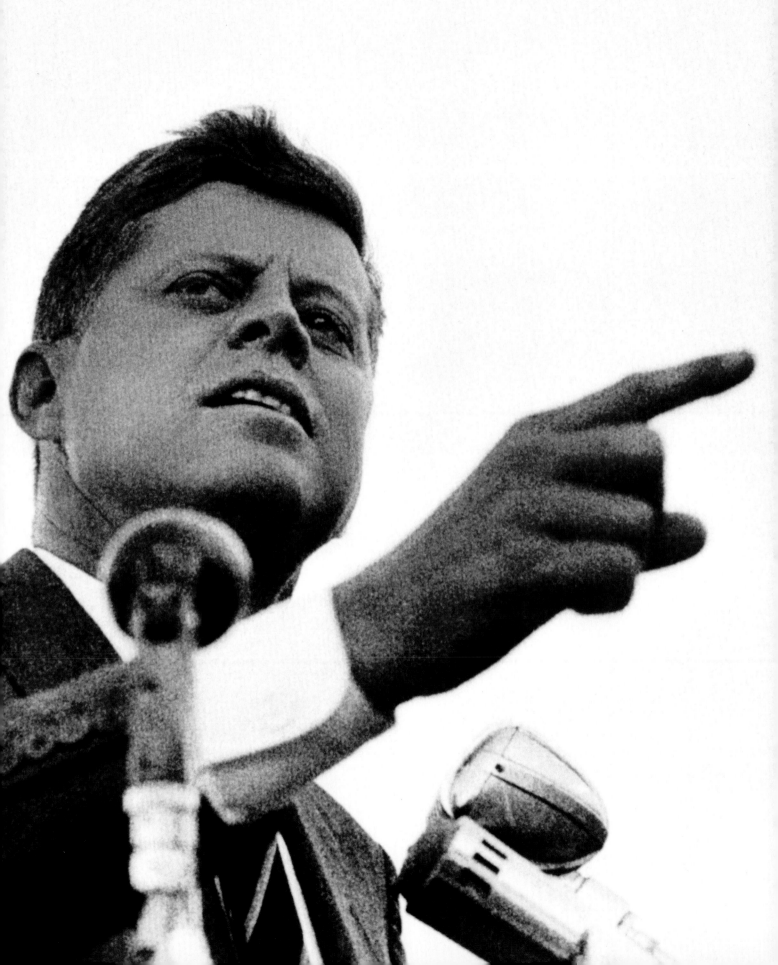

Des Moines, Iowa, August 1960

The liberal wing of the Democratic Party remained wary of Kennedy because of his nomination of Johnson for Vice President. The appearance with the liberal stalwart Senator Hubert Humphrey at a farm conference right at the beginning of the campaign was meant to show that Jack united the party. Governor Herschel Loveless of Iowa rode with the candidates and hoped to get elected to the Senate on their coattails. (He was defeated.)

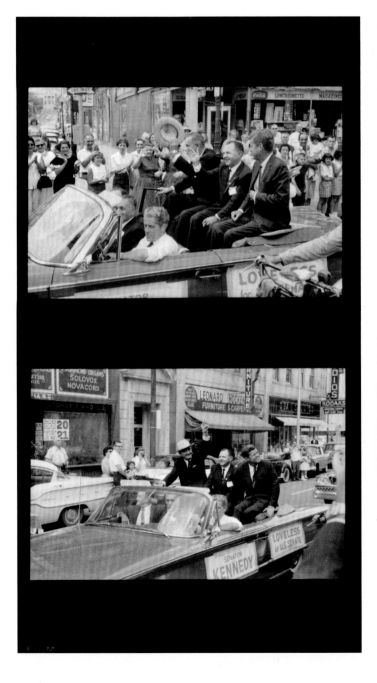

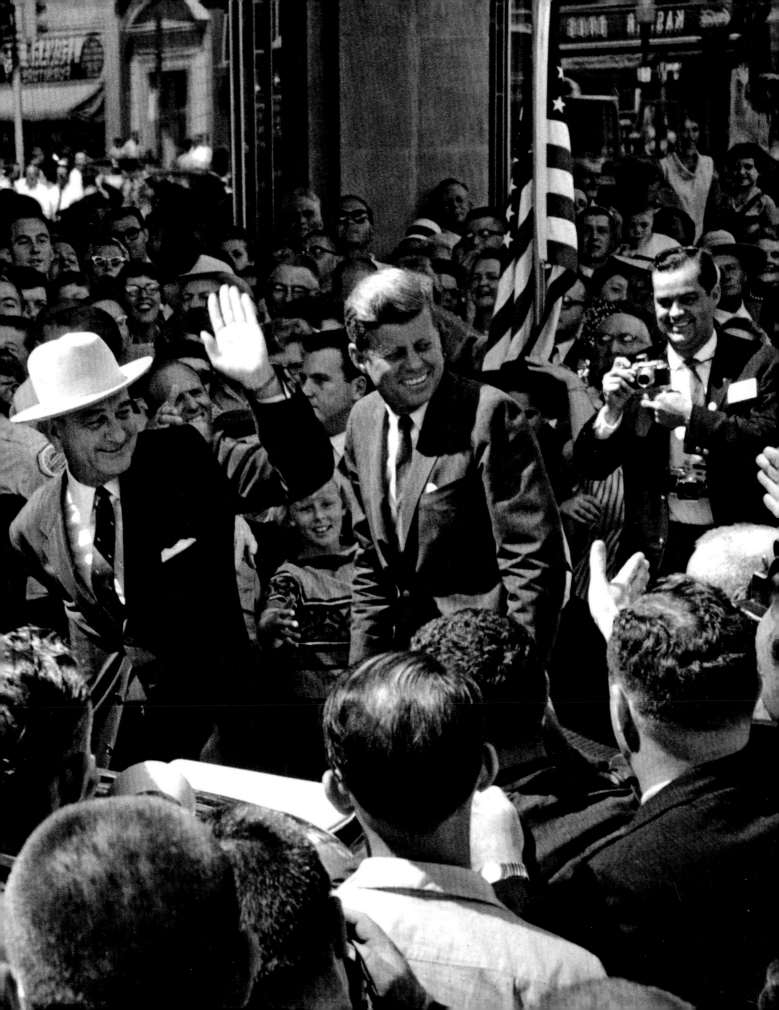

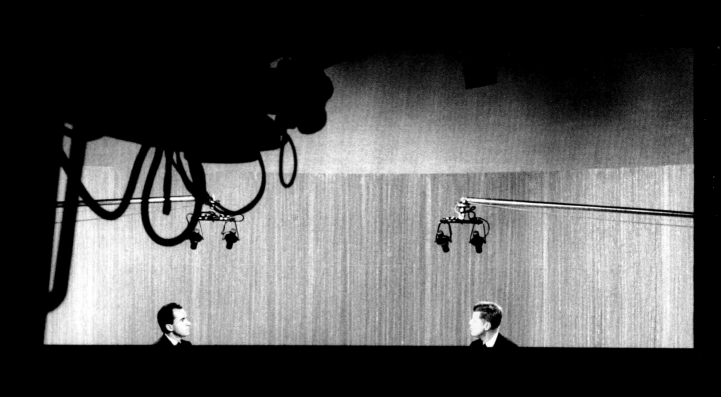

"Jackie came to watch the debate at the ABC studios in New York. Because of her pregnancy she had appeared in public very infrequently during the campaign. Most of the time a political wife was expected to sit and smile, and Jackie was not too happy with that anyway."

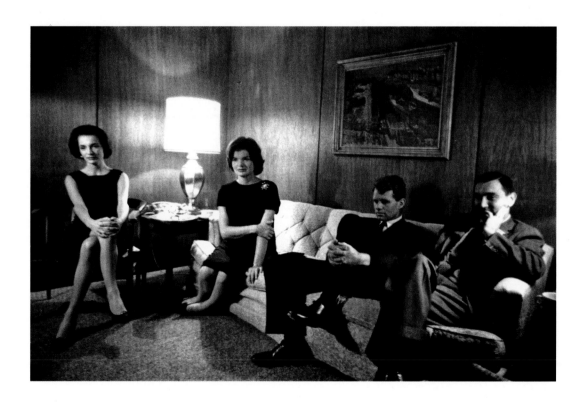

New York, October 1960

Lee Radziwill, Jackie, Bobby, and campaign manager Kenneth O'Donnell watch the fourth television debate between the two candidates. This was the first presidential election that had these debates and they were crucial to introducing Jack to the American public as a viable candidate. The visual impact of television was striking. The majority of people who saw the first debate on television believed that Jack had won it while the radio audience rated the debate a tie.

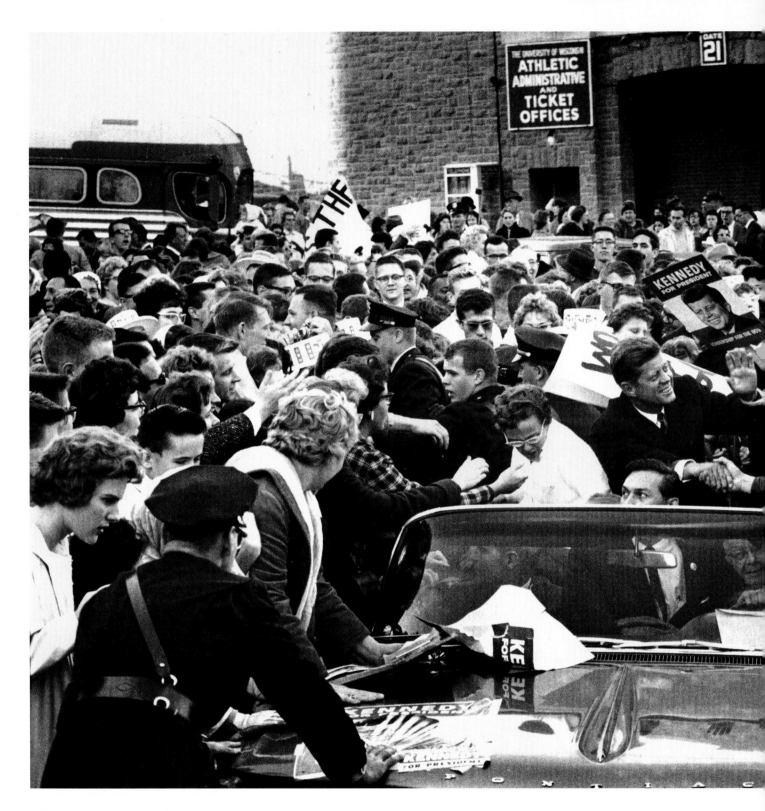

"The drivers were volunteers, and it was considered a great honor to chauffeur Kennedy around, an honor usually handed to especially hard workers or especially heavy contributors."

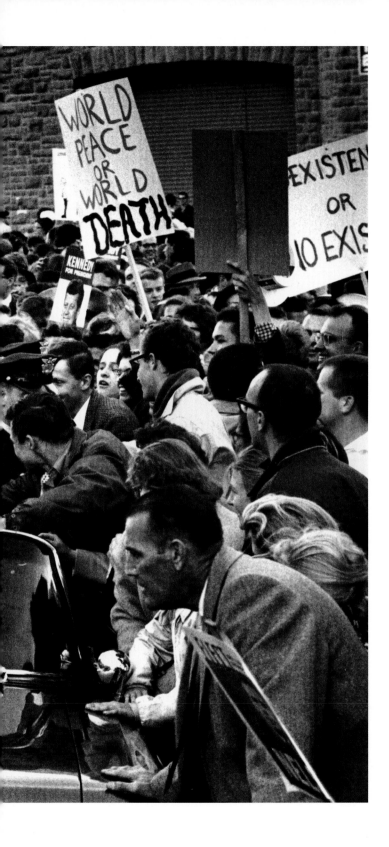

Madison, Wisconsin, October 1960

At the University of Wisconsin, Jack told his audience, "if there are going to be inequalities [between people], it should be on the grounds of their ability and dedication, not on the grounds of their color." He informed the students that a baby born to black parents had "one-half as much chance of finishing high school as the white baby, one-third as much chance of finishing college, one-fourth as much chance of being a professional man or woman." Jacques noted how the content of the speeches reminded the listeners that it was a statesman addressing them.

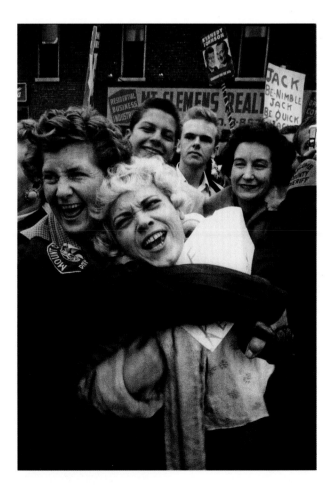

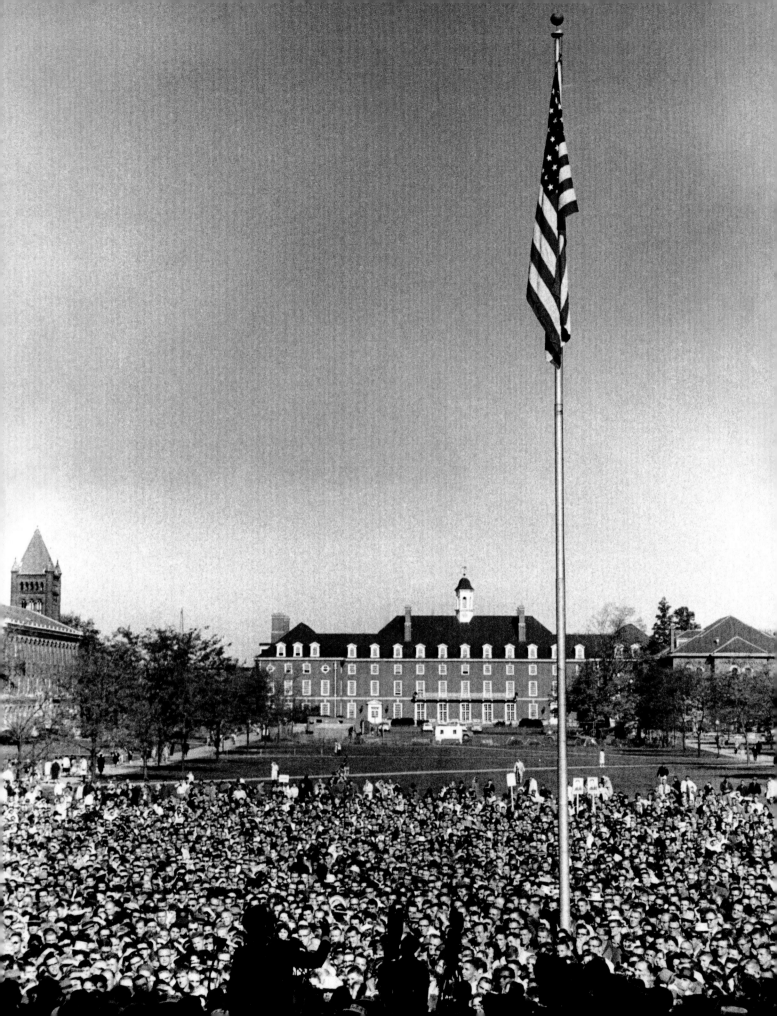

University of Illinois at Urbana-Champaign, October 1960

Two weeks before the election, Jack told this hugh crowd: "Prince Bismarck once said that one-third of students of German universities broke down from overwork, another third broke down from dissipation, and the other third ruled Germany.

I do not know which third of the student body of this university is here today, but I am confident I am talking to the rulers of America, in the sense that all educated men and women have the obligation to accept the discipline of self-government."

"There was no baby-kissing or posing in ten-gallon hats or Indian feathers, if he could help it...his campaign style was so sophisticated and dignified."

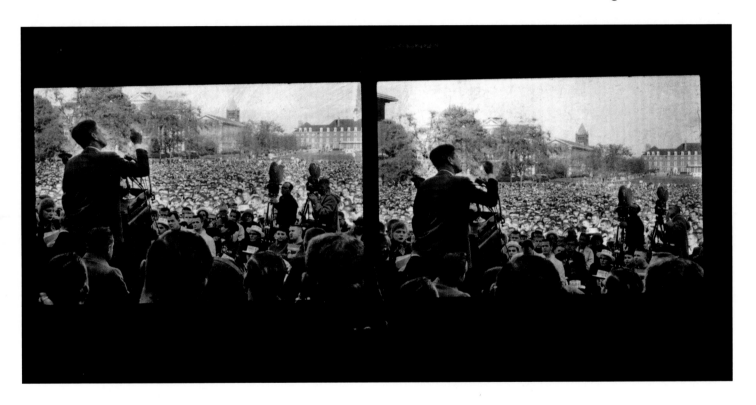

Overleaf: Late in the campaign, in Pekin, Illinois, there was something close to a feeding frenzy. People threw themselves on the car and ripped buttons from Jack's coat. It didn't matter what time of day or what the weather was, they waited for hours to see the motorcade. There was a feeling in the air that the campaign had achieved a momentum that would carry Jack to a big victory.

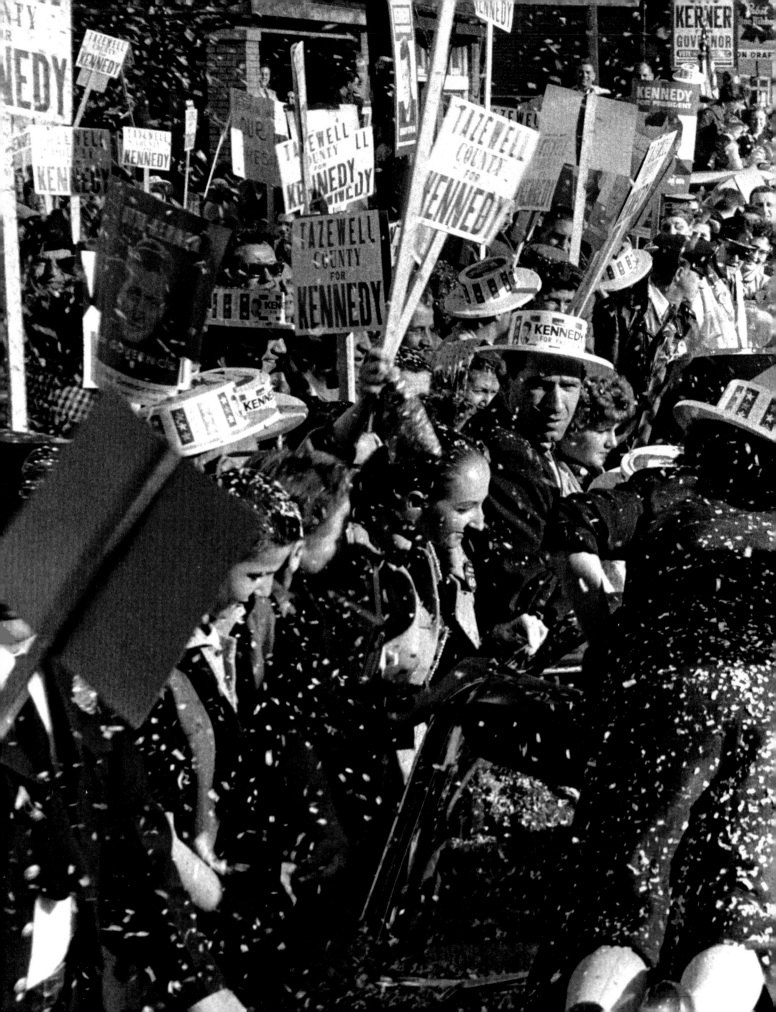

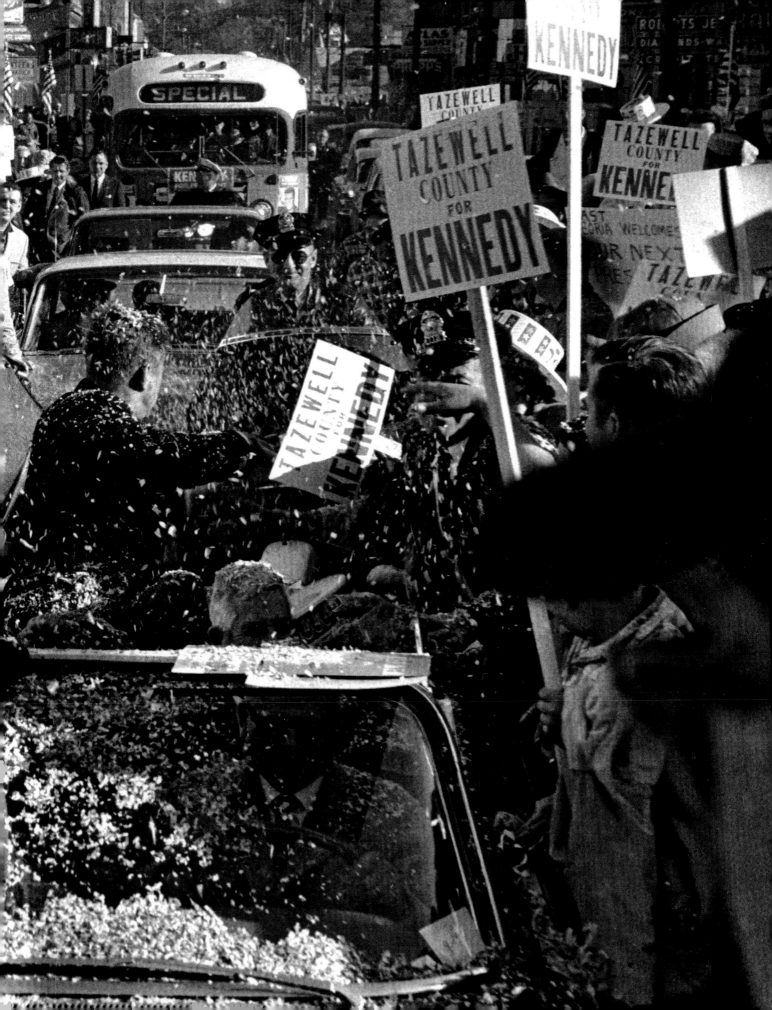

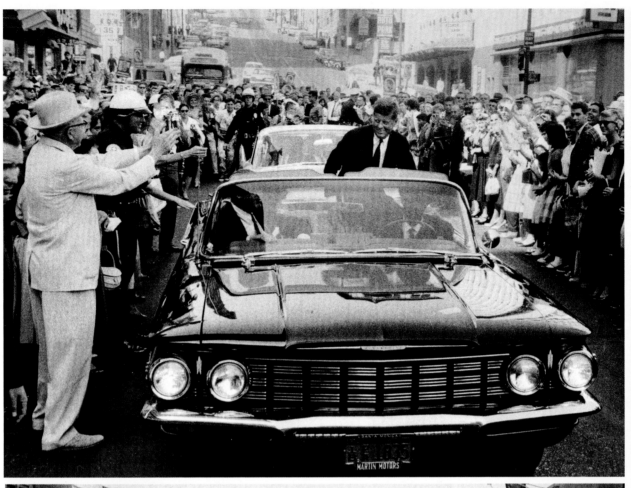

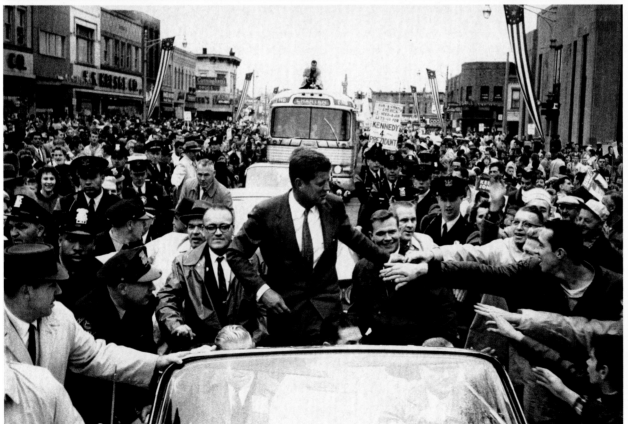

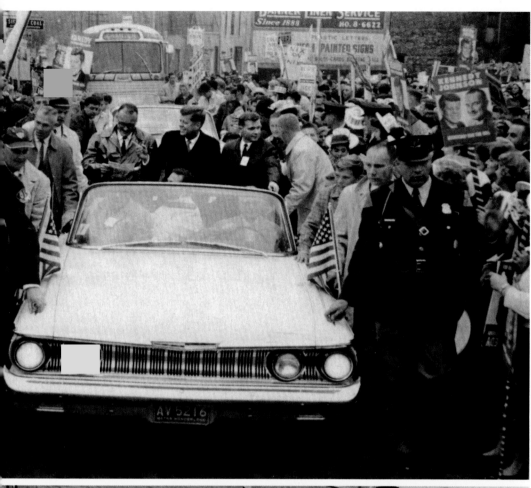

As the campaign rolled on, the crowds were invariably large and invariably fervent. In Philadelphia, Jack saw a sign that read "PT-236." "Who is that guy?" Jack asked. "Stop the car!" The sign was held by Charles Ridewood, a fellow PT-boater Jack had known in the Pacific in World War II. After a brief reunion, the motorcade resumed.

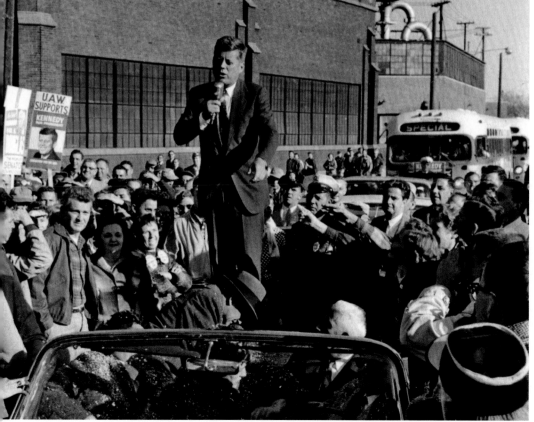

"Even in bad weather, he would always ride with the top down on his convertible...we rode one car ahead in the motorcade— to photograph him coming forward."

Los Angeles, November 1960

The last days of the campaign coincided with American Education Week and in speeches to a convocation of first-time voters at the University of Southern California and to a gathering at the Beverly Hilton Hotel the following day, Jack took up the theme: "Today the frontline of the battle for freedom is not in the trenches—or by the missile-launching pads—it is in our classrooms, and universities—in the jungle schools of Africa, or the remote instruction huts of northeast Brazil—it is wherever free societies are struggling to train the minds of the young."

Overleaf: In 1950 about 5.3 million American homes had television. By 1959 the number had grown to over 42 million. The Kennedy campaign used the medium effectively and it would play a decisive role in the campaign. Henry Fonda, who had originally been a Stevenson supporter, conducted this interview with Jack (in Los Angeles) and Jackie (in Washington) on CBS the week before the election. Family movies were part of the broadcast, including shots of Caroline with her cousin Stephen Smith Jr. and images of Jackie at a Washington foundling home that she visited regularly.

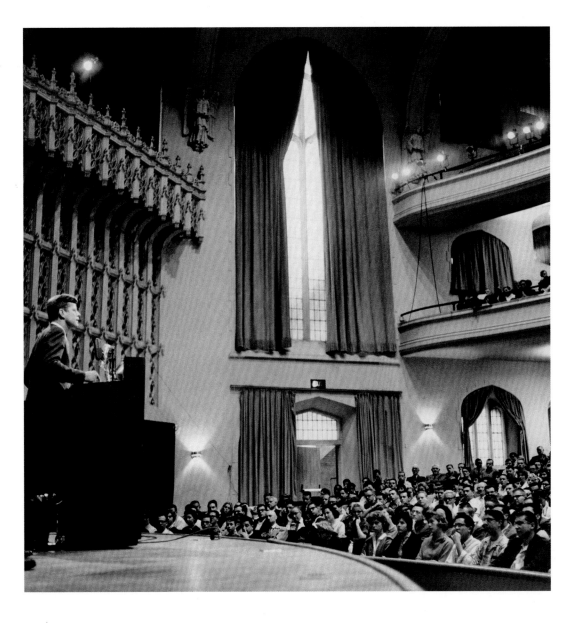

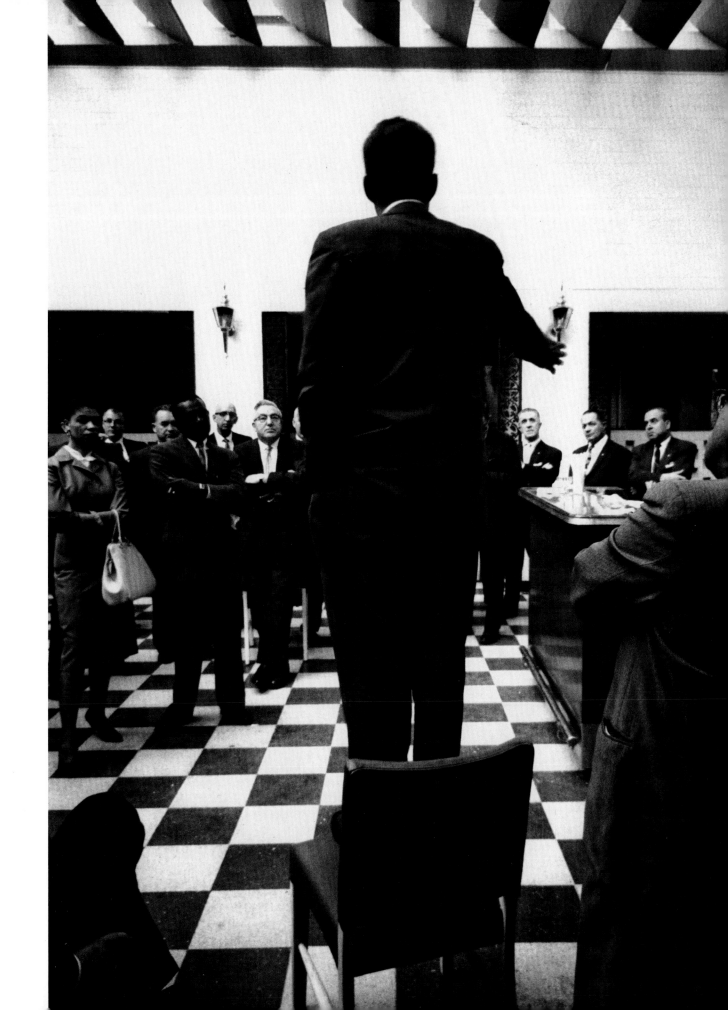

Wilmette, Illinois, November 1960

In the last week of the campaign Jack visited some fifteen states. He had traveled over 400,000 miles since his first exploratory trips in 1959.

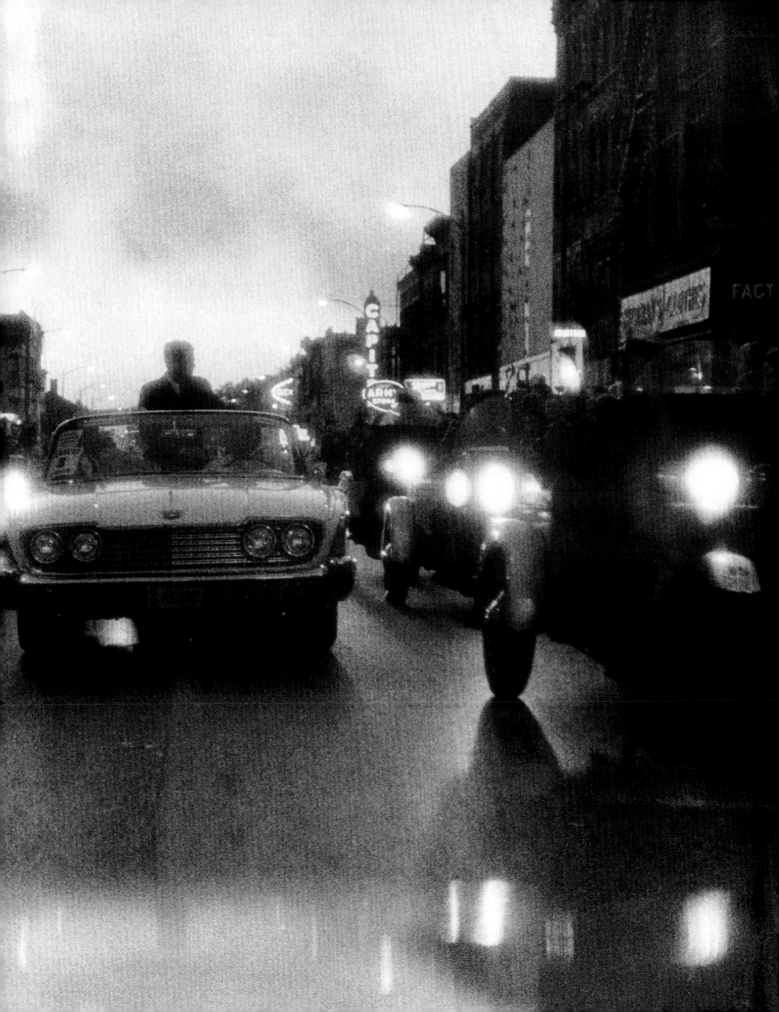

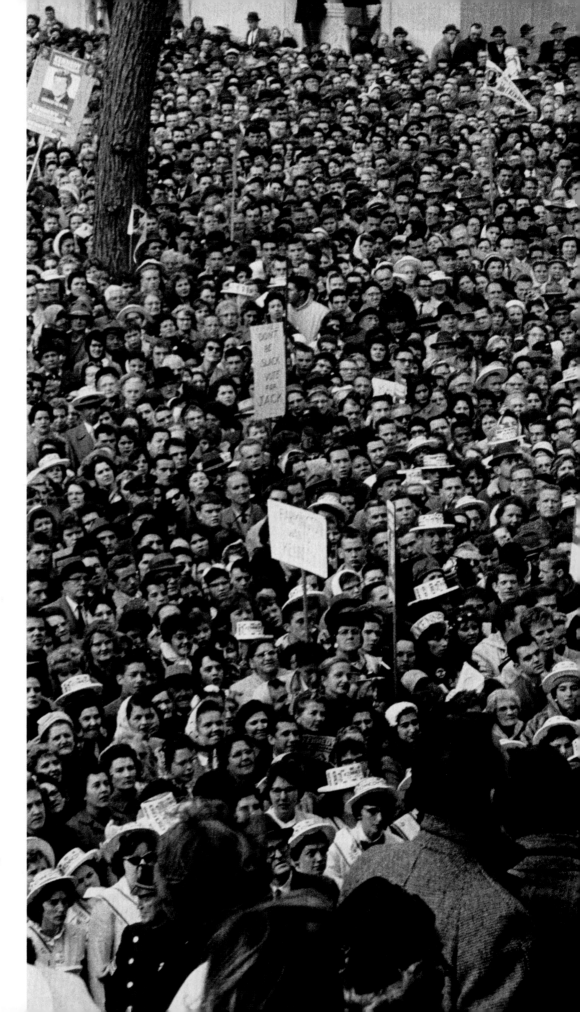

"Jack was likely to deliver only the first three minutes of his prepared speech. Then he would roll up his text and bang it for emphasis while he launched into an impromptu speech."

Hartford, Connecticut, November 1960

One of the last campaign appearances, on the steps of the *Hartford Times*, the day before the election. As the campaign drew to a close, the Kennedy bandwagon headed through New England toward a final election-eve rally in Boston.

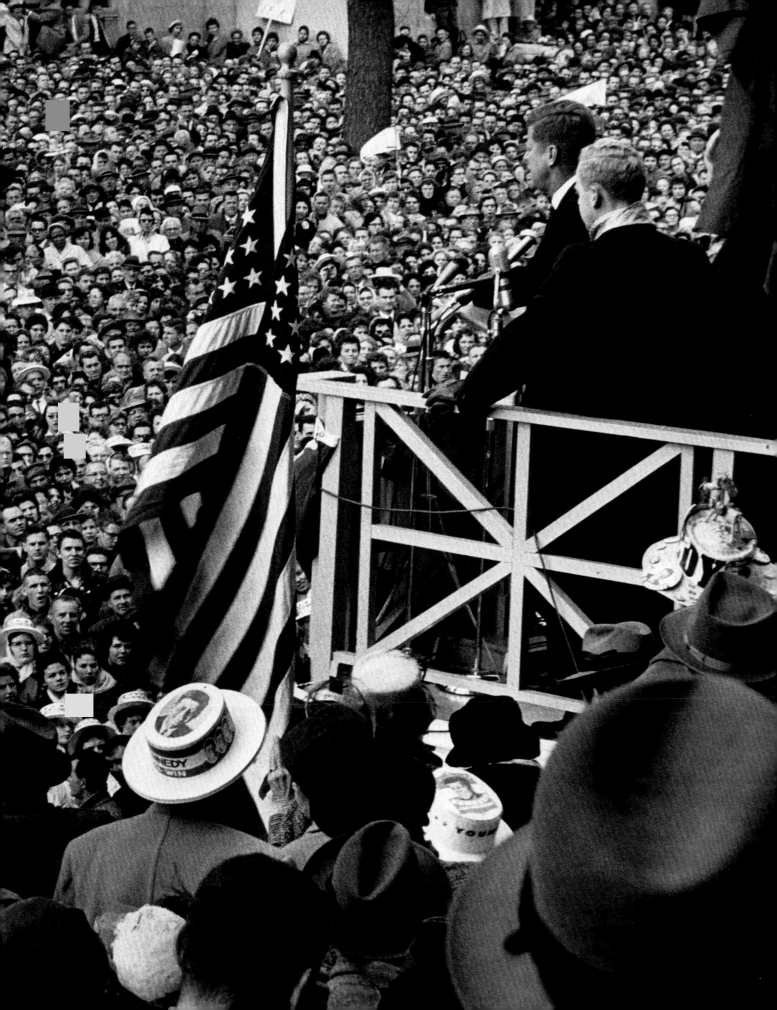

One disadvantage of being so close to Jack was that he never carried any money. He was constantly turning to me, or whoever was closest, and asking for fifty cents or a dollar. One particular time when we were checking into a big hotel, Jack leaned over on top of me and whispered: "Jacques, can you give me a dollar for the bellboy." I only had a five-dollar bill so the bellboy got a nice tip and I was out of pocket five dollars.

One exception to the hysterical audiences was when Jack would appear before mostly minority or immigrant audiences. They often stood in rapt silence, trying to connect with this great American who, they felt, understood their problems.

The debates with Nixon were a turning point. The visual contrast of the cool and collected Kennedy with the sweaty, haggard Nixon followed the Kennedy script: the smart young Democrat against the tired old Republican. As it happened, I was in a car on my way to document the Kennedy Foundation in Boston and heard the first debate on the radio. Though I couldn't see the visual contrast between the two men, I certainly thought Kennedy had won. Many newspapers called the debates a draw but if nothing else they gave Kennedy a level of national exposure that put him on a par with Nixon. Nixon's eight years of experience no longer seemed so telling when everybody could see how intelligent and informed Kennedy was. I remember their discussion of Quemoy and Matsu, the two disputed islands between China and Taiwan. I don't think the audience cared a bit about the issue but they got to see that Kennedy could discuss the matter at least as adeptly as Nixon, that he had brains as well as charisma.

Jack's famous light touch was also on display in the debates. When asked about President Truman's use of colorful language, he said simply that he didn't think he could say anything that would cause the former President, at the age of 76, to change the way he spoke. "Perhaps Mrs. Truman can, but I don't think I can." Nixon on the other hand launched into a long ponderous speech about upholding the dignity of the office.

Jackie came to the fourth and last debate at the ABC studios in New York. Because of her pregnancy she had appeared in public very infrequently during the campaign. Most of the time a political wife was expected to sit and smile, and Jackie was not too happy with that anyway. Because she spoke French and Spanish, she would occasionally be drafted to speak to those constituencies. On those occasions, it was Jack who sat and smiled; he didn't speak any language, aside from Bostonian.

After the debates, our crowds grew even larger and the campaign became more circus-like and more partisan. Jack had really learned to work the crowd by now. With his famous jabbing forefinger, he projected a kind of belligerence that ignited the crowd. Two days before the election, thirty thousand people assembled in Waterbury, Connecticut, on a cold, rainy November evening to see Jack. We didn't arrive until three in the morning and they were all still there. The campaign finished up at a frenzied rally in Boston Garden. It was so noisy Jack could only stand and wave; he never got to speak. It was hard to resist the feeling that we had achieved an overwhelming popularity. Some of the polls even predicted a Kennedy landslide.

The next morning was Election Day. Jack and Jackie voted in Boston and then we flew to Hyannis Port to await the results. Once more I felt incredibly privileged to have complete access to the family compound while most of the press corps, some two thousand strong, hung around the Hyannis National Guard Armory. After the hectic clamor of the campaign, Election Day was almost eerily calm. I went to the local polling station with Bobby and Ethel Kennedy and later in the day I got Jack and Jackie to pose with Caroline.

It wasn't until six o'clock that the action began to pick up. Bobby's house had been set up as a command center and that was where we would wait for the election returns. The first floor had been outfitted with wire-service tickers and a bank of fourteen telephones connected to various key districts around the country. Any information would be relayed up to the next two floors where the Kennedys and their pollsters and analysts had set up shop in the children's bedrooms. The whole family was at the command center: brothers, sisters, husbands, and wives. And of course the patriarch, Joe Kennedy.

By midnight the mood was edging on euphoria. Jack had a two-million-vote lead and you could see a party spirit in the faces of the campaign workers. Jack had remained at his house as the early returns came in, only occasionally walking across the lawn to the command center to see how things were going. But then, as more returns came in, it all started to go in the wrong direction. The lead began to slip slowly but steadily during the early morning hours. At one point, when Jack's lead was down to one million, the NBC computer decided that Nixon would be the winner. A short time later it changed its mind. Though Kennedy maintained his lead, it continued to slip. The faces of everyone in Bobby's home became taut and drawn.

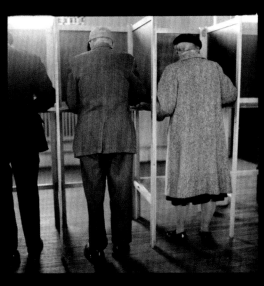

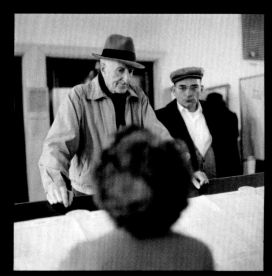

Hyannis Port, November 1960

Election Day, November 8. Bobby and Ethel fill out their ballots and then drop them into the ballot box. Barnstable township, where Hyannis Port is located, went Republican, as it had for many years.

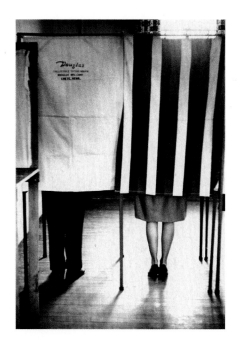

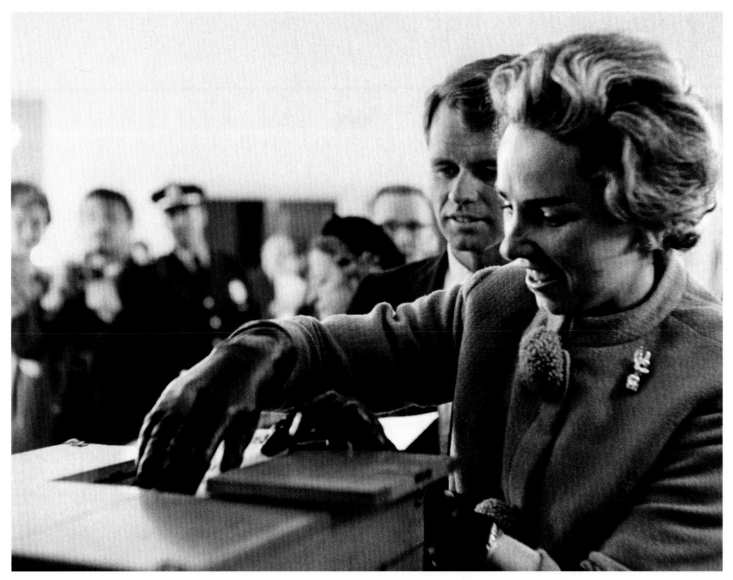

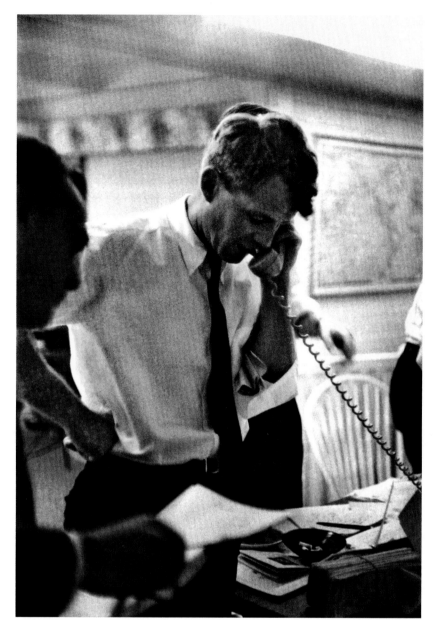

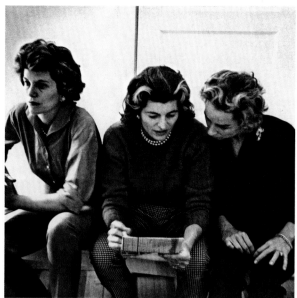

For much of the evening, Jack remained at his own house, which was illuminated by the lights of the television networks. Periodically he would wander over to Bobby's house, which had been set up as a command center and was where everyone waited for the election returns. At midnight Jack came again, and stayed the rest of the night. The first floor had been outfitted with wire-service tickers and a bank of fourteen telephones connected to various key districts around the country. Any information would be relayed up to the next two floors where the Kennedys and their pollsters and analysts had set up shop in the children's bedrooms. The whole family was at the command center, brothers, sisters, husbands, and wives.

The early returns looked good for Jack but during the night his lead began to dwindle. By morning the lead was down to 100,000 votes. To relieve the tension, some of the family took a walk on the cold November morning. After the walk they first went over to Joe's house and then to Bobby's where they sat for almost an hour in front of the television waiting for votes from one of the big states to come in that would push Jack over the line.

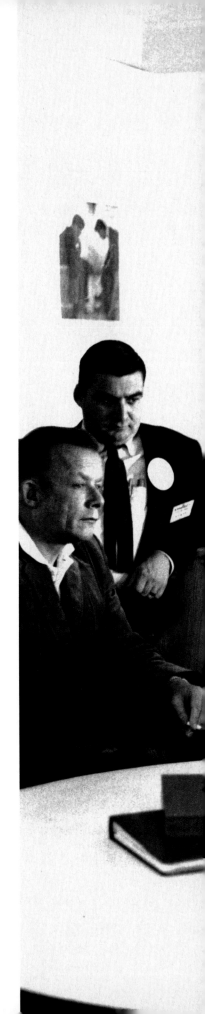

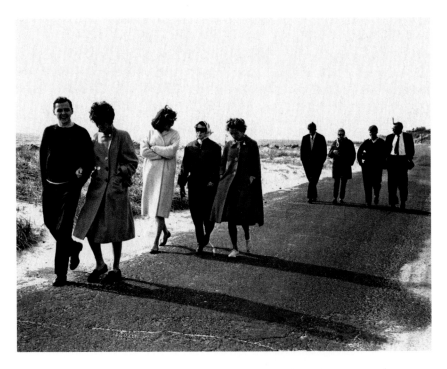

"By the time I awoke—shortly after 7.30 a.m.—Secret Service men had arrived. This was a good omen, I thought."

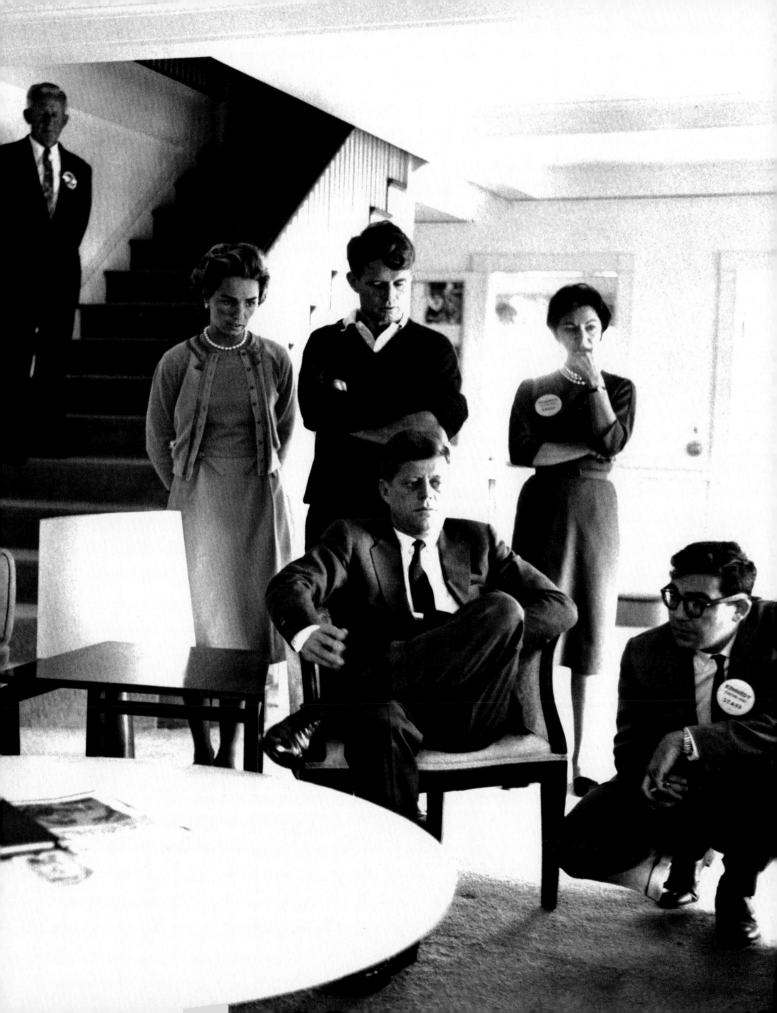

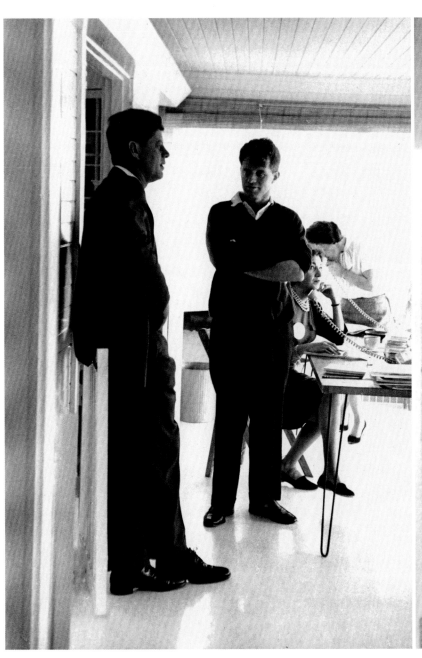
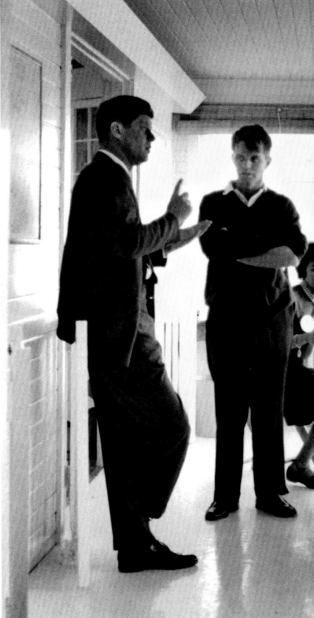

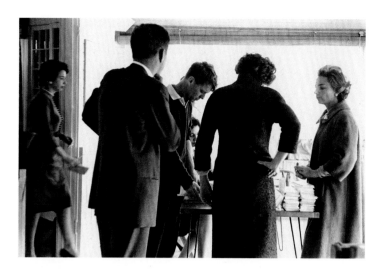

"As they were going over the electoral counts on Bobby's porch the news came in: Jack had carried both Minnesota and Illinois and he was now President."

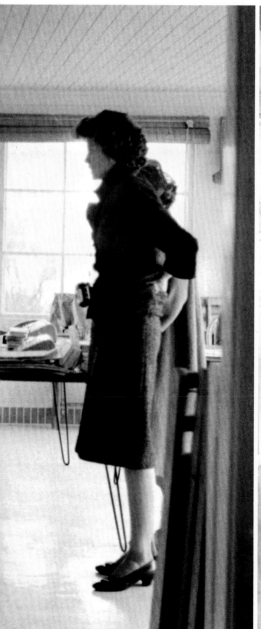

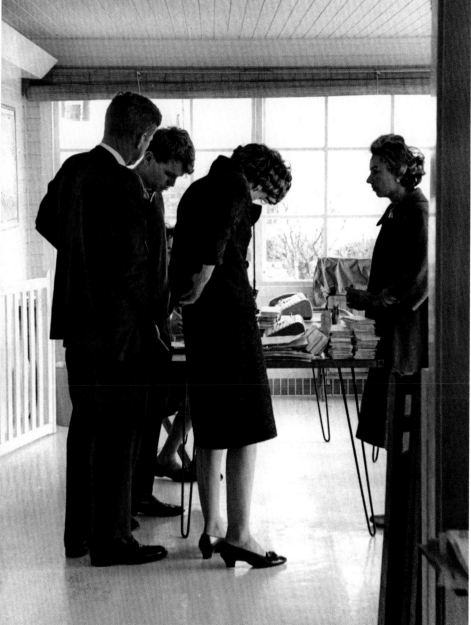

At 3:00 a.m. we heard that Nixon was going to concede. A wave of relief ran through the house. Then we learned he wasn't going to concede and it was back to nervous watching and waiting. At 3:30 a.m. Nixon came down from his hotel room in Los Angeles. We all crowded around televisions as he began to speak. At first it sounded like a concession speech as he thanked his supporters and his wife, Pat, who stood at his side crying. But in the end he said only that Kennedy would be the next President if the present trend continued. Unfortunately for Jack, the trend was actually going the other way.

Jack Kennedy was probably the only member of the family to sleep that night. After saying he would make no statement himself until after Nixon spoke again, he went back to his home and I saw his light go out at 4:00 a.m. I went to sleep on a cot in a maid's room and was twice awakened by false alarms that Nixon had conceded.

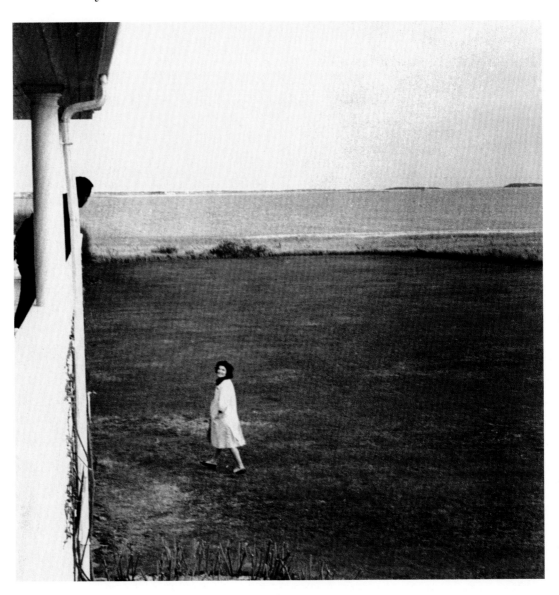

Jackie donned her raincoat and set off for a walk by herself. Jack went out to find her so they could have a photograph taken of the whole Kennedy family at the moment of victory.

CAMPAIGNING FOR THE PRESIDENCY

By the time I woke up at 7:30 a.m., Kennedy's lead was just a hundred thousand. I went over to Bobby's house and found Ethel alone downstairs. The rest of the family had gone for a walk. The maids were all out, so the two of us made coffee and cooked enough eggs and bacon to feed a dozen exhausted people who were hanging around the house. Later, we joined the family on their walk. Bobby carried a football and tossed it around with Ted to relieve the tension.

After the walk, we all assembled in the "big house," Joe's home, and then meandered back to Bobby's. No one could sit still. Kennedy's lead had stabilized at about one hundred thousand but he needed only eleven more votes in the Electoral College to clinch his election. There were still two big states, Illinois and Minnesota, to report. The tension was extraordinary but at 12:30 p.m. Minnesota went for Kennedy and soon after Illinois did as well. Nixon conceded and it was all over.

A little later, I was standing by a window in Joe's house and I saw Jackie run out of the house, pulling a raincoat on because there was a slight drizzle. She set off by herself along the beach. She was clearly upset. Though she very much wanted to be First Lady, I think it was just dawning on her how different her life was going to be from then on. Meanwhile, I had one big task left to do. I had been asked countless times for a picture of the whole clan but someone was always missing when I tried. Now they were all here and it was a momentous occasion. I knew this would be my only opportunity but as I tried to get them all together they kept wandering away. Finally, I realized how to pull it off: I enlisted Joe Kennedy to set the thing up and he ordered everybody to assemble in the library. When they were all there, Jack asked, "Where's Jackie?"

"She's down by the water," I responded.

"I'll go get her," he said. He came back with her, and she went upstairs to get dressed while we waited. When she came back down and entered the room everyone got up and applauded the First Lady-elect. It was a wonderful moment.

My first real encounter with John F. Kennedy, President-elect, was in his father's house a short while later. Jack spotted me from the next room and jumped up and came over to me.

"How are you doing, Jacques?"

I was suddenly flustered. What should I call him? Finally, I managed to blurt out, "Congratulations, Mr. President."

Then he looked slightly flustered as he said: "Thanks a lot, Jacques."

Perhaps I was the first person to call him Mr. President.

Jacques had been trying to get a portrait of the entire clan for months. This was the best and probably the last chance he would get. He had to enlist Joe to round everybody up. When Jack had retrieved his wife from her walk, she went upstairs to get dressed. "When she came back down and entered the room everyone got up and applauded the First Lady-elect. It was a wonderful moment." Seated from left: Eunice Kennedy Shriver, Rose Kennedy, Joseph Kennedy, Jackie Kennedy, Edward Kennedy. Standing, from left: Ethel Kennedy, Steve Smith, Jean Kennedy Smith, John F. Kennedy, Robert Kennedy, Patricia Kennedy Lawford, Sargent Shriver, Joan Bennett Kennedy, and Peter Lawford.

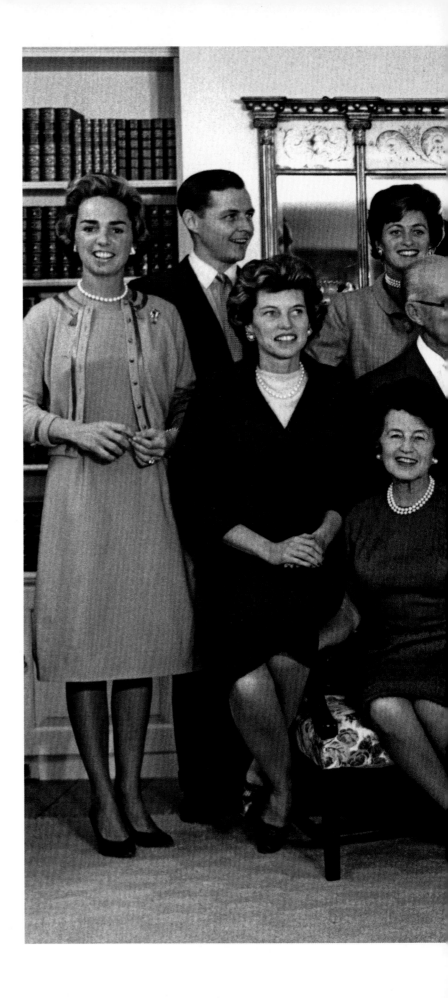

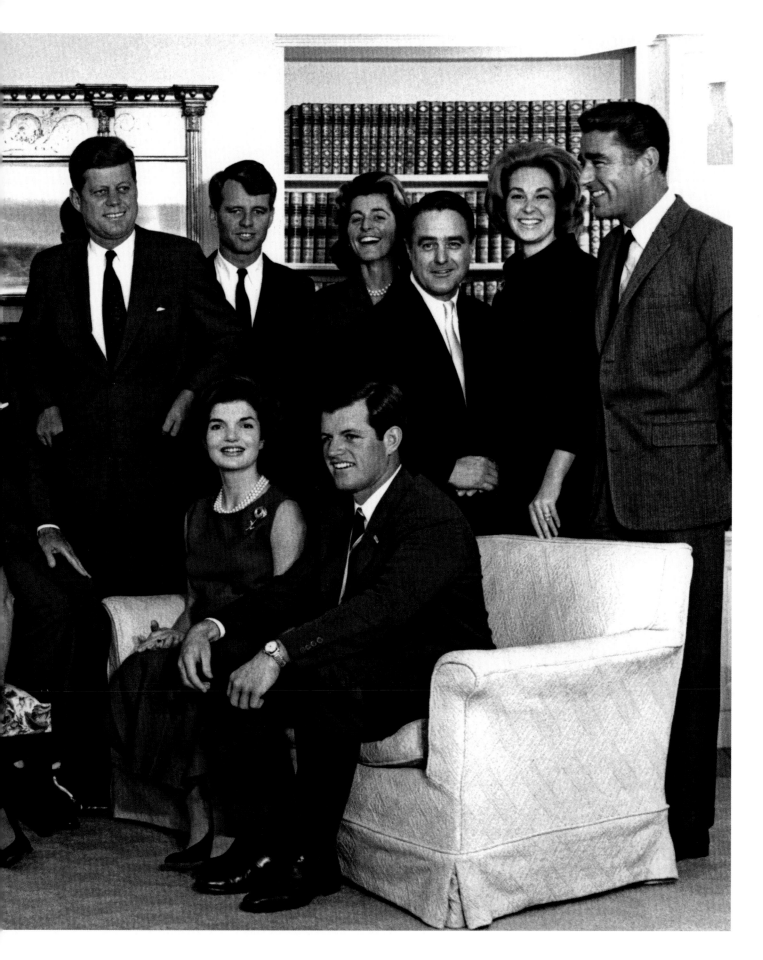

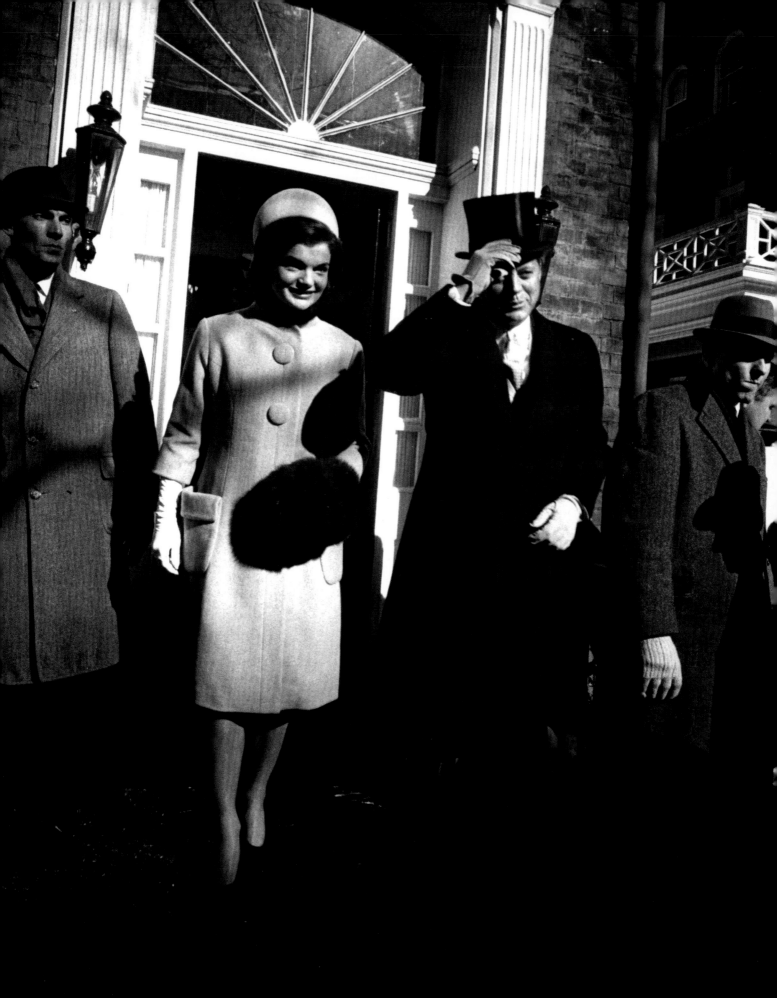

All of the Kennedy family's brilliant instincts for presenting themselves, along with the lessons learned on the campaign trail, were on display as they turned the inauguration into an unprecedented spectacle of grace, elegance, celebrity, and moving ceremony. All this in spite of the fact that the capital was overwhelmed by a blizzard that dumped eight inches of snow on the city.

When I got to Washington and picked up my press passes and credentials, my heart sank. I would need over thirty different passes just to cover the parade route. I began to wonder if my easy access to the Kennedys was a thing of the past. But at least by now I knew how the system worked, and how to work the system, so I was finally able to finagle a "superpass" for myself that read: "All Events, All Areas."

I wasn't staying at the Mayflower Hotel but it was the place to be seen. The lobby had turned into an impromptu reunion party. Campaign workers and politicians I had run into in Nebraska, Oregon, West Virginia, and California had turned up to celebrate. After renewing many brief acquaintances, I headed to the Washington Armory for the rehearsal of the first big event, the Inauguration Gala, which would take place that evening.

Ominously, a few flakes of snow were falling by the time I got to the Armory. The Gala was being staged by Frank Sinatra and an extraordinary collection of celebrities had agreed to appear, including Leonard Bernstein, Harry Belafonte, Tony Curtis, Laurence Olivier, Anthony Quinn, Bette Davis, Ella Fitzgerald, Gene Kelly, Nat King Cole, and many more. I had several more events to cover that afternoon but by the time I left the rehearsal the blizzard had descended in full force. The twenty-minute trip back to the Mayflower turned into a three-and-a-half-hour odyssey involving two taxis, one bus, and several blocks of slogging on foot.

By now the people in the Mayflower lobby looked lost and confused. It was eight o'clock and no one knew if the Gala would be canceled. And if it weren't canceled, how would anyone get to the Armory? As for me, I was dressed in a sports jacket and bow tie. The Gala was a black-tie affair and

5

Taking the Oath

Washington, DC, January 1961

Rehearsing for the Inaugural Gala at the Washington Armory while a blizzard rages outside. Among the celebrities Frank Sinatra recruited for the Gala were Nat King Cole, Tony Curtis, Gene Kelly, Leonard Bernstein, Bette Davis, and Ella Fitzgerald.

my tuxedo was back at my own hotel. Even if I forgot about the tuxedo, I would have to compete with all these people in the lobby for a taxi to get back to the Armory. Luckily, I remembered that Pierre Salinger was staying at the Mayflower and I gave him a call. "Of course I can take you," the resourceful Pierre said. "I've got my brother's car and it has snow tires."

Forgetting about the tuxedo, I set off with Pierre and we made it to the Armory in less than an hour. Thanks to the weather, we were practically the first people to arrive. As the others began to trickle in, I saw they were in all sorts of disheveled attire and I didn't feel underdressed. The President-elect and Jackie did not arrive until eleven. It felt like the campaign again and I was back at Jack's side as he dove into the crowd. The Secret Service was not used to such a fast-moving, gregarious President and it was amusing to watch them scramble to keep up with him.

It was a wonderful evening but what with the difficult travel, I did not get to sleep until 4:30 a.m. and I was back up at 6:00 a.m. for the big day. I went to the Kennedy home in Georgetown. Jack had gone to Mass and I met him there and headed back to his house. I tried to stay close to him all day, from the trip to the White House to pick up President Eisenhower and his wife on the way to the swearing-in, to the famous inauguration of the 35th President of the United States. It was impressive to see the President shift gears so effortlessly from the exuberant gala to the sober and moving inaugural ceremony.

After the ceremony at the Capitol, the procession drove slowly up Constitution and Pennsylvania avenues to the White House. I had been stuck in the truck provided for photographers but it was too far ahead of the President's car to be of any use. Finally, I jumped out and lugging my twenty pounds of equipment I ran next to the President's car all the way to the White House. Jack later told me I should have run for president instead of becoming a photographer since it was more comfortable to be president. I was exhausted when we arrived at the White House, where there was a box from which the President and the family would observe the rest of the parade. The security people wouldn't let me into the box at first. After some confusion, it turned out the Kennedy family had left my name, so I was able to photograph the parade from their point of view.

Jack and Bobby stayed at the parade until every float had passed. It was dark by the time the President left the box and I followed him into the White House for the first time. The Inaugural Balls would come later that evening; for now I was free to wander about the White House, our beckoning destination for so many months.

TAKING THE OATH

→7 →8 →9

→14

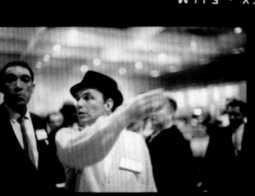

The finale of the Inaugural Gala at the Washington Amory. Because of the blizzard, which covered Washington with eight inches of snow, the gala was almost cancelled. The black tie requirement had to be waived and guests attended in everything from evening gowns to sports clothes. It was difficult for some of the performers as well. Ethel Merman, who couldn't get to her wardrobe, sang in her street clothes. Despite the weather, the President-elect and Jackie arrived at the gala looking immaculate.

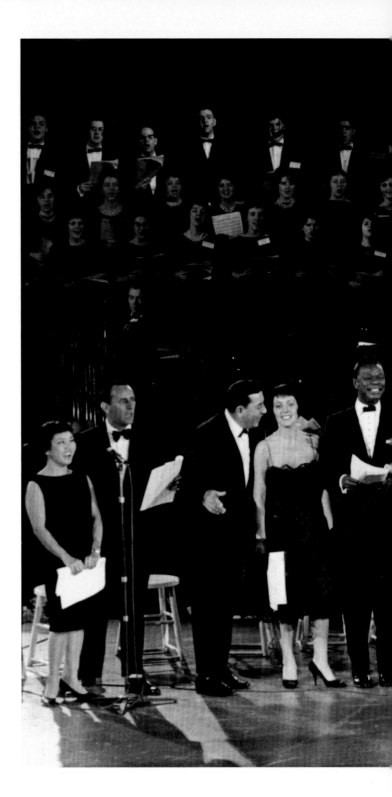

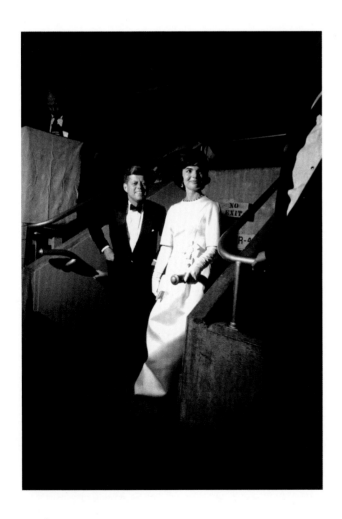

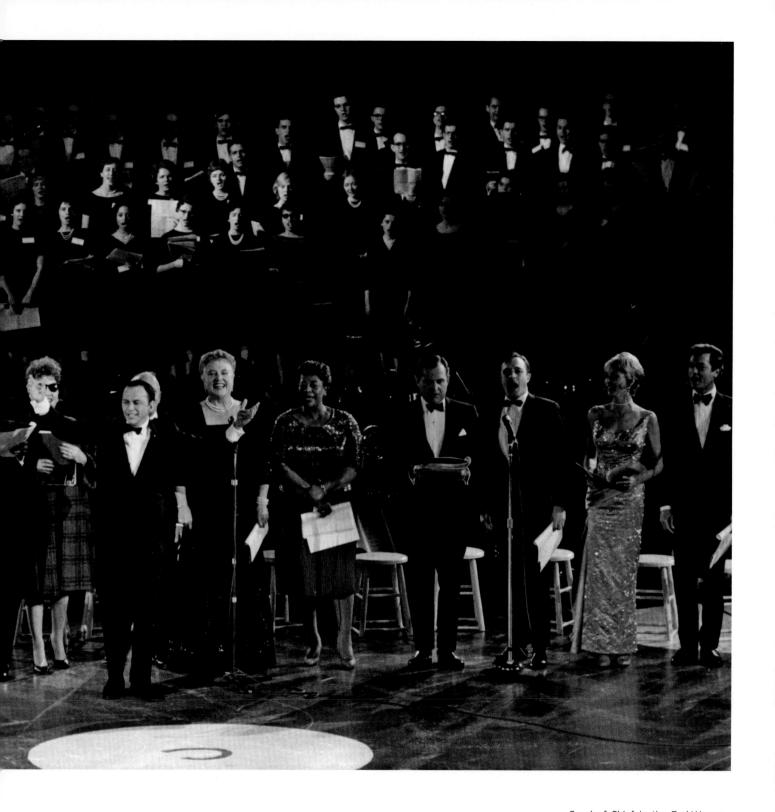

Overleaf: Chief Justice Earl Warren swears in John F. Kennedy as the 35th President of the United States. Robert Frost captured the mood of expectation in his poem "Dedication":
"A golden age of poetry and power
Of which this noonday's the beginning hour."

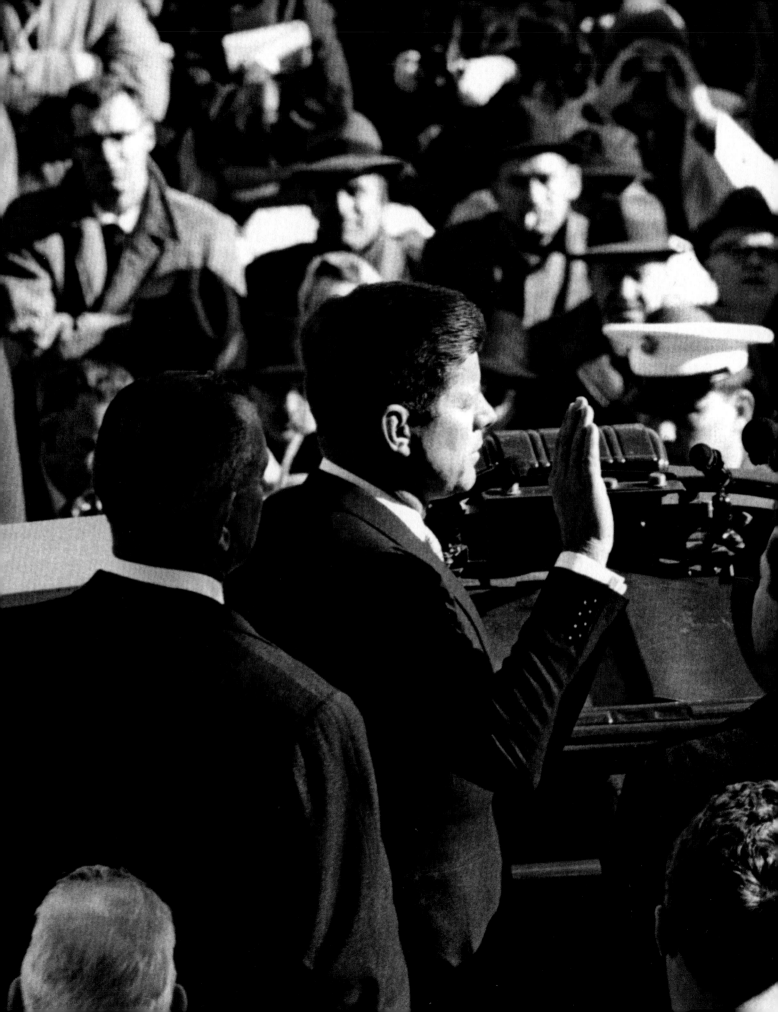

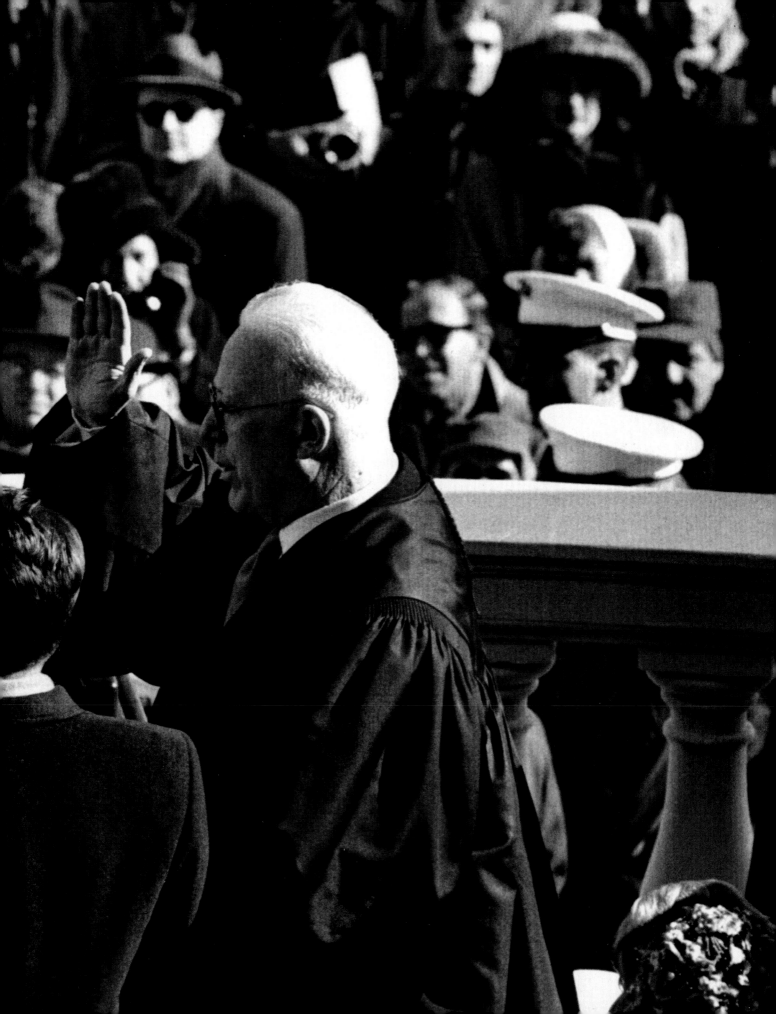

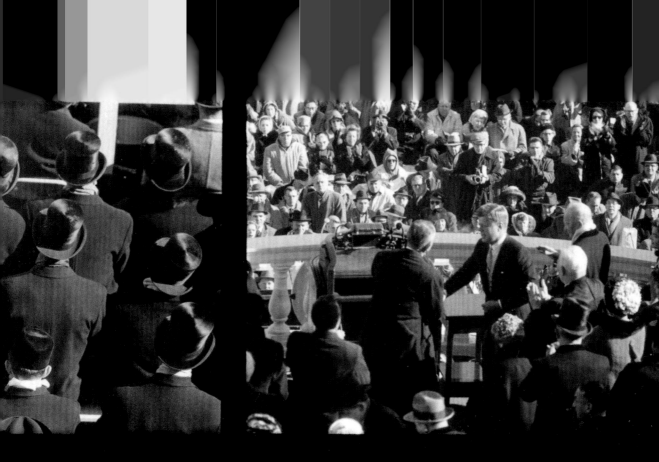

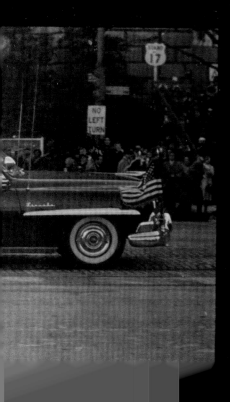
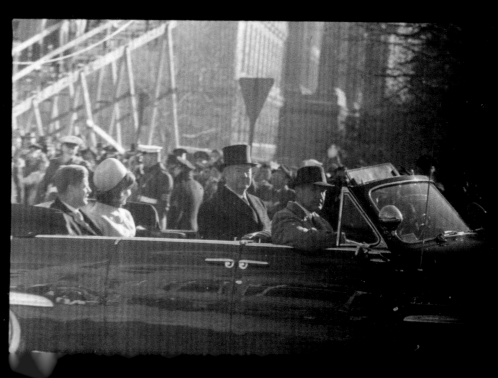

SAFETY FILM

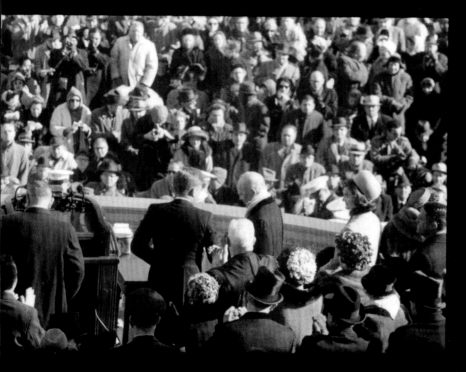

9

KOD

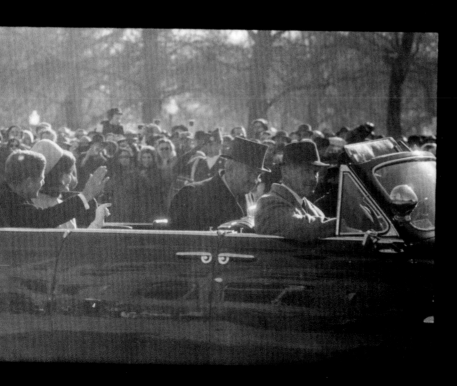

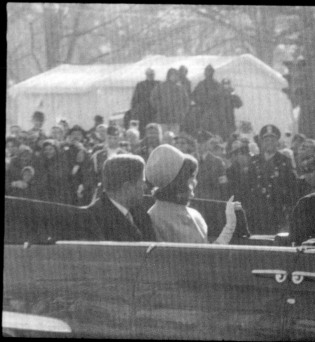

Pages 178–179: On a bitterly cold day, Jack and Jackie ride from the inauguration to the reviewing stand. Lugging his camera equipment, Jacques ran alongside the limousine most of the way.

Jackie watched the inaugural parade for about an hour before leaving to dress for the balls. Jack stayed until the last float went by in the gathering gloom.

"The PT-109 float came by, with members of his wartime crew on it. An enormous howl went forth now from this distinguished gathering. 'Great work!' Jack exclaimed. From then on it was a party."

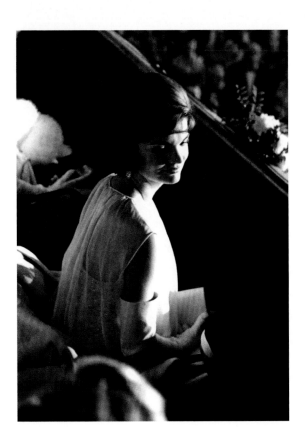

The first Inaugural Ball was at the Washington Armory. There were five balls in all and Jack attended every one of them. Jackie, who had given birth to John Jr. two months previously, had less stamina. Jack went on to a famous late evening party at the journalist Joseph Alsop's home in Georgetown.

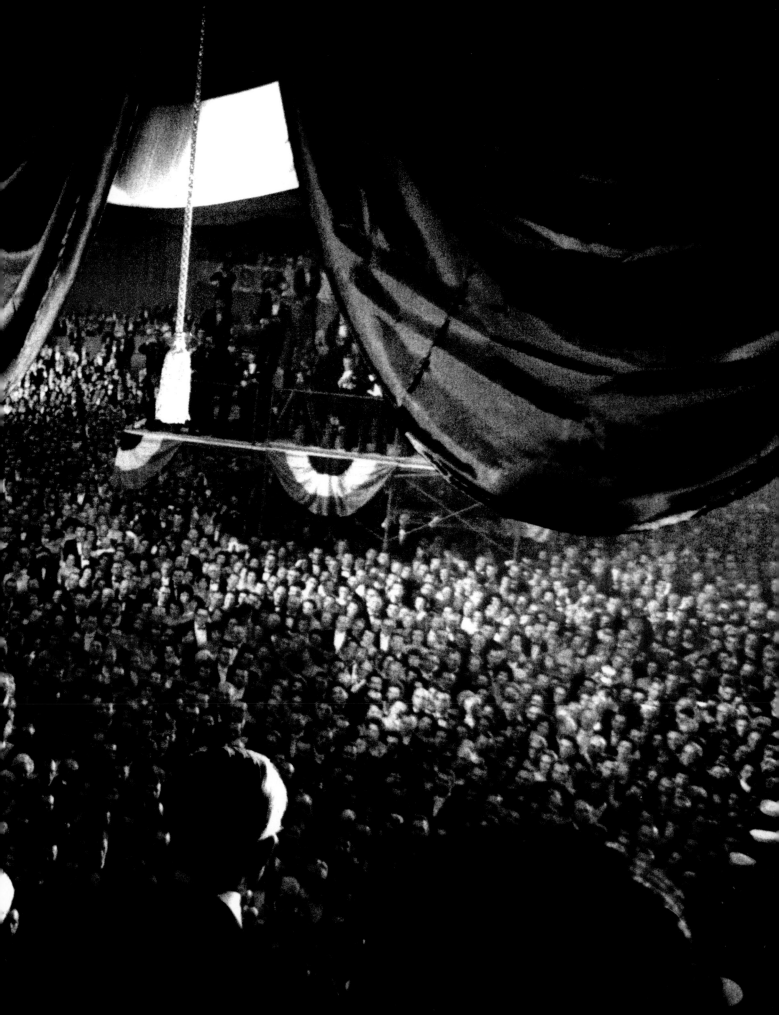

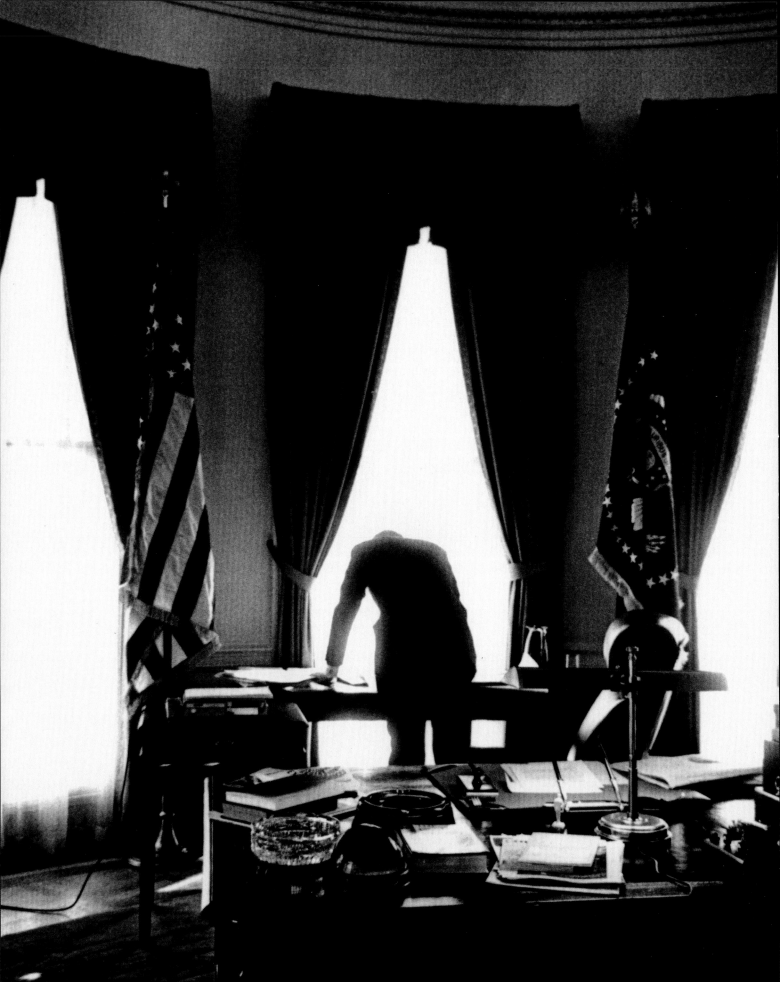

The first time I saw the Oval Office was the first occasion the President entered the office, on January 21, 1961. And the thing about the Oval Office that made an immediate impression on me was that the beautiful parquet floor had a thousand or so tiny holes in it. After some investigation it was discovered that the holes were there because the previous occupant, President Eisenhower, liked to walk around the room in his golf shoes and practice putting. The whole floor had to be redone.

If I was concerned about losing access to Jack now that he was President, I was soon reassured. The President wanted me to take the official White House photographer's job, but that involved shooting him at ribbon-cutting events and shaking hands with visiting dignitaries. As a freelance photojournalist, I was pretty much my own boss; working for the government was not my style. Jack explained, however, that he wanted me to document his presidency from the inside. "Stick around," he said, "and I'll make it worth your while."

During those early months I had an extraordinary entrée to the entire administration. With the President's encouragement, I spent time with his staff and with the cabinet officers and their staffs. I went to their meetings and sat in their offices. For all the tension and difficulty involved in a new administration taking control, it was also clear to me that Jack was enjoying himself. He was always quick on his feet and was not afraid to have impromptu press conferences.

Although Jack liked to tease me as the only person who made money from the campaign, he was in fact quite generous. If someone asked for a photograph, he'd say "Call Jacques Lowe." He would tell them he'd let me into the White House to take the photograph but no one else. When NBC wanted to follow Jack around with a 16mm camera and document the early days, Jack said no. "I'll let you do the story in stills and I'll allow Jacques to follow me around." They had no choice; they had to hire me. Jack was the best agent I ever had.

6

The White House

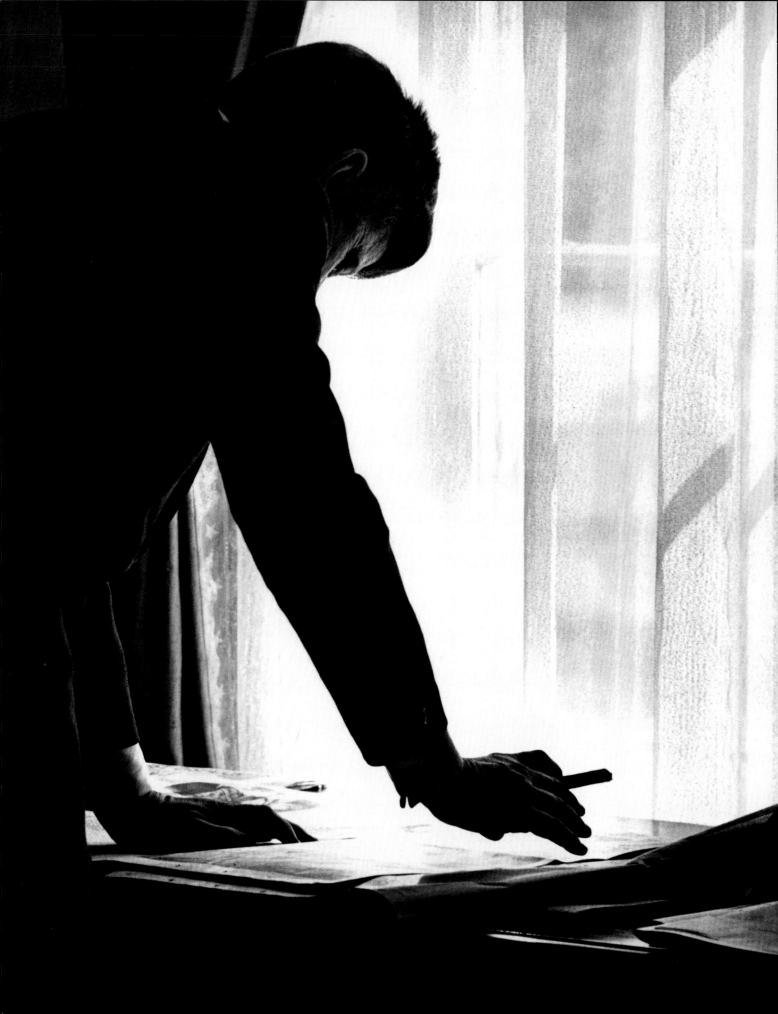

Page 184: In the Oval Office. When Jacques saw Jack leaning over a desk and bracing himself he knew the President was in considerable pain from his old back injury.

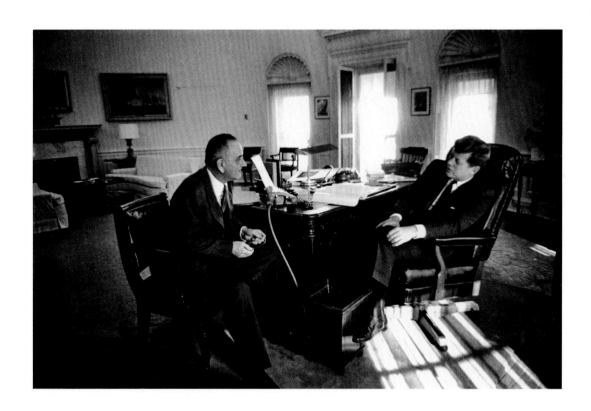

The White House, January 1961

Jack did not often light his cigars, but used them as a prop or distraction. Lyndon Johnson, who had been a powerful Senate Majority Leader, was isolated and unhappy as Vice President. Behind his back, many Kennedy aides referred to him as "Uncle Cornpone."

Overleaf: Jack's first meeting with the Joint Chiefs of Staff on January 25 was a guarded affair. Main picture, from left, Admiral Arleigh Burke, General Andrew Goodpaster, General David Shoup, General George Decker, and General Lyman Lemnitzer, Chairman of the Joint Chiefs of Staff.

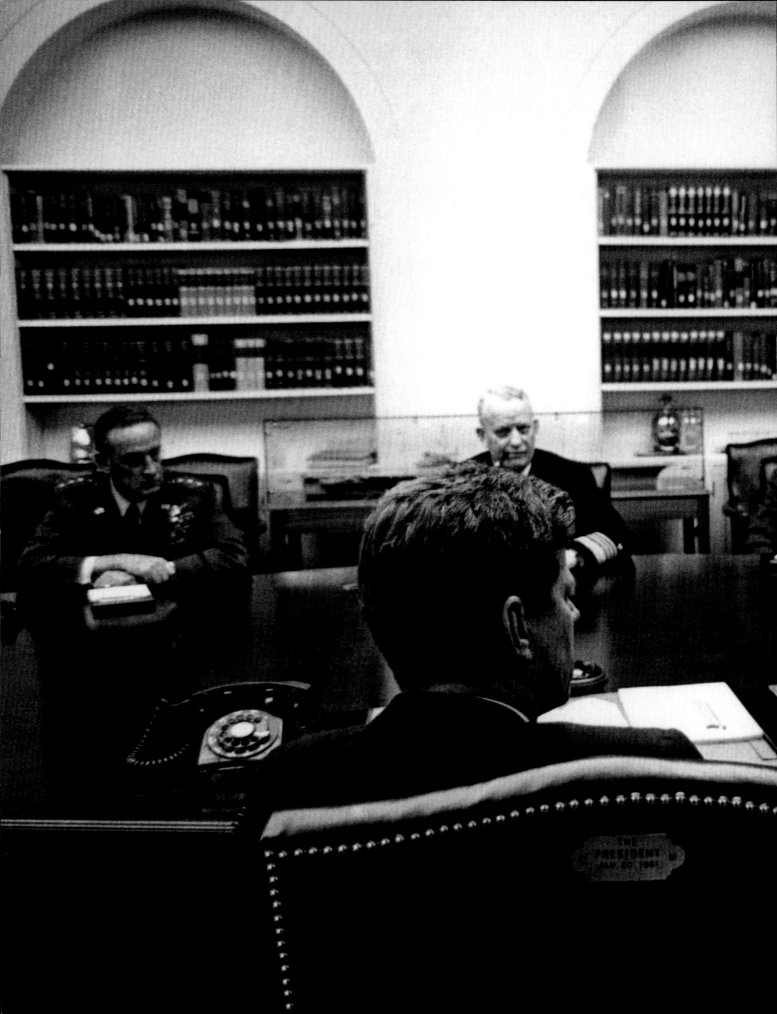

"Jack knew the generals didn't have much respect for him, and he didn't mind finding little ways to show his contempt for their self-importance."

At their first meeting with the President, the Joint Chiefs of Staff outlined six options for overthrowing Fidel Castro. The CIA, under Allen Dulles, would take over the management of the Cuban venture from the military, which less than three months later led to the ill-fated Bay of Pigs invasion. The Joint Chiefs pictured here are, from left, General Thomas D. White (Air Force), Admiral Arleigh Burke (Navy), General George Decker (Army), and the Chairman, General Lyman Lemnitzer. The Joint Chiefs were extremely uncomfortable at having Jacques in the room during the meeting but Jack insisted.

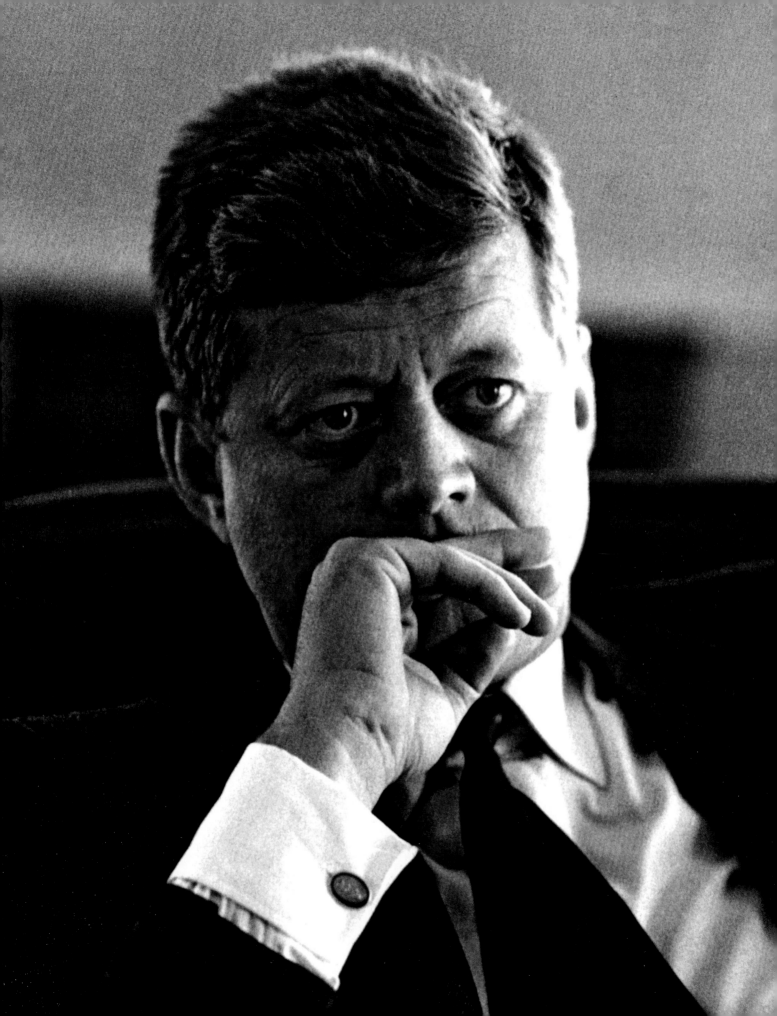

The White House, April 1961

Jack's look of penetrating suspicion told Jacques that a conversation was not going well. A week before the Bay of Pigs invasion, Secretary of State Dean Rusk and Richard Bissell, who ran the operation for the CIA, discuss matters with the President. Defense Secretary Robert McNamara makes a point.

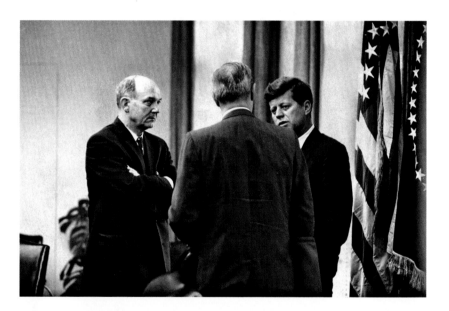

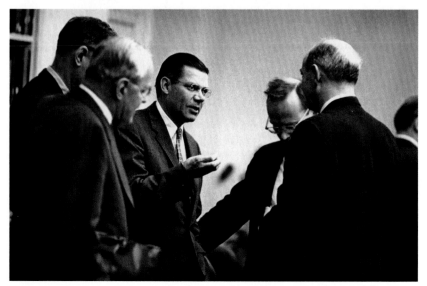

During the first few months in the White House, I spent a great deal of time in the Oval Office. After the excitement of the campaign, the Office felt small and a little claustrophobic. The French windows opened out onto the Rose Garden and a sort of veranda walk where Secret Service operatives carrying walkie-talkies were stationed. When the President sat at his desk, to his left was a very tiny office where he could retire to take a nap or conduct very private matters. To his right was the office of his personal secretary, Evelyn Lincoln, who also had her own secretary. Beyond the secretary's office was the Cabinet Room. And then facing the President was a door that led to the main corridor of the White House where there were at least two more Secret Service men.

For great stretches of the day I would hang around the Oval Office, shooting the occasional photograph while Jack worked away at his paperwork or dictated to a machine or made telephone calls. He never asked me to leave the room because he was discussing something I shouldn't be privy to. Of course, I had security clearance at a high level and a White House pass, but how many people at any level would have been at ease with an ever-present photographer? Visitors would come in—everyone from the President's brothers to foreign statesmen to the Secretary of State—and he let me keep on shooting. In the evenings, after dinner, he would come back to the Oval Office to catch up with his paperwork and there would just be the two of us.

It wasn't as if he was oblivious to my presence. I was a kind of sounding board. He'd interrupt what he was doing to make comments to me about political figures that he liked or disliked, ask me what I thought about a political speech or my reaction to someone who had just visited him. If someone irritated him he'd bitch about him to me. There were also long stretches of silence while he was completely absorbed in what he was doing and I just sat there.

Early on he asked me if I could get something for him. I walked to the door and then turned around, a little puzzled, and said, "How do I do that?"

"Just open the door to the corridor, stick your head out and whisper."

I didn't even need to whisper. As soon as I opened the door, eighteen people sprang into action; ready to help me help the President.

A few days after the inauguration, Jack held his first meeting of the Joint Chiefs of Staff. Jack wanted me to photograph the meeting, but I knew the generals were very security conscious. I asked the President how I should handle it.

"Why don't you let me go in and then you come in five minutes later," he said. "Don't knock, just walk right in."

So I walked in after five minutes, thinking Jack had paved the way. General Lyman Lemnitzer, Chairman of the Joint Chiefs, was speaking and when I saw the horrified look on his face I realized JFK had said nothing about me.

"Go on, General," Kennedy said, who knew exactly what he was doing. "Is something bothering you?"

Meanwhile I was moving around the room taking photographs. The general finally resumed speaking. Jack knew the generals didn't have much respect for him, and he didn't mind finding little ways to show his contempt for their self-importance.

The President also had a disconcerting habit of picking up the phone and making his own calls, especially if something irritated him. One night, back in my studio in New York, I answered the phone to hear a familiar voice say in a very emphatic tone, "JACQUES!" It turned out the *New York Times Magazine* had run one of my photographs of him on its cover that showed him wearing glasses—actually they were pushed back on top of his head. The image had been used before but now he didn't want any more pictures published of him wearing glasses. But once Jack got some annoyance like that off his chest, it was forgotten.

This habit of making his own calls could sometimes lead to amusing moments. One night he tried to contact Ralph McGill, the editor of the *Atlanta Constitution*, because he wanted him to serve on some committee.

"Is your daddy home?" I heard him say to McGill's daughter. "Okay, I'll speak to your mummy if he's not home. Who's calling? It's the President. Just tell her the President is trying to call your daddy."

When the mother finally got on the phone she practically fainted when she discovered it was *the* President.

Jack had become very much at ease with journalists during the convention. Once in the White House, he recognized that his ability to communicate was a way of staying in touch with the American people. In addition to his formal news conferences, he often surprised the White House reporters by organizing impromptu press conferences, which allowed him to control the agenda. At one of these, May Craig confronted him about his campaign promises on women's rights. Craig, who represented a string of small New England regional newspapers, was a bit of a character, known for always wearing a somewhat outlandish hat.

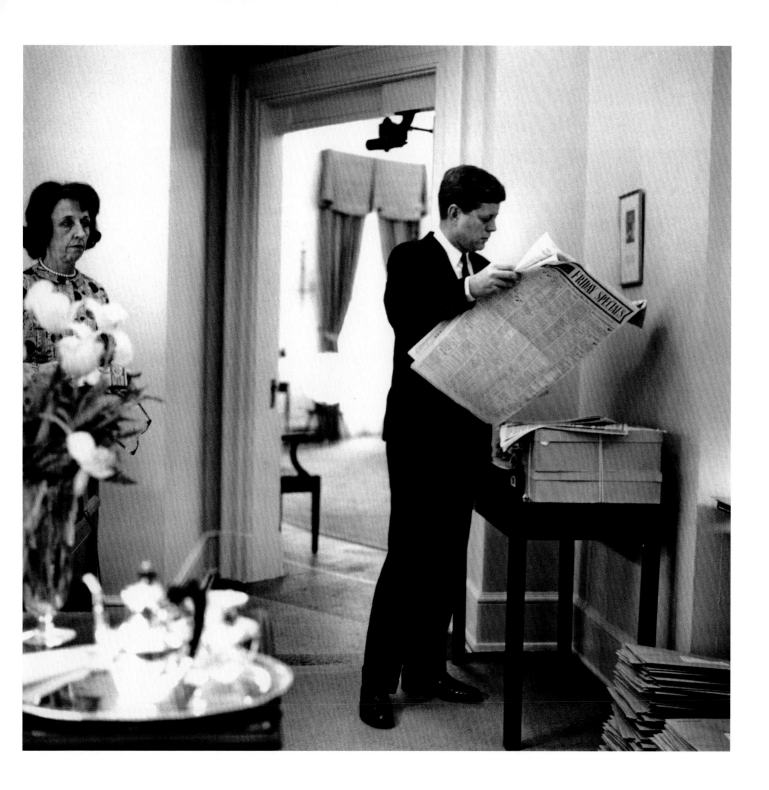

Caroline Kennedy had the run
of the White House and was
completely at ease with the staff.
While standing in the office of his
long-time secretary, Evelyn Lincoln,
Jack scans the headlines. He was a
voracious consumer of newspapers.

"For great stretches of the day I would hang around the Oval Office, shooting the occasional photograph while Jack worked away at his paperwork or dictated to a machine or made telephone calls. He never asked me to leave the room because he was discussing something I shouldn't be privy to."

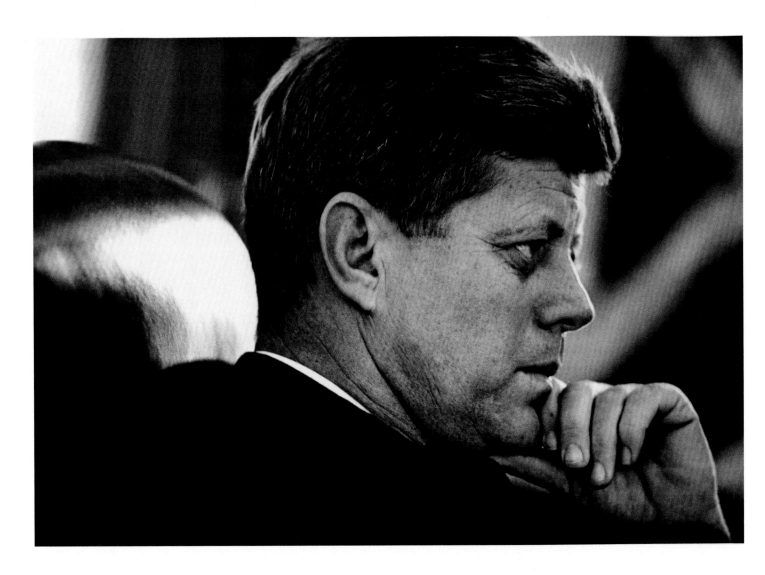

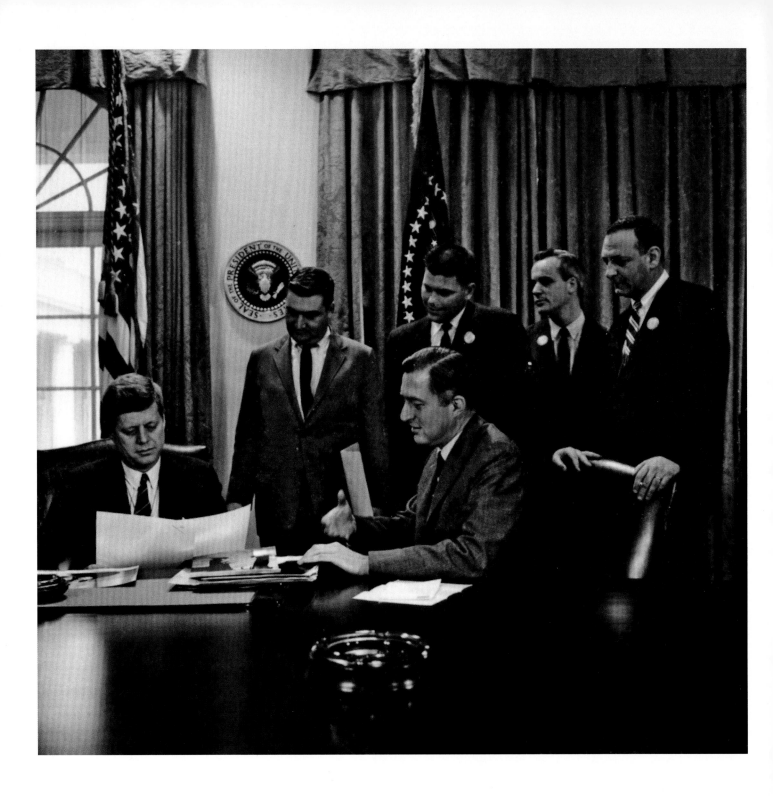

Jack was so at ease with journalists that he often held impromptu meetings with them in addition to his scheduled press conferences. One of the doughtiest members of the press corps was May Craig, who was well known for her slightly outlandish hats. She reported for a string of regional New England newspapers and had covered Jack from the time he first ran for the House of Representatives. Jack talks to her and other journalists in the Cabinet Room.

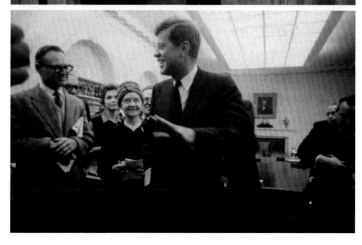

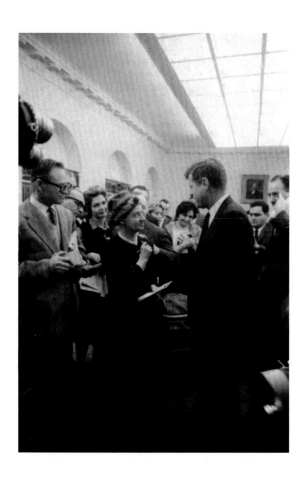

Jack did not plan on being put on the spot about his plan for women's rights so he simply said: "Well, whatever it is, I'm sure it's not enough," which got a big laugh; all the other reporters knew how stubbornly Craig had fought over many years to have just as much access as male reporters in Washington. But Jack wasn't trying to embarrass her. Though her newspapers had a very small audience, when he was a Massachusetts Representative and Senator her coverage was important to him; he never forgot and always took care to call on her in press conferences.

The Kennedys had a lot of tolerance for little children. Caroline had the run of the White House. All the staffers were used to her unexpected appearances. Jackie, however, had become more reluctant to exploit her daughter and I had to be careful about photographing Caroline. I tried to respect Jackie's instructions, but what would happen is that Jack would call me into his office and ask me to take some photographs of Caroline, say for his good friend Ben Bradlee at *Newsweek* magazine.

"I can't do that. Jackie doesn't want pictures of Caroline in any magazine. I've promised her: no pictures of Caroline without her approval."

"Well, just don't tell her about it."

"But once the pictures show up in *Newsweek*, she'll know who took them."

"Take the pictures and I'll straighten it out with Jackie."

I had no choice. I took the pictures, gave them to Bradlee, and once more Jackie was furious with me. And I had to take it. I couldn't very well point my finger at Jack and say, "The President made me do it."

Jackie was very aware of the power of photographs. To Jackie an image was a piece of art; composition, light, and shadow interested her and she had photographer friends such as Peter Beard and Mark Shaw. Jack looked at content. For him a photograph was a document. All the Kennedys were very interested in photography but as a historical record and for publicity. Bobby had framed photographs all over his home, on the walls, on the piano, on every mantel and commode. He even had a waterproof glass wall installed in his shower to display photographs. Jack would have extended conversations with me debating the relative merits of a *Time* magazine cover of him versus a *Newsweek* one.

Jack's dislike of being photographed wearing glasses wasn't just vanity. He never wanted to admit to any physical frailty although he was being treated for chronic Addison's disease and suffered from frequent and severe back pain. Before the convention, Lyndon Johnson had tried to make an issue of his Addison's disease but the campaign had deftly deflected the

issue. Kennedy always tried to appear active and athletic, but he often read newspapers and other documents while standing and leaning slightly over a desk or table, bracing himself with his hands to take pressure off his back. At those moments I would know that the pain was severe. He had gone through the whole campaign in almost constant pain but he refused to let it restrict his activities.

My first book, *Portrait*, traced the Kennedy story through the campaign and right up until the inauguration. When it came out early in 1961, I brought a copy for Jack to autograph. Bobby and a number of campaign aides had already signed the book but there was a page that I had reserved for Jack and Jackie to sign. Jack managed to use up the entire page from top to bottom. It became clear he had already gone through a copy. He opened the book to the photograph of his arrival at the Portland airport on a bleak day in 1959 when just three supporters were there to meet him.

"Maybe nobody remembers that day but that's why it's my favorite picture."

That was just the sort of reaction that had endeared him to me. Although there were plenty of triumphant images, Jack's real satisfaction was to be reminded of how far he had come. We chatted some more and then, as I turned to leave, Jack said, "Hey, Jacques."

I saw he had a slight smile on his face. "Yes, Mr. President?"

"Do I really owe you five dollars?"

I had mentioned in my book his habit of borrowing cash from whomever was at hand and I related the anecdote of the bellboy for whom Jack extracted five dollars from me. "You certainly do, Mr. President."

"That's very funny," he said, and that was the last I heard of it. I never got the five dollars.

During my first months at the White House I saw a good deal of Lyndon Johnson who was in and out of the President's office quite frequently. Jack was unfailingly courteous to Johnson but I could see that Johnson's attempts to enlarge his role in the new government were going nowhere. In just a few short months he had gone from being the second most powerful man in Washington to something of an afterthought. The President insisted that Johnson attend all cabinet meetings but he was essentially powerless. Johnson was not used to concealing his emotions and his unhappy frustration was often obvious. It couldn't have made it any easier that the person he had the worst relationship with, Robert Kennedy, was not only the President's closest advisor but now had a Cabinet-level appointment as Attorney General.

I
t was Jack and his father, Joe Kennedy, who were the most insistent that Bobby be appointed Attorney General. Almost everyone else (including Bobby) was against it. Southerners thought of him as too committed to civil rights and many others remembered what a tough (some said ruthless) counsel he had been for the McClellan Committee on labor racketeering. But Jack had no close friends in the Cabinet and he could see that if he was going to make any headway on civil rights, the Attorney General's office would be key. Jack prevailed on Bobby and the brothers became even closer, if that was possible. They spoke on the telephone almost hourly and saw each other a couple of times a day.

Though I had learned to say "Mr. President," Bobby would always be "Bobby" to me. Jack and I had grown close over the campaign but Bobby and I had a special relationship. One reason is that Bobby was more emotional than his brother and I found him more accessible. Jack was more intellectual and reserved in his style. Though he had a quick temper, Bobby's warm side was also close to the surface. After the West Virginia primary, when Bobby embraced Humphrey, he had tears in his eyes.

Now that I had begun to document the Kennedy presidency, I was spending a lot of time in Washington again. I resumed visiting Bobby's home, Hickory Hill, on weekends. It was still the same riotous place I had encountered five years before, except there were more children, and more ducks, geese, horses, rabbits, and dogs. Bobby was a loving and enthusiastic father, always ready to participate in games with his children. He loved to organize football games in which the Kennedys played teams made up of visitors. Visitors were often taken aback by the competitive zeal of even the youngest Kennedy children. Ethel was every bit as energetic and enthusiastic as Bobby. When there weren't enough visitors to form an opposing football team, Bobby and Ethel would divide up the family and play each other. In the summer, the entire Robert and Ethel Kennedy family circus would relocate to Hyannis Port. Along with the horseback riding, there were sailboats and, as always, lots of touch football.

7

RFK and Me

Page 204: In Hyannis, right after the election, Jack asked his brother if he wanted to be Attorney General. Bobby turned him down but Joe Kennedy kept on pushing the idea. Jack then offered the job to Abe Ribicoff who preferred Health, Education, and Welfare, and also sounded out Adlai Stevenson, who was more interested in foreign affairs and took the post of Ambassador to the UN. Bobby was finally persuaded to take it on.

The annual Robert Kennedy family Christmas card was always a major production. Ethel would start calling me in June, asking me to come up with a theme and she wouldn't relent until I showed up in August. At first, when the family was smaller, we would do group pictures. But as the family grew (eventually there were eleven children, the last born after his death), it became harder to round everyone up and get them to smile simultaneously. We decided to create portfolios of separate images of each of the children. One year each child was shown at bedtime prayers; another year each one carried a candle. One of the more ambitious Christmas card ideas was to photograph each child leading a favorite animal. Everything was fine until Michael's shot, in which he was supposed to lead several geese. The geese would not cooperate. As I ran around like a madman trying to capture Michael and the geese in one image, the Attorney General, Ethel, and several friends attempted to herd the geese into formation. Once we got the

Jacques Lowe captured in a rare moment of relaxation with Bobby's daughter Mary Kerry. The photograph was taken at Hickory Hill just before Jacques took a family portrait.

geese lined up, then Michael became uncooperative and the whole production took hours.

Things were always exciting and frequently a little out of control at Hickory Hill. Ethel might get a last-minute call from Bobby in which he told her he was bringing ten or twenty people home for dinner. Celebrities, dignitaries, and journalists were always passing through. On any given weekend you might encounter John Glenn, Frank Sinatra, Joseph Alsop or Sir Edmund Hillary.

Bobby brought an extraordinary level of intensity and involvement to everything he did. An indifferent student at Harvard, he was rejected by Harvard Law School and was only belatedly admitted to the University of Virginia Law School. Perhaps because of his mediocre academic record, Bobby became a relentless self-improver. He asked Arthur Schlesinger, Jr. to organize a series of monthly evening seminars at Hickory Hill that would expose members of the administration to the world of thinkers and writers outside of politics. People like Sir Isaiah Berlin, John Kenneth Galbraith, and even Al Capp gave seminars. Guests were encouraged to question the speakers. Bobby also became a voracious reader, especially works of history. One reason Bobby and I got along so well is that we both had an appetite for argument and debate.

I also spent some time with him in his office as he took control of the Department of Justice. If anything, he had even more impatience than Jack with the trappings of dignity and power. The large, forbidding Attorney General's office at the Department of Justice was soon transformed. His children were in and out of the office and their drawings brightened the dark paneled room. Bobby encouraged staffers to bring their children to the office and he sometimes brought his dog to work. During staff meetings, everyone would stand around and toss a football while they talked.

Bobby was more intensely religious than his brothers and he wasn't reluctant to raise the moral implications of almost any action. During the Cuban missile crisis, it was Bobby who could not accept the idea that the US would, in a surprise attack, kill thousands of innocent Cuban civilians. And despite the heated opposition of the hawks—General Curtis LeMay practically called him a coward in front of everybody—it was Bobby who was the most effective proponent of the quarantine and blockade strategy.

But it was over issues of social and economic justice that his religious beliefs most famously informed his actions. Even at law school he had distinguished himself by forcing the institution to allow Ralph Bunche, the African-American UN diplomat, to address an integrated audience.

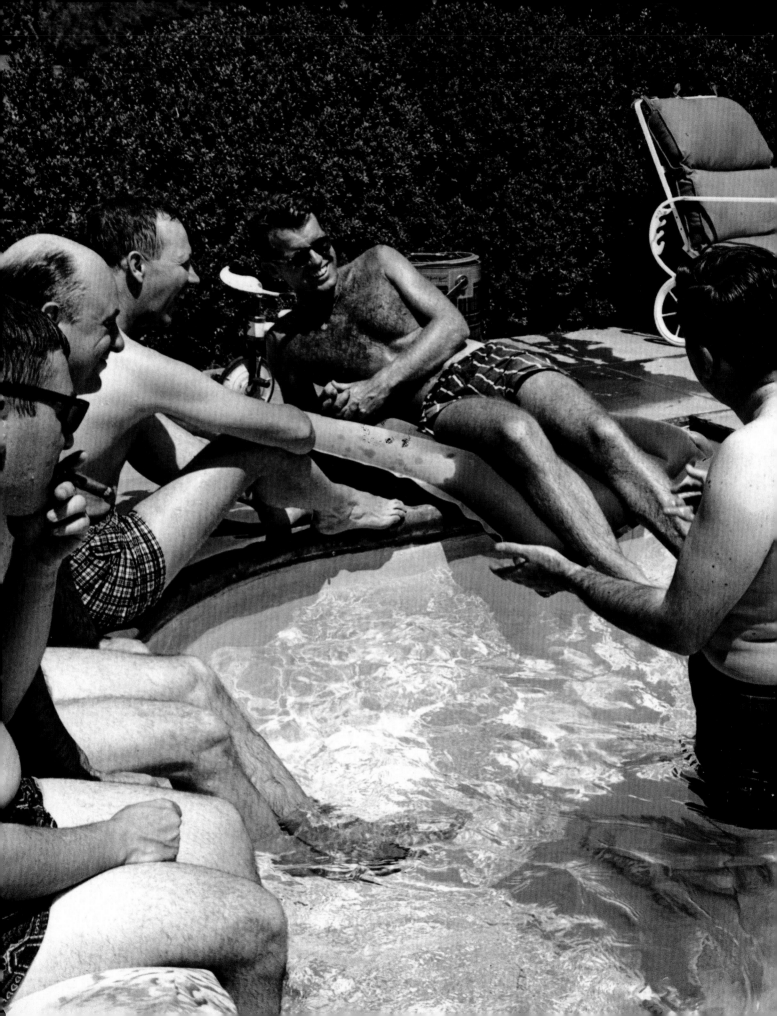

Hickory Hill

Family, friends, and staffers
would mix with visiting scholars
and experts around the pool
at Bobby's Virginia home.

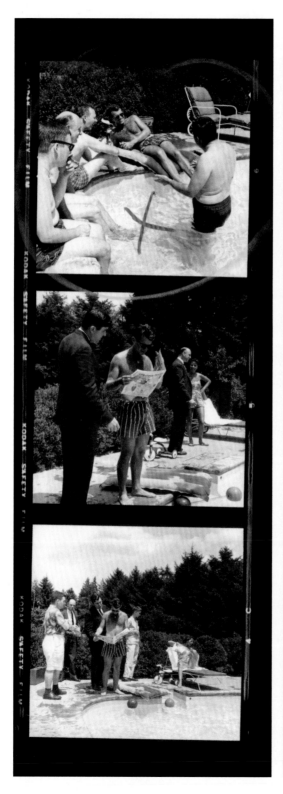

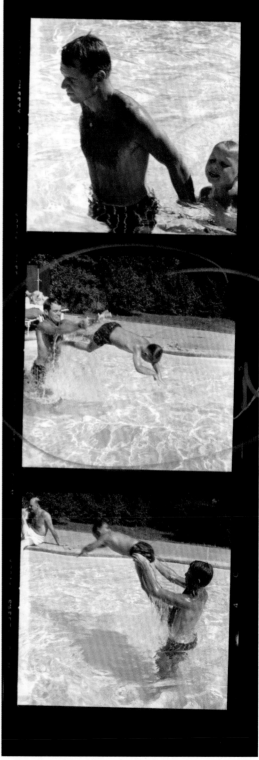

If there were no visitors to recruit for touch football, Ethel and Bobby would divide the family into teams and play. Ethel was almost always game, even when pregnant. Jacques saw her play touch football in Hyannis Port one summer when she was expecting another child. "The next Sunday she was in the hospital, and when I saw her two months later in New York, she was as slim and attractive as ever."

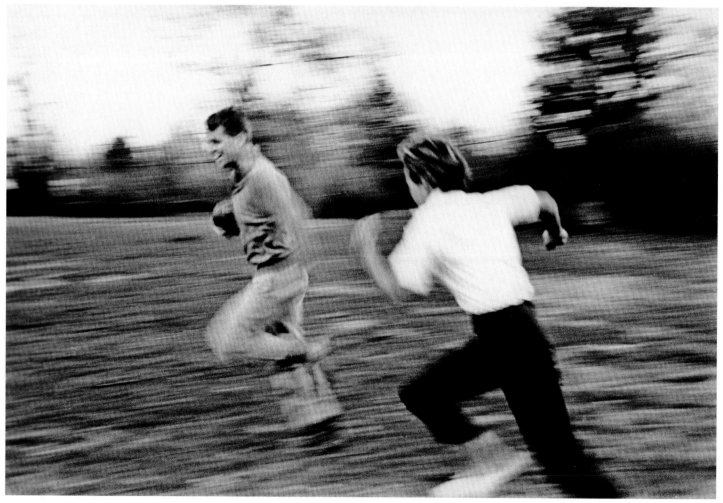

The tradition of family portraits continued. Because new children came along frequently, the house at Hickory Hill was filled with these portraits as well as outtakes from the family Christmas cards. Ethel gave birth to eleven children, the last one after Bobby's assassination. In this 1961 portrait, the children are, from left, Kathleen, Bobby Jr, Mary Kerry, David, Courtney, Michael, and Joe II. Along with touch football, riding horses was the other major activity at Hickory Hill.

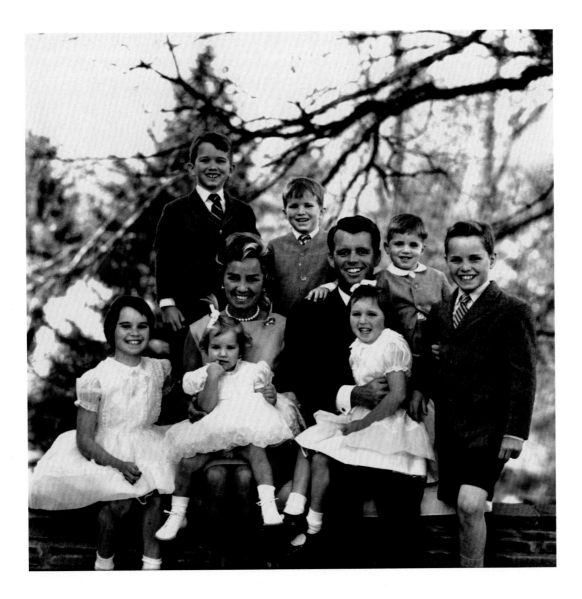

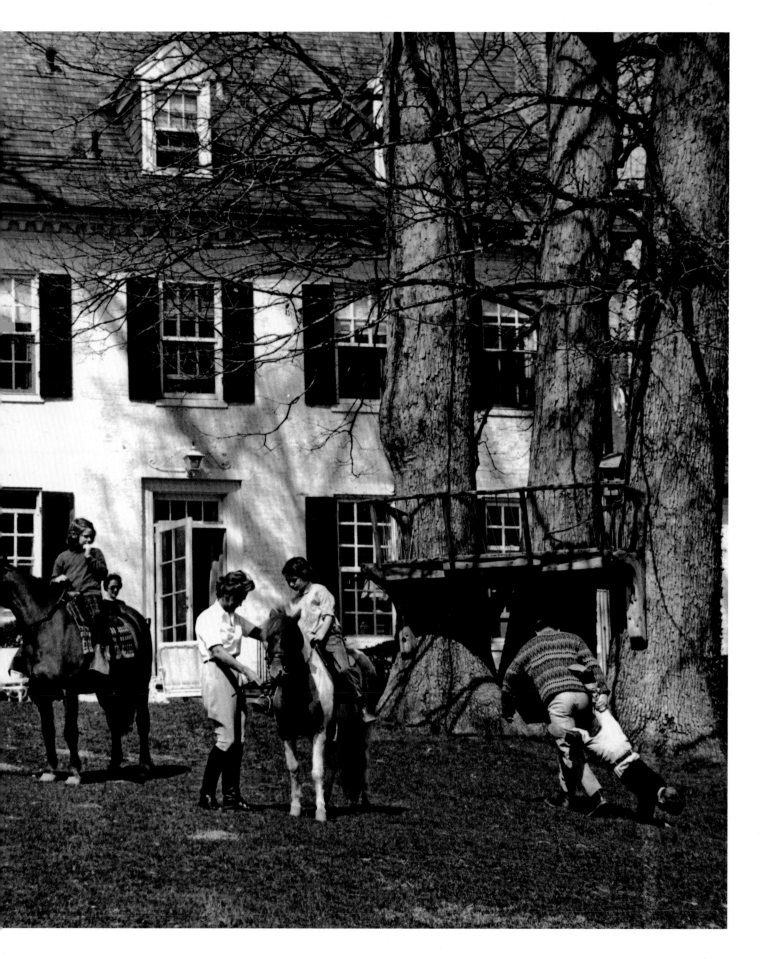

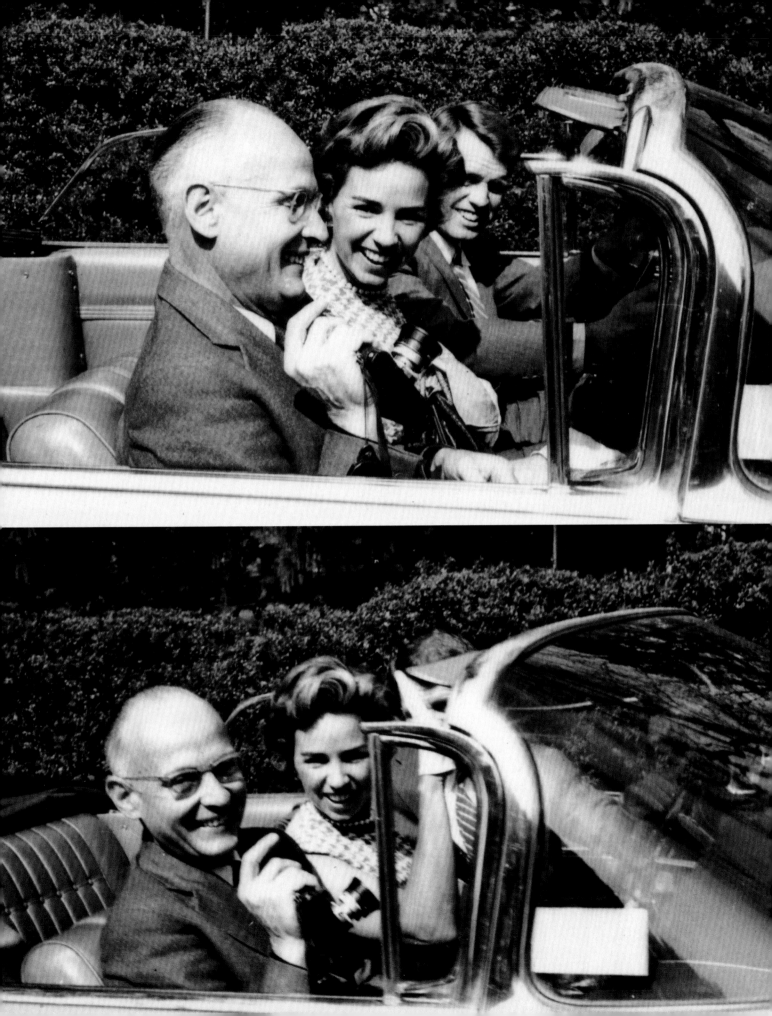

Bobby loved bringing people from all sorts of professions and pursuits to Hickory Hill and to his house in Hyannis Port. The great photojournalist Henri Cartier-Bresson shares the front seat of the car with Ethel and Bobby.

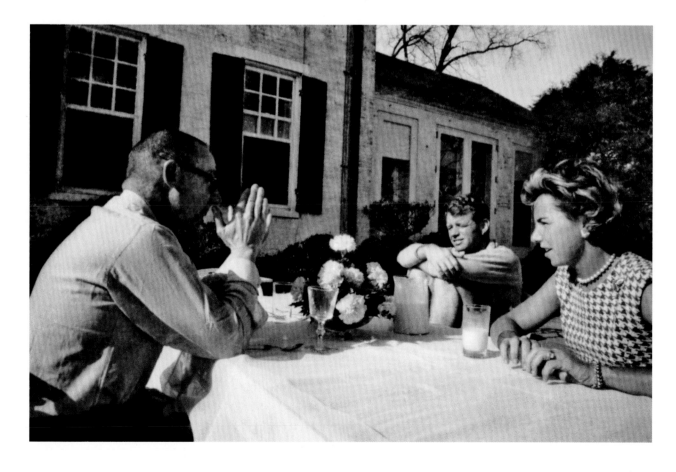

Washington, DC, 1961

Everything about Bobby irritated J. Edgar Hoover, who ran the FBI as if he owned it, from his convictions about civil rights to his personal style. One day, when Hoover was in the Attorney General's office, Bobby began to toss darts at a board on the wall. The gesture was probably calculated to annoy Hoover and it did. But when Bobby missed the board and hit the wall, Hoover became apoplectic and cut short his visit. Later, Hoover called it "desecration of government property."

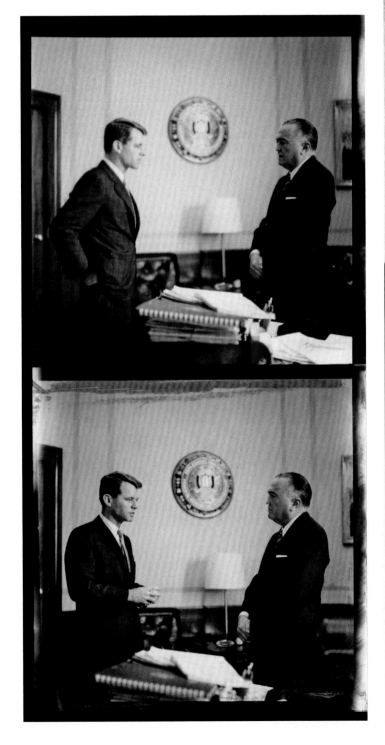

A desegregated event was forbidden in Virginia at that time. Bobby's identification with the poor, with blacks and the downtrodden was instinctive, while Jack was more political and pragmatic. And it was over civil rights that Bobby's conflict with J. Edgar Hoover was most difficult.

Hoover, the long-time director of the FBI, was feared in Washington for the dirt he was rumored to have in his files on almost everyone. From Hoover's point of view, not only was his new boss thirty years younger than him, he was also the President's brother and his closest advisor. Although he loathed Bobby, it would be difficult from now on to go over the Attorney General's head directly to the President, as he had with previous Attorneys General. After Hoover made a cordial formal visit to the White House, I went with Bobby to Hoover's office where their wariness of each other was on full display.

Bobby was impatient enough with Hoover's lack of action against organized crime. But on civil rights they were destined to be opposed. Bobby insisted that the Department of Justice be integrated and did his best to bring young black lawyers into the department. But when he told Hoover to integrate the Bureau, Hoover was infuriated. Hoover hated Martin Luther King and thought he was a Communist while Bobby tried to protect King.

In 1968, I was with Bobby briefly during his campaign for the Democratic presidential nomination. On the afternoon of April 4, he spoke in Muncie, Indiana. His next stop that evening was a rally in the heart of the black ghetto in Indianapolis. When we got to the airport in Muncie, Pierre Salinger phoned to tell Bobby that Martin Luther King had been shot in Memphis. Pierre suggested that we might want to cancel the rally. When we landed in Indianapolis, we were informed that King had died. The police chief who greeted us at the airport warned us not to go into the ghetto but Bobby insisted on going directly to the site of the rally. As we drove into the ghetto, the police escort disappeared. A good-sized audience had already gathered, and from their cheerful mood, it was clear they had not yet heard about King. Speaking from a podium on a flatbed truck, Bobby broke the dreadful news to them. They were devastated. Then, drawing on his own tragic history, he made one of the greatest speeches I have ever heard. The crowd sat in silence as he spoke of the need to heal, to get beyond violence and lawlessness. In the end, Indianapolis was one of the few major cities where there was no rioting that awful day.

Although the brothers did not socialize that much after hours, during the working day they spoke to each other almost hourly on the phone. Jack did not always take Bobby's advice but he always sought it. And on certain issues, most notably the Cuban missile crisis, Bobby's advice and support were invaluable.

RFK AND ME

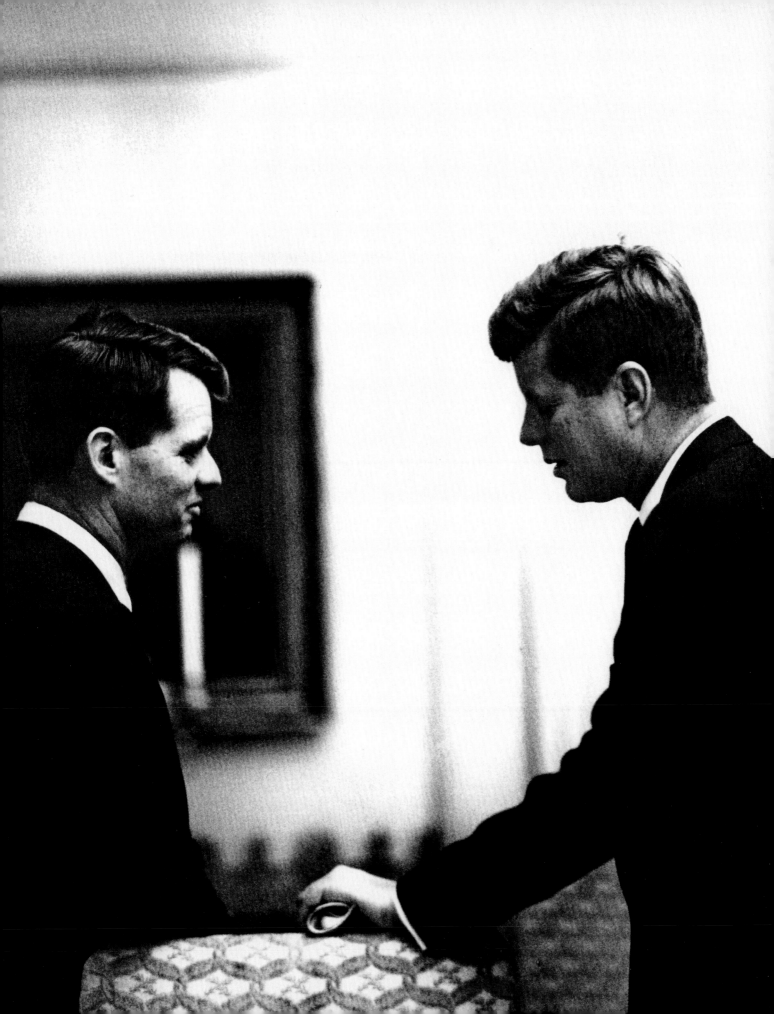

Even while he was on the telephone, Jack's face was very expressive, and he didn't mind being photographed by me as he spoke. Early in his term, in February 1961, I was in the Oval Office with him as he took a call from Adlai Stevenson who was now UN Ambassador. As I was shooting, I heard Jack say, "Oh no!" as he put his hand to his forehead in dismay. He had just learned that Patrice Lumumba, the recently deposed head of the Congo, had been assassinated. Although Lumumba's death had actually occurred before the inauguration, the situation in the Congo was chaotic and this was the first Jack had heard of it. Lumumba had supposedly been under the protection of UN peacekeeping forces in the Congo. This was a real blow to Jack. He had hoped to make a fresh start with some of the nationalist leaders in Africa, who had been regarded as leftists by the previous administration. Jack's instinctive reaction suggests he was unaware, so early in his administration, that the CIA itself had made plans to assassinate Lumumba with the tacit encouragement of Eisenhower, though it seems in the end it was Belgian security forces that enabled the execution.

The Lumumba episode was a reminder to me that the people I photographed were sometimes grappling with difficult and occasionally perilous problems. At that early Joint Chiefs of Staff meeting, for instance, where Jack needled the generals by having me barge in with my camera, the Joint Chiefs of Staff had presented the President with a list of options for getting rid of Fidel Castro. And a few days later, at another meeting, Allen Dulles, the CIA Director, described the plan that the CIA had in the works: the training of a guerilla force to infiltrate Cuba and overthrow the Castro regime. Over the next two months there were a number of meetings as the project, spearheaded by Richard Bissell, the CIA's brilliant Deputy Director for Plans, evolved into an invasion that became a debacle.

There were happier moments during this period as Jack turned his attention to the international arena. An early visitor was the British Prime Minister Harold Macmillan, whose senior counsel Jack greatly valued.

8

On the World Stage

Page 220: At the Elysée Palace,
Paris, May 1961.

The White House,
February 1961

Adlai Stevenson phoned to tell
Jack that news had come through
of the assassination of Patrice
Lumumba, the deposed Prime
Minister of the Republic of
the Congo. This image of Jack
in a moment of sadness and
consternation was always one
of Jacques' favorites.

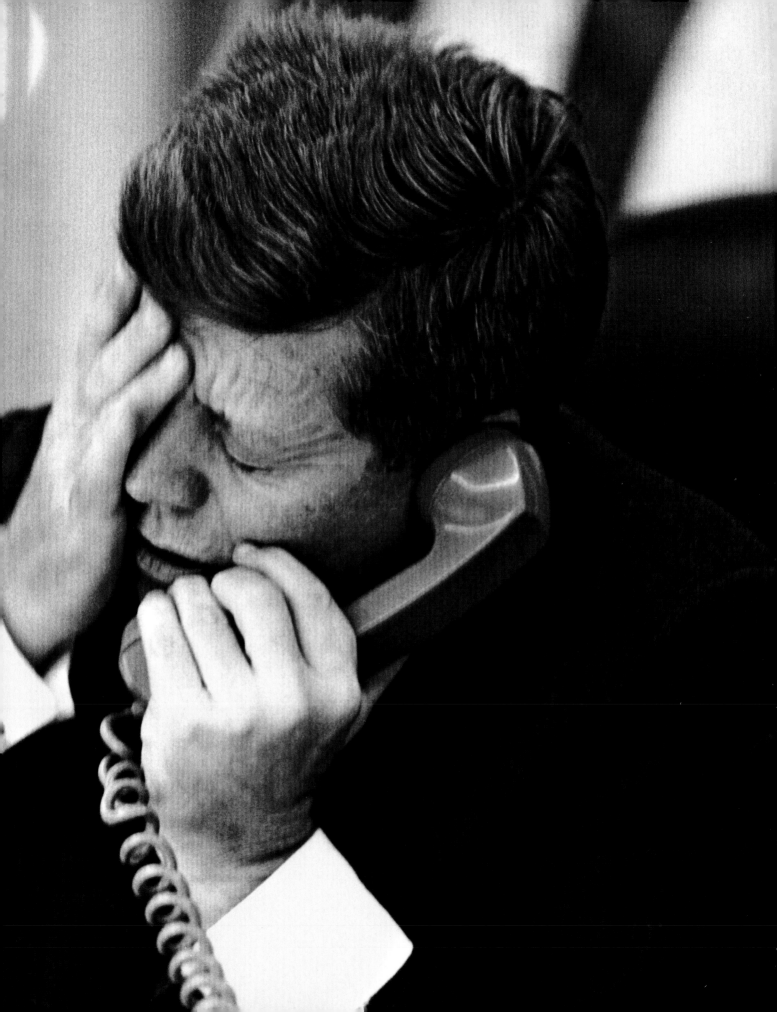

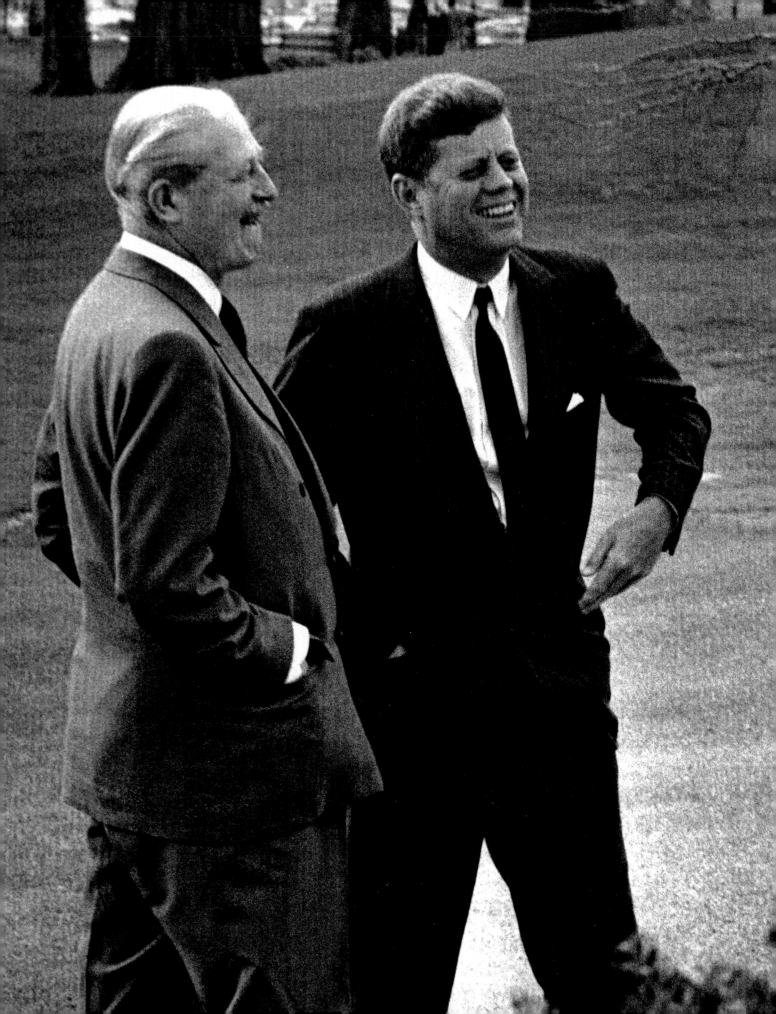

The White House, April 1961

After the debacle of the Suez Crisis, the British Prime Minister Harold Macmillan had worked hard to restore a good relationship with President Eisenhower. A first brief meeting between Kennedy and Macmillan in Key West in March 1961 did not go well but Macmillan's visit to the White House the following month was the beginning of a better relationship.

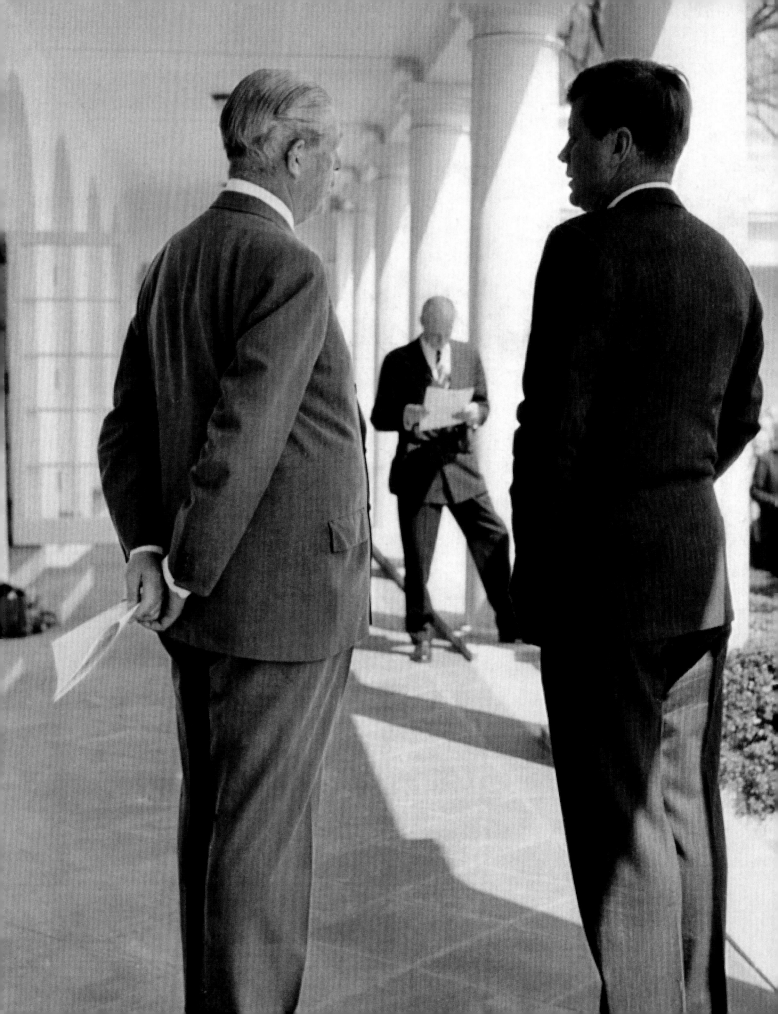

There was a great superficial contrast between the very British and very intellectual Macmillan and Jack, the Irish-American Boston pol. But Jack had spent time in Britain when his father was Ambassador and he had written a book about British history, so he approached the "special relationship" with sensitivity. Though Jack tended not to make new friends and relied on old friends for counsel and advice, he and Macmillan became quite close.

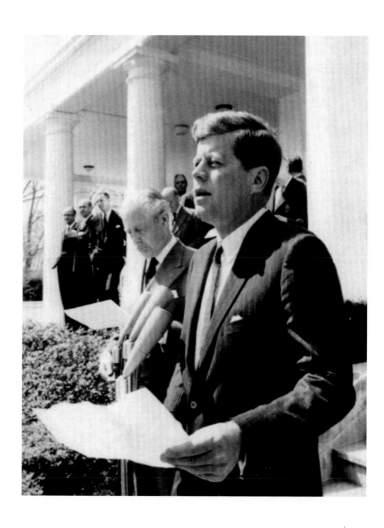

Jack was a great believer in the "special relationship" with Britain. He had lived in London for a period when his father was the American Ambassador there, and Jack's honors thesis at Harvard, *Appeasement at Munich,* was an analysis of the country's response to the approach of World War II. It was later published quite successfully as *Why England Slept.*

Later in the spring, the President made his first trip abroad. The main agenda was a meeting with Nikita Khrushchev in Vienna. But the trip also included a visit to France on the way to Vienna and a visit to London on the way back. I didn't expect to be invited on the trip since there would be thousands of photographers clicking away, but the point of the London visit was for Jack to become godfather to his sister-in-law's new daughter. Since that leg of the journey was meant to be "private," Jackie didn't want press coverage, but Jack wanted me there to document it and Jackie agreed.

We left in May, only a m onth after the Bay of Pigs fiasco. Jack had taken full responsibility for the failed mission but there was some apprehension about how we would be received overseas. From the very first moment of our arrival in Paris, when Jackie made a short speech in excellent French, the couple seemed to have enraptured the usually restrained Parisians. Over a million people lined the streets as the motorcade made its way into Paris and they were all screaming "Jackie! Jackie! Jackie!" Over the next few days the French delighted in her style and charm. To the French, Jack and Jackie represented a new and vibrant America. Of course, it didn't hurt that Jackie had some French ancestry and had lived in France for her junior year of college. She even managed to soften the rather austere and haughty President Charles de Gaulle, who famously told Jack that Jackie knew more French history than most Frenchmen. At one press luncheon Jack's humor won everybody over when he introduced himself as "the man who accompanied Jacqueline Kennedy to Paris, and I have enjoyed it."

The two big formal events were receptions at the Elysée Palace and Versailles. Kennedy and de Gaulle's differences on international relations also extended to more petty matters, such as publicity. De Gaulle hated photographers and he didn't want any at the receptions. Jack of course wanted everything documented. The compromise, finally, was to select three photographers—one for all the European media, one guy who shot for all the American media—and me.

I had brought a tuxedo with me, as had the other American photographer, but the reception at the Elysée Palace was supposed to be white tie and tails. There ensued a series of negotiations between Pierre Salinger and the French Press Office. First they said we could wear our

tuxedos; then they changed their minds and said no, we had to wear tails. The dispute even got kicked up to Jack, who didn't understand why we couldn't wear tuxedos. Finally, only hours before the reception, the French Press Office said that there would be no compromise: we had to wear tails. I'm sure it was de Gaulle's attempt to exclude us.

We went racing back to my hotel. Luckily, I was staying at the Crillon, an excellent hotel. The concierge there, being something of a magician, managed to produce and have altered two sets of white tie and tails on a Saturday afternoon. So off we went, with me grabbing at my throat every so often because the stiff white collar kept popping up. When we got to the Elysée we discovered that the reception room was very long and narrow. And there we were at one end, cordoned off by velvet ropes and watched by about ten French guards in their sixteenth-century uniforms, while the party was taking place three hundred feet away at the other end of the hall. Even with a 200mm lens I couldn't have got anything. De Gaulle strikes again!

As we were standing there helplessly, General James Gavin, the recently appointed American Ambassador to France, got close enough to notice me. I had become friendly with Gavin during the campaign and subsequently had done a story about him. When he noticed me behind the velvet ropes he waved and said, "Come on over."

So I jumped the ropes. The guards didn't like it but there was nothing they could do. Now I was part of the party and I began to photograph. Eventually, I made my way to Jackie, Jack, and de Gaulle. De Gaulle couldn't have been too happy at my presence but Jack knew what was going on. He came by me and leaned close. "Jacques," he said, "if the French government decides to cut your balls off because you're mingling with the upper crust, don't expect the President of the United States to come to your aid."

The Paris trip was a big boost to everyone's mood but things were more serious when we got to Vienna. Jack's Bay of Pigs misadventure had framed him, in Khrushchev's eyes, as an inexperienced and impetuous young president. So Khrushchev came to Vienna thinking he could bully the President. Once more, Jackie managed to charm a head of state. Khrushchev seemed to glow when he was in her presence at several formal events but it did not warm up his relations with Jack. They did not agree at all on a wide range of issues, most importantly, Berlin. In Paris, de Gaulle had cautioned Kennedy to be strong in the face of the Russian's threats over Berlin. Khrushchev's desire to get allied troops out of West Berlin, and Jack's insistence on maintaining the status quo there, had every possibility of leading to war. Their testiness with each other was on display several times.

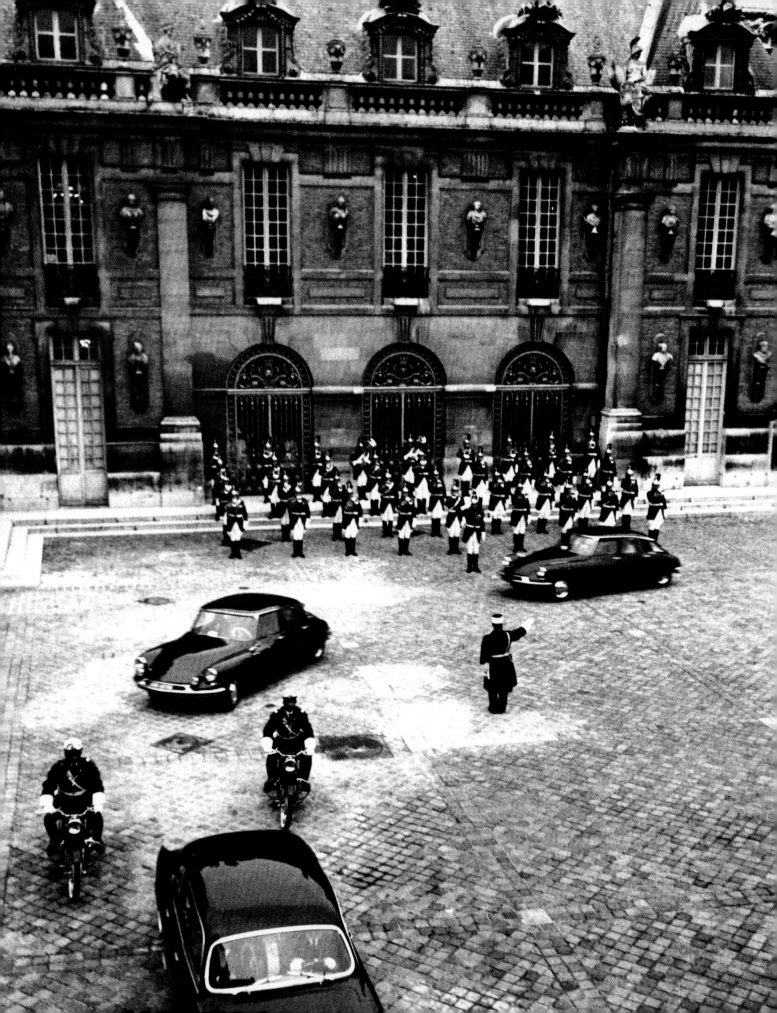

Paris, May 1961

Jack's first major foreign trip took him first to France and then to Vienna and London. In Paris' he had a series of meetings with French President Charles de Gaulle, the austere and somewhat imperious leader of the French. De Gaulle did his best to stiffen Jack's resolve for when he faced Khrushchev in Vienna, especially in regard to the status of Berlin.

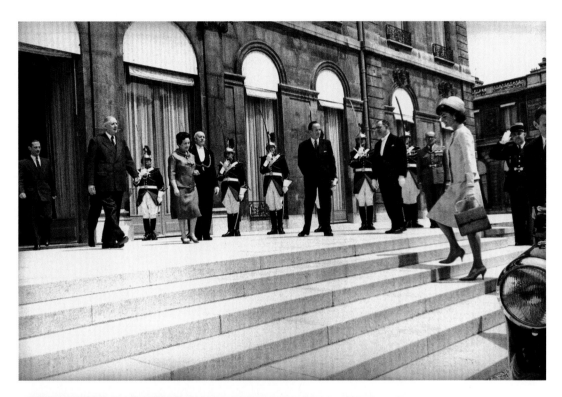

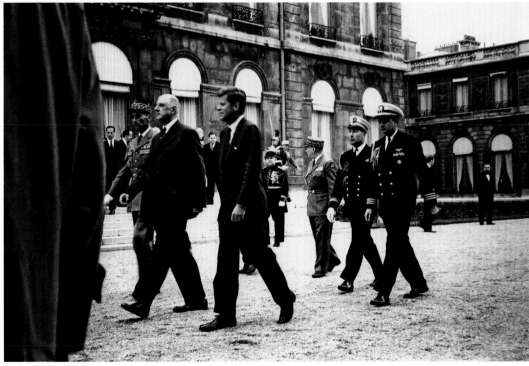

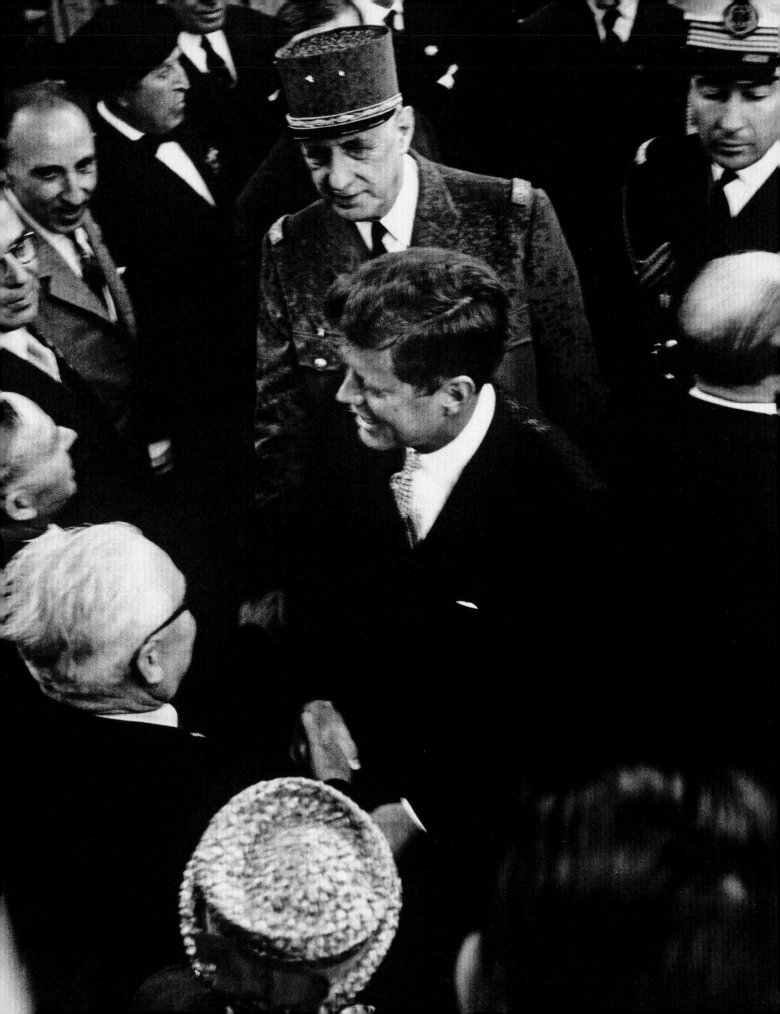

The birth of John Jr. had been difficult and Jackie had only just begun to get back her strength before she left for France. Amid the formal choreography of a French honor guard, she strikes a vibrant, youthful contrast. Both Jack and Jackie were well received by the French people but Jackie, who spoke French, had French ancestry, and dressed with wonderful style, struck a particular chord.

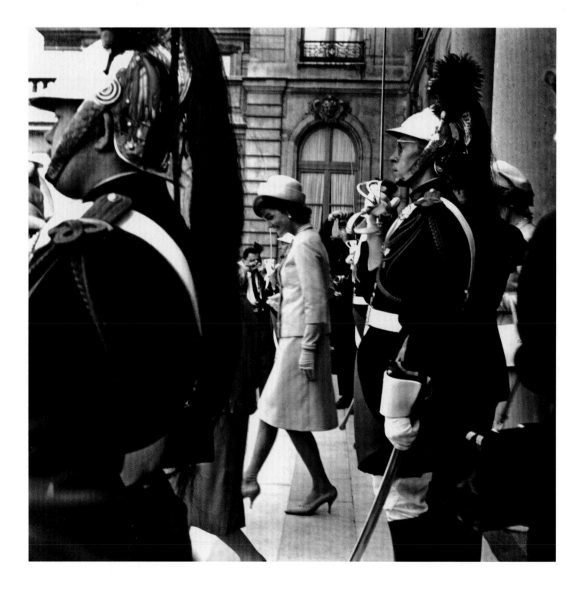

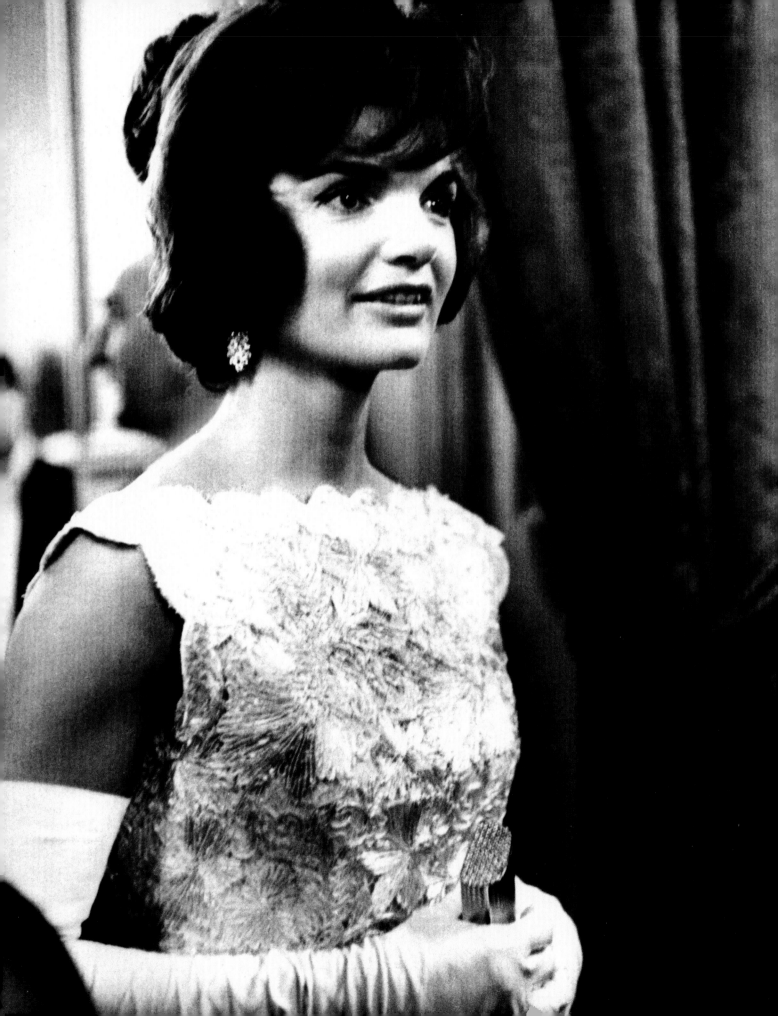

The lavish reception and dinner at the Elysée Palace was the social event of the year in Paris.

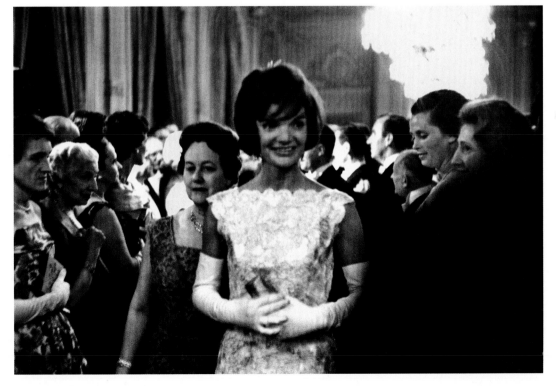

"This is Madame Kennedy at her best—looking radiant. It's in Paris, where she made a huge impression on the Parisians. She spoke French, in her little voice, and they loved it. General de Gaulle was enchanted by her, as was all of Paris. Everybody wanted to imitate her."

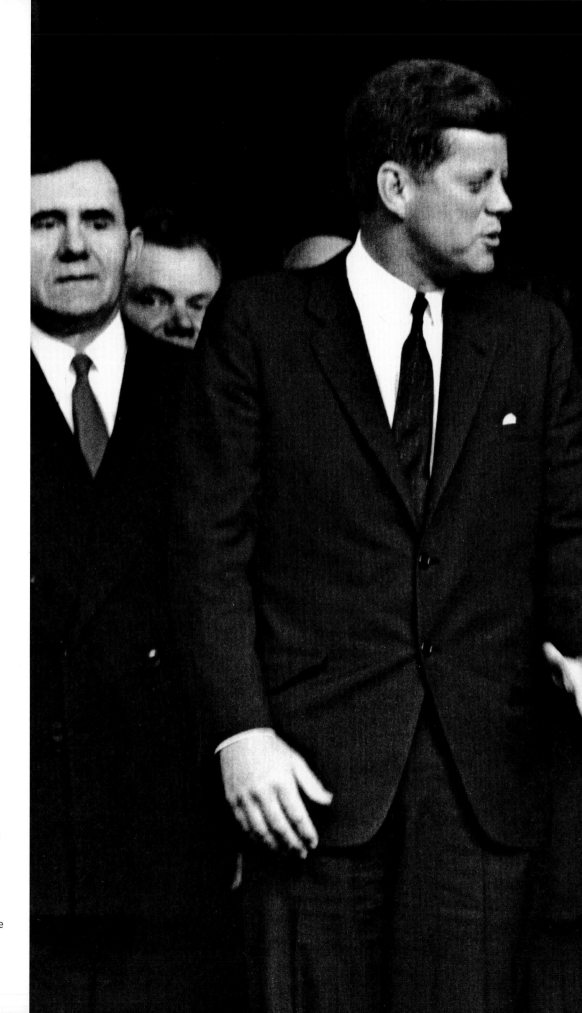

Vienna, June 1961

In Vienna for the summit. From the very first day the Soviet leader was confrontational. Beneath Khrushchev's crude jocularity, Kennedy said later, was a "repressed rage." The Russian clearly believed that a young and inexperienced president could be pushed around. When it came to real issues, such as the Test Ban Treaty and the status of Berlin, the two men made no progress at all.

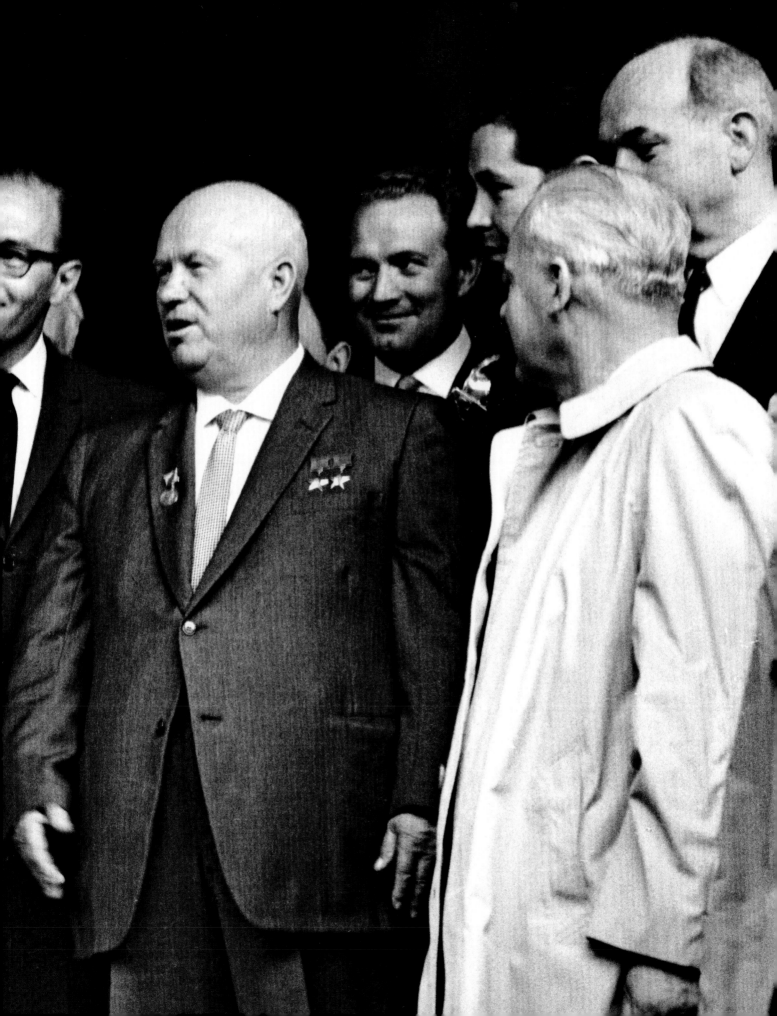

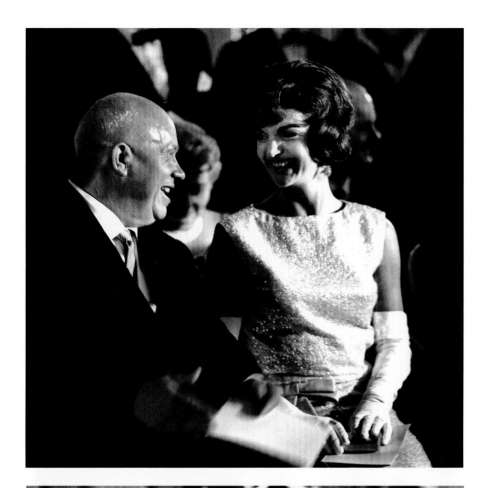

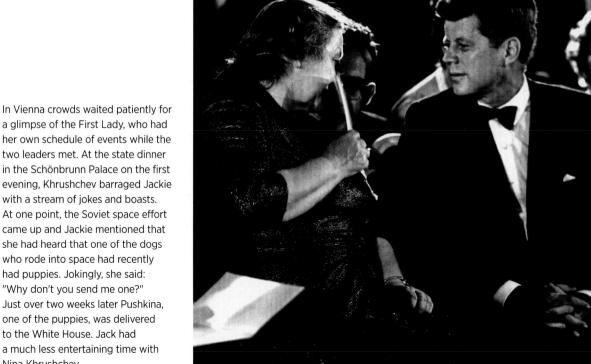

In Vienna crowds waited patiently for a glimpse of the First Lady, who had her own schedule of events while the two leaders met. At the state dinner in the Schönbrunn Palace on the first evening, Khrushchev barraged Jackie with a stream of jokes and boasts. At one point, the Soviet space effort came up and Jackie mentioned that she had heard that one of the dogs who rode into space had recently had puppies. Jokingly, she said: "Why don't you send me one?" Just over two weeks later Pushkina, one of the puppies, was delivered to the White House. Jack had a much less entertaining time with Nina Khrushchev.

At the reception at the Schönbrunn Palace Kennedy asked Khrushchev about the medal he was wearing.

"It's the Lenin Peace Prize medal."

"Lets hope you get to keep it," the President said wryly.

On another occasion, as they were entering a reception, the photographers asked Khrushchev to shake hands with JFK.

Spotting Jackie nearby, he said, "No, no, I'd rather shake hands with Mrs. Kennedy."

At the end of the summit, as the two men were parting, Khrushchev once again made clear that he was still going to force the issue in Berlin.

"In that case," Jack said, "it is going to be a long winter."

Then it was on to London, where Jack conferred with Prime Minister Harold Macmillan about the difficult meetings with Khrushchev. While we were in London, Jack had to face the first press reports on the summit, which were mostly quite critical of his performance. Although there were hundreds of reporters clamoring for Jack to hold a press conference, he insisted on the personal and private nature of the brief trip: the christening of Lee Radziwill's daughter, Anna Christina.

Lee Radziwill lived in London with her husband, Prince Stanislaw Radziwill. After the christening, there was going to be a private reception at their home at 4 Buckingham Place. If there were hundreds of reporters wanting to hear Jack speak, it seemed as if there were thousands of photographers who wanted to shoot the christening and reception. Jackie was insistent; not only would no other photographers be admitted but my presence was supposed to be kept a secret as well. Nonetheless, the other photographers knew of my role and were sure I had made some exclusive deal with the Kennedys. I asked her if I could release one image as a pool picture but she would not give in. It did not make me popular.

Although my role was not exactly a secret, I still had to be smuggled into the vault at Westminster Cathedral by several police officers who escorted me through backyards and over rooftops. The ceremony itself was intimate and simple. Afterwards, my little group of police officers took me on another covert journey to the reception. Lee Radziwill and her husband were very much a part of London upper-class society and the party was a glittering affair. The guest list included Harold Macmillan, Douglas Fairbanks, Jr., Randolph Churchill, Hugh and Lady Antonia Fraser, and Joe Alsop. Although some people marveled at the way Jack could face off against Khrushchev one day and the next day gracefully slip into a social role, I could see that the events in Vienna had left him somewhat distracted.

London, June 1961

By the time they reached London, Jack was exhausted and his back was causing him pain. As he went over the newspaper accounts of Vienna with Pierre Salinger, the early reports were not positive about his performance. But Macmillan was reassuring and supportive when he met with him.

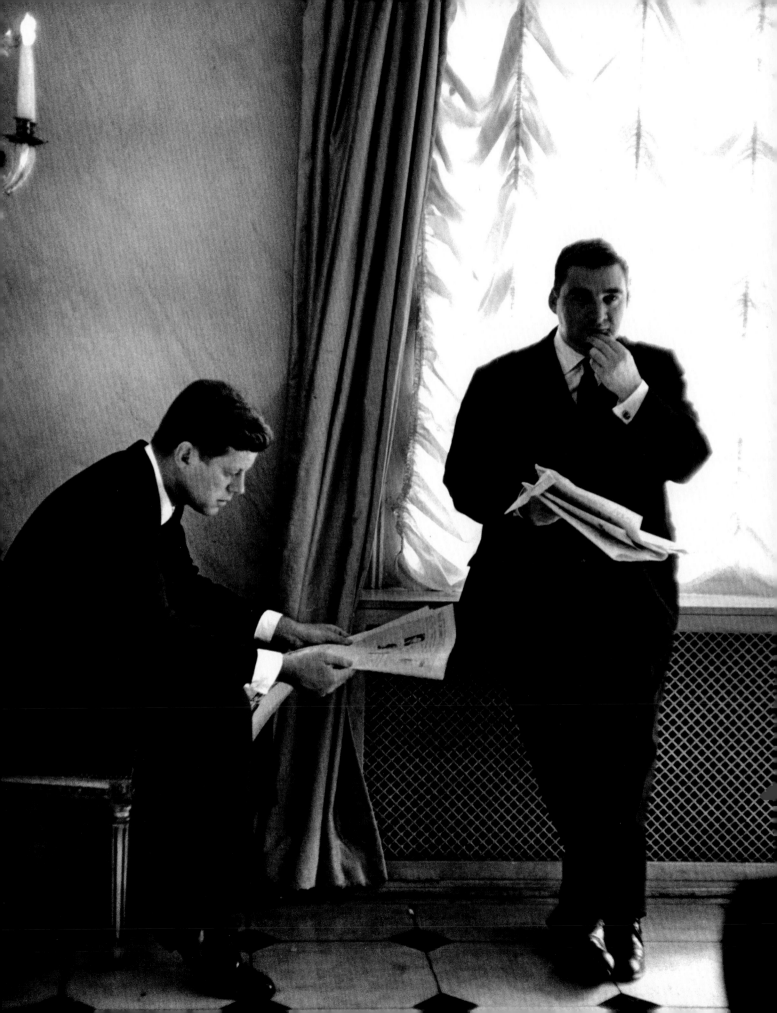

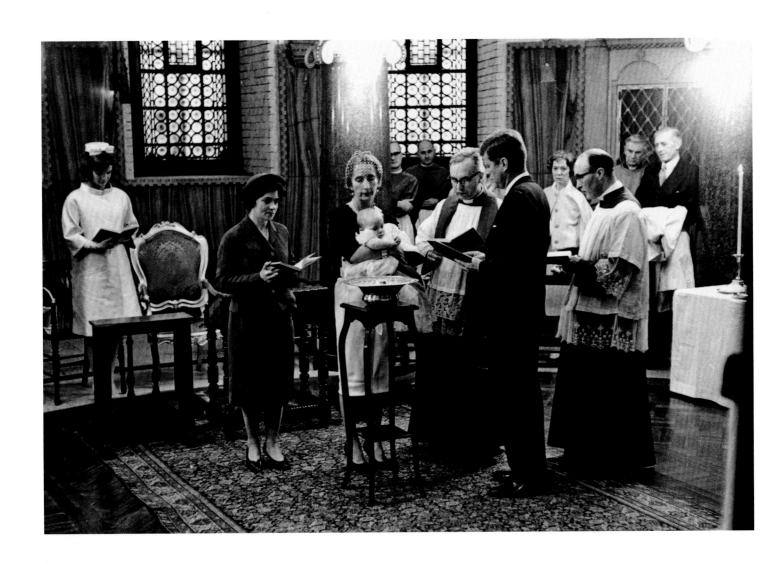

The other agenda in London was for Jack to be godfather at the christening of his niece, Lee Radziwill's daughter, Anna Christina. Jacques was the only photographer permitted to attend the ceremony, while the thousand or so other photographers lined up outside, and he had to be smuggled into Westminster Cathedral by the police. After the christening Jackie met Lady Elizabeth Cavendish at a reception at her sister's Buckingham Place home. Lady Elizabeth's brother, the Marquess of Hartington, had been married to Kathleen Kennedy, the President's sister, and Lady Elizabeth's aunt was the wife of Harold Macmillan.

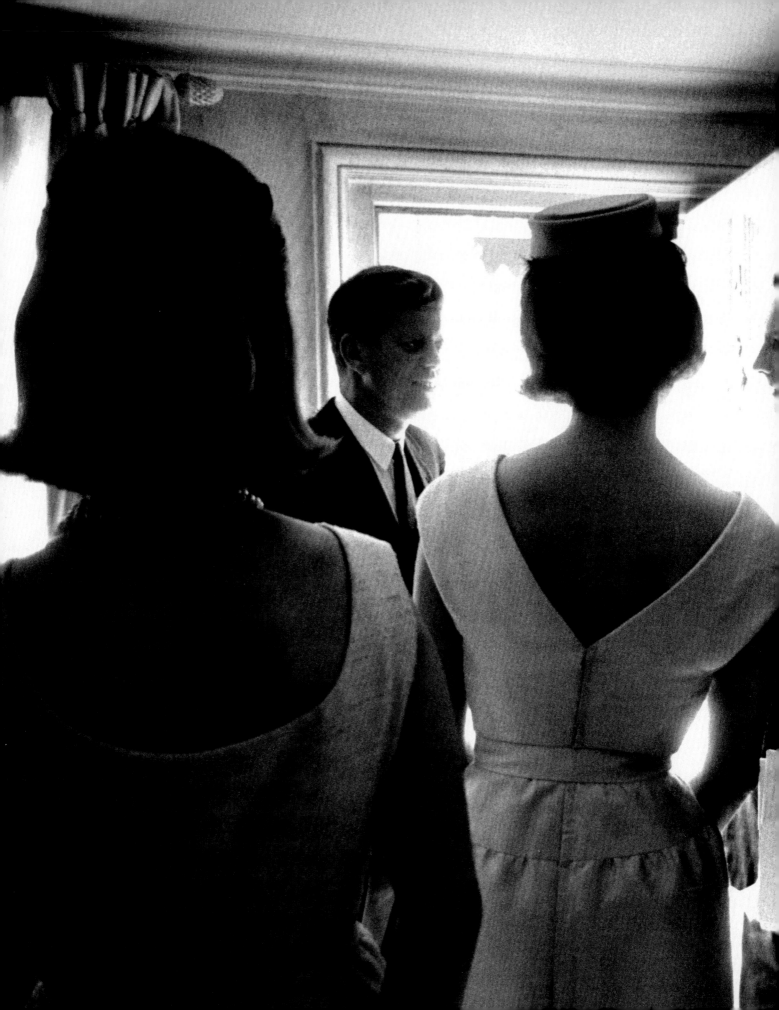

Lee (on the far left, next to Jackie) and her husband, Prince Stanislaw Radziwill (on the right), led a very social life in London and the reception was attended by the cream of society. Jacques enjoyed the European assignment but, with the campaign over, he was bored in Washington and he decided to re-establish his studio in New York.

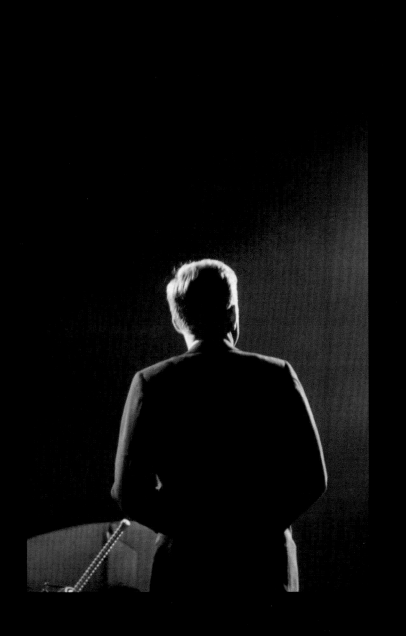

When I returned to the US, it seemed to me it was time to leave and re-establish my studio in New York. Documenting the new administration had been very exciting but after a while I realized that the same routine happens each day. I missed the crazy energy of the campaign, where something new occurs every minute and people are shouting and screaming at each other. New York had so many more possibilities for a photographer.

I stayed in touch with the Kennedys and returned once or twice for visits to the White House. On one of those occasions I brought with me a print of the picture I had taken of the President at the moment he found out about the death of Lumumba. I thought the image was one of my best depictions of Jack's marvelous expressiveness and I asked him to sign it. With an impish grin, he put the picture down on the desk. Then he put his hand to his head and imitated the same look of dismay as the picture. Speaking with mock seriousness, he said: "Is Jacques Lowe in the White House again!" And that is what he wrote on the picture.

On the morning of November 22, 1963, I had finished a commercial photo shoot in Central Park for a Volkswagen ad. I had another job two hours later at my studio to photograph a quartet of black jazz musicians and I decided to walk back downtown to 29th Street. I was on 6th Avenue when I noticed that something weird was happening. I couldn't put my finger on it until I realized there was no traffic coming up 6th Avenue. All the cars had pulled over to the curb and there were people standing around the cars. As I approached one of the cars, I realized people had gathered around to listen to the radio. "What's going on?" I asked the driver.

"The President's been shot."

It didn't register at first. "Which President?"

"President Kennedy."

The hair stood up on the back of my neck and a cold chill ran down my spine. I ran the rest of the way. Close to my studio, some of the local shopkeepers, who knew of my Kennedy connection, yelled to me, "It's fine. He isn't dead. He's all right!"

I raced up the stairs to the studio but when I saw the tears streaming down the faces of the musicians and my secretary I knew he was dead.

I went to Washington that night. I witnessed the awful and stunning aftermath of the assassination—the killing of Lee Harvey Oswald broadcast live on television—in the White House, in Pierre Salinger's office. Before the funeral I met with Robert and Ethel. I didn't have a chance to meet with Jackie but I walked alongside her for part of the funeral procession. At the end of the day, as the sun set, I took my last picture of Jack Kennedy.

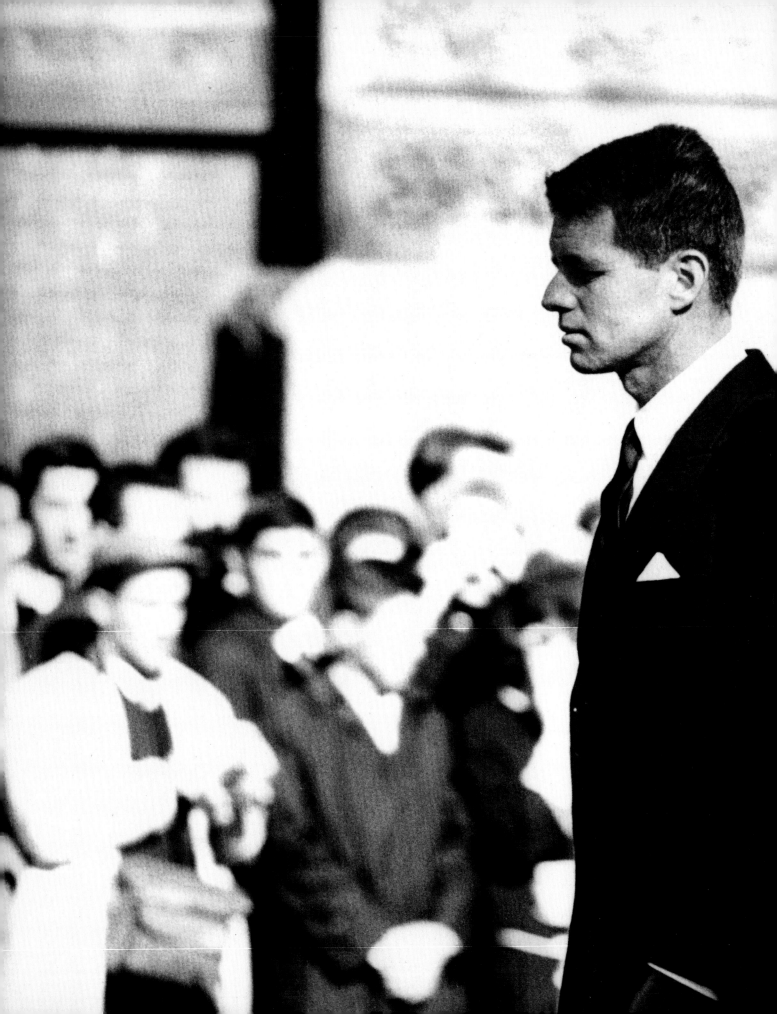

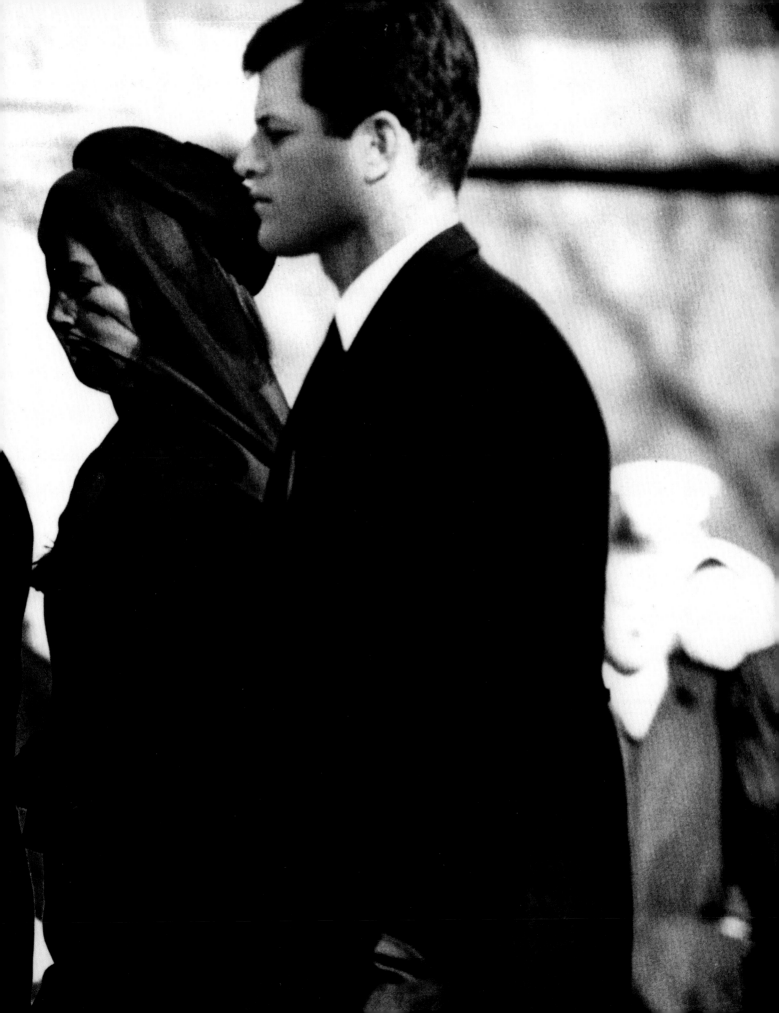

After JFK was assassinated, I stayed in touch with Bobby and other members of the family. But after Bobby was assassinated I left the country. I couldn't deal with it. First it was Jack, then Martin Luther King, and then there was Bobby. It was such an emotional shock that for twelve years I didn't take any photographs. I moved to Europe and bought a chateau in France that I set up as a kind of art colony and invited painters, musicians, and photographers to visit. I also started an art-book publishing business called Visual Arts. Maybe it was all a way of distracting myself from my association with the Kennedys. I returned to the US to live in 1983, but it wasn't until 1988 that I re-established my photography studio in New York, specializing in portrait photography. Though I had plenty of requests, I didn't exhibit my Kennedy photographs until 1990.

In 1991, I had an exhibition of my photographs in Moscow. The exhibit opened only a short time after the failed August Coup, in which hardliners attempted to depose Mikhail Gorbachev. The show became a kind of celebratory event, with women in babushkas placing flowers under the pictures and people returning again and again with tears in their eyes. I hadn't realized how much the ordinary Russian people had loved Jack.

At the opening of the exhibit, I walked though it with Eduard Shevardnadze, who was then Foreign Minister of the Soviet Union. The picture of Jack reacting to the news of Lumumba's assassination fascinated him. "How did he ever allow you to take this picture?" he asked. He just couldn't understand how the leader of the Western world could let himself be portrayed as a human being, in a moment of despair. After we moved

Epilogue

on, he asked me if we could go back to that picture. "But the President never saw that picture when he was alive?" he said, implying that Kennedy would have torn the picture up if he had seen it.

"Oh yes he did," I said. And I told him the story of the autograph. He was even more bewildered. Every photograph of a Communist leader he had ever seen, or sat for, had the leader sitting stiffly behind his desk looking very serious. But that was what made Jack unique; he was utterly at ease with himself and impatient with useless conventions.

In 1998, I had an exhibit at the UNESCO facility in Paris. At the opening, one of the speakers was Robert F. Kennedy Jr., whom I hadn't seen in many years. Before the ceremony and speeches we had a wonderful reunion. In his speech, Robert said of me: "Jacques was such a great friend of our family. As I grew up, he was in our house when I woke up and in our house when we went to bed."

After that, RFK Jr. and I kept in touch. I realized he was only two and a half years old when we first met and I think I gave him a kind of access to the wonderful world that was lost to him when his father was assassinated. But he gave to me as well an intimate access to my Kennedy years, which I was at last prepared to embrace.

I sometimes ask myself, Why me? After all, I was 26 when I met Bobby and 28 when I met JFK. Why did he ask me to stay on and create a documentary record? And why did I stay on, when I really wanted to go back to New York and make some money? In Jack Kennedy and in Bobby Kennedy I had something I could believe in, something I could look up to, something that was bigger than me. When Jack went, we lost all that.

Index

Page numbers in *italic*
refer to captions.
'JFK' refers to John
Fitzgerald (Jack) Kennedy;
'JL' refers to Jacques Lowe.

Africa 221
Alaska *120*
Alsop, Joseph *182*, 207, 240
Atlanta Constitution 195

Barnstable, Massachusetts *157*
Beard, Peter 202
Belafonte, Harry 171
Berlin 229, *231*, *236*, 240
Berlin, Sir Isaiah 207
Bernstein, Leonard 171, *172*
Bismarck, Prince Otto von *141*
Bissell, Richard *193*, 221
Boston, Massachusetts 15, *117*, 119, *152*, 154–55
Bradlee, Ben 26, 202
Bugnand, Bob *60*
Bunche, Ralph 207
Burke, Arleigh *187*, *191*

California 27, *80*, 83, *120*, 123, 171
Capp, Al 207
Caroline airplane *26*, 27, *58*, *59*, *79*
Cartier-Bresson, Henri *215*
Castro, Fidel *191*, 221
Cavendish, Lady Elizabeth *242*
CBS *146*
Charleston, West Virginia *72*
Chicago *68*, 82, 123
Churchill, Randolph 240
CIA (Central Intelligence Agency) *191*, *193*, 221
Cole, Nat King 171, *172*
Colliers magazine 11
Congo 221, *222*
Connecticut *152*, 155
Coos Bay, Oregon *26*, *40*, 47
Coronet magazine 11
Craig, May 195–202, *201*
Cuba 221
 Bay of Pigs invasion *191*, *193*, 228, 229
 missile crisis 207, *218*
Curtis, Tony 171, *172*

Daley, Richard J. 82, 123
Davis, Bette 171, *172*
De Gaulle, Charles *26*, 228–29, *231*, *235*
Decker, George *187*, *191*
Des Moines, Iowa 122, *134*
DiSalle, Mike 130
Dulles, Allen *191*, 221

Eisenhower, Dwight D. 83, 123, *172*, *172*, 185, 221, *225*
Eisenhower, Mamie *172*, *172*
Esquire 85

Fairbanks, Douglas, Jr. 240
FBI (Federal Bureau of Investigation) *216*, 218
Felker, Clay 85
Fitzgerald, Ella 171, *172*
Fonda, Henry *146*
Foreign Correspondent 11
France 228–29, *231*, *233*

Fraser, Hugh and Lady Antonia 240
Frost, Robert, *Dedication* *175*

Galbraith, John Kenneth 207
Gavin, James 229
Glenn, John 207
Goodpaster, Andrew *187*
Goodwin, Richard 130
Gorbachev, Mikhail 252
Green, Edith *35*

Hartford, Connecticut *152*
Hartford Times *152*
Hartington, William Cavendish, Marquess of *242*
Harvard University, Massachusetts 228
Harvard Law School 207
Hickory Hill, McLean, Virginia *14*, *16*, 205–7, *206*, 209, *209*, *211*, *212*, *215*
Hillary, Sir Edmund 207
Hoover, J. Edgar *216*, 218
Humphrey, Bob 82
Humphrey, Hubert 67, *70*, 72, *75*, 82, *88*, *134*, 205
Humphrey, Muriel 82
Hungarian Revolution 11
Hyannis Port, Massachusetts *9*, 14, 15, *20*, 83, 84, 119, *120*, *127*, 155, *157*, 205, *215*
 National Guard Armory 155

Illinois 83, 122, *141*, *150*, 165
Indianapolis, Indiana 218
Iowa 122, 130, *134*

Jefferson-Jackson Day Dinner *80*
Johnson, Lyndon B. *13*, 67, 83, 84, *88*, *91*, *96*, *108*, *111*, *134*, *187*, 202, 203

Kefauver, Estes 83
Kelly, Gene 171, *172*
Kennedy, Caroline 15, *20*, *23*, *26*, *49*, *51*, *125*, *129*, *146*, 155, *197*, 202
Kennedy, Courtney *18*, *212*
Kennedy, David *16*, *18*, *212*
Kennedy, Edward (Teddy) 27, *55*, 82, 84, 85, 165, *166*
Kennedy, Ethel *16–19*, *105*, *115*, 122, *127*, 155, *157*, 165, *166*, 205–7, *211*, *212*, *215*, 247
Kennedy, Jacqueline (Jackie)
 assistance to JFK *53*, 60
 and Caroline *51*, *125*, *129*, 202
 as First Lady-elect *166*
 in Georgetown *49*, *172*
 and Henry Fonda *146*
 at Hyannis Port 119, *120*, 122, *127*, *164*, 165
 at Inaugural Balls *182*
 at inaugural parade *181*
 at Inauguration Gala 172, *172*, *174*

 and JFK's assassination 247
 and JL 14–15, *23*, 203
 in London *242*, *245*
 in New York *137*, 154
 in Oregon 35, 37, 39, 40, 47
 in Paris 228–29, *233*, *235*
 pregnancy *60*, 82, 122, *137*, 154, *182*
 at Teddy's wedding *57*
 in Vienna *239*, 240
 in West Virginia 82
Kennedy, Joan Bennett 27, *55*, *57*, *105*, 122, *127*, *166*
Kennedy, John Fitzgerald (Jack) *9*
 assassination 247, 252
 in Boston *117*
 in California *80*
 campaign for Presidential nomination 67, 82–85, *91*
 on campaign trail *58*, *59*, *60*
 and Caroline *49*
 as Catholic candidate 67, 72, 75, 82, 83
 at Chicago stopover meeting *68*
 with coal miners *75*
 in Coos Bay, Oregon *40*, 43, 47
 at Democratic National Convention (1956, Chicago) 83
 at Democratic National Convention (1960, Los Angeles) 67, 84–85, *87*, *91*, *102*, *105*, *108*, *113*
 elected President *163*, 164–65
 on Election Day 155
 in Georgetown *26*, *49*, *51*, *172*
 and Harold Macmillan 221, *225*, *227*
 in Hartford, Connecticut *152*
 hatred of hats 123, *141*
 at high schools *45*
 at Hyannis Port 14–15, *20*, 119, *159*
 in Illinois 83, 122, *141*
 at Inaugural Balls *172*, *182*
 at inaugural parade *181*
 at Inauguration Gala 172, *172*, *174*
 with Jackie and Caroline *23*, *129*
 and Johnson 84, 85, *96*, *108*, *111*, *134*, *187*, 203
 and journalists 195–202, *201*
 in London 240, *240*, *242*
 in Los Angeles 87, 88, *146*
 and Lumumba assassination 221, *222*, 247, 252–53
 meeting with Chiefs of Staff *187*, *191*, 194–95, 221
 at Mills College 27, *62*, *64*
 National Campaign poster *30*
 in New York *137*
 in Omaha, Nebraska *25*, *28*, *30*, *33*
 in Oregon 25–26
 in Oval Office 185, *187*, 194–95, 221
 in Paris 228–29, *231*, *233*

in Pendleton, Oregon *37, 39*
photographed wearing glasses *53, 195, 202*
physical problems 202–3
in Portland, Oregon *35,* 203
as President-elect with clan *166*
Presidential campaign 119, 130, 154–55, 164–65
relationship with Bobby 205, *218*
relationship with JL 67, 84, 165, 185, *185,* 194–95, 198, 203, 229, 247
in Senate Office *53*
and "special relationship" with Britain 228
swearing-in as President *175*
at Teddy's wedding *57*
in Vienna 228, *236, 239,* 240
in West Virginia *72*
in Wisconsin *70, 139*
Appeasement at Munich (Why England Slept) 228
Kennedy, John Fitzgerald, Jr. *60, 182, 233*
Kennedy, Joseph (Joe) 14, 15, *20,* 27, 119, 123, 155, *160,* 165, *166,* 205, *206,* 227, 228
invites JL to meet JFK *9*
Kennedy, Joseph (Joe) II *18, 212*
Kennedy, Kathleen (JFK's sister) *242*
Kennedy, Kathleen (RFK's daughter) *18, 212*
Kennedy, Mary Kerry *206, 212*
Kennedy, Michael *18,* 206–7, *212*
Kennedy, Robert (Bobby)
 assassination *212,* 252, 253
 as Attorney General 203, 205, *206, 207, 216, 218, 218*
 dislike of Lyndon Johnson *13,* 85, *108, 111,* 203
 on election day (1960) *157, 166*
 family games and sports 14, *16,* 205, *211, 212*
 at Hickory Hill 14, *16, 18,* 205–7, *209, 211, 212, 215*
 at Hyannis Port 119, 155, *159, 160,* 165, *215*
 at Inauguration Gala 172
 interest in photography 202
 and J. Edgar Hoover *216,* 218
 as JFK's campaign manager 67, 82, 84, 85, *91*
 JL's photographs of *9*
 relationship with JL 11, 14, *19,* 203, 205–7, 247
 religious beliefs 207
 and shooting of Martin Luther King 218
Kennedy, Robert (Bobby), Jr. *18, 19, 115, 212, 253*
Kennedy, Rose 122, *166*
Kennedy Foundation 154
Kennedy Special airplane *115*

Kerouac, Jack, *The Dharma Bums 60*
Khrushchev, Nikita 228, 229, *231, 236, 239,* 240
Khrushchev, Nina *239*
King, Martin Luther 218, 252
Kraft, Joe 26
Ku Klux Klan 67

Lawford, Patricia Kennedy 122, *166*
Lawford, Peter *166*
Lawrence, David 82
LeMay, Curtis 207
Lemnitzer, Lyman *187, 191,* 195
Life magazine 11
Lincoln, Evelyn 194, *197*
Lippmann, Walter 26
London 228, *231,* 240, *240, 242*
 Westminster Cathedral 240, *242*
Look magazine 11, 85
Los Angeles 83, *146,* 164
 Beverly Hilton *146*
 Biltmore Hotel 84, 85, *91*
 Coliseum *113*
 Democratic National Convention 67, 84–85, *87, 91*
 Memorial Sports Arena *102*
 Shrine Auditorium *87*
Loveless, Herschel C. *134*
Lowe, Jacques *13, 206*
 attacked in Peoria 130
 and Bobby 14, 205–7
 congratulates JFK on becoming President 165
 early career 11
 first meeting with JFK and Jackie 14–15
 introduces Salinger to Bobby 11
 moves to France 252
 in New York *245,* 247
 Portrait 203
 Visual Arts company 252
 see also Kennedy, John Fitzgerald (Jack), relationship with JL
Lowe, Victoria 14
Lumumba, Patrice 221, *222,* 247, 252

Maas, Peter 85
McCarthy, Eugene 97
McCrea, Joel 11
McGill, Ralph 195
MacLaine, Shirley 80
McLellan Committee 11, *13,* 205
Macmillan, Harold 221, *225, 227,* 240, *240, 242*
McNamara, Robert *193*
Madison, Wisconsin *139*
Mailer, Norman 85
Maine *120*
Martin, Dean *80*
Memphis, Tennessee 218
Merman, Ethel *174*
Michigan *120*
Millay, Edna St. Vincent *129*

Minnesota 165
Modern Screen 27
Moscow 252
Mt. Clemens, Michigan *130*
Muncie, Indiana 218

NAACP (National Association for the Advancement of Colored People) rally *87, 89*
NBC 155, 185
Nebraska 25, *28, 33, 79,* 171
New York *137,* 195
 Bronxville Country Club *55*
 Central Park 247
 Park Avenue 15
 upstate 130
New York Times Magazine 195
Newman, Arnold 11
Newsweek 26, 202
Niagara Airport 130
Nixon, Pat 164
Nixon, Richard 83, 123, *130,* 154, 155, 164–65

Oakland, California, Mills College 27, *62, 64*
O'Brien, Lawrence 84, 85
O'Donnell, Kenneth 84, *137*
Ohio 130
Olivier, Laurence 171
Omaha, Nebraska *28, 33*
Oregon 25–26, *35, 37, 39, 40, 47,* 171
Oswald, Lee Harvey 247

Paris 228–29, *231, 233*
 Elysée Palace *222,* 228–29, *235*
 Hotel Crillon 229
 UNESCO 253
 Paris Match 11
Pekin, Illinois 122, *141*
Pendleton, Oregon *37, 39*
Peoria 130
Philadelphia *145*
Portland, Oregon 25–26, *35,* 203
Powers, Dave *26*
PT-109 *181*

Quemoy and Matsu 154
Quinn, Anthony 171

Radziwill, Anna Christina 240, *242*
Radziwill, Lee *137,* 240, *242, 245*
Radziwill, Prince Stanislaw 240, *245*
Reston, James 26
Ribicoff, Abraham *96, 206*
Ridewood, Charles *145*
Rusk, Dean *193*

Salinger, Pierre 11, 84, 122, 172, 218, *240,* 247
Saturday Evening Post 11
Schlesinger, Arthur, Jr. 207
Senate Committee on Government Operations 11

Shaw, Mark 202
Shevardnadze, Eduard 252
Shoup, David *187*
Shriver, Eunice Kennedy *105,* 122, *127, 166*
Shriver, Sargent 84, *166*
Sinatra, Frank *80, 171, 172,* 207
Smith, Jean Kennedy 122, *127, 166*
Smith, Stephen 25, 26, *39,* 82, 84, *166*
Smith, Stephen, Jr. *146*
Sorensen, Ted *83,* 84, 130
Southern California, University of *146*
Soviet Union, August Coup (1991) 252
Spellman, Cardinal Francis *55*
Stevenson, Adlai 15, 27, 67, 83, 84, *96, 146, 206, 221, 222*
Suez Crisis *225*
Symington, Stuart 67, 85

Teamsters union 11
Test Ban Treaty *236*
Time magazine 11, 202
Truman, Harry S. 154

UNESCO 253
United Nations 221
Urbana-Champaign, University of Illinois at *141*

Versailles, Palace of 228
Victura 125
Vienna 228, *231, 236, 239, 240*
 Schönbrunn Palace *239, 240*
Vietnam war 85
Virginia 218
 University of, Law School 207
Vogue 26, *121,* 122

Warren, Earl *175*
Washington, DC 25, *49,* 146, 171–72
 Armory 171–72, *172, 174, 182*
 Attorney General's Office 207, *216*
 Georgetown 26, *49, 51, 172, 182*
 Inauguration Gala 171–72, *174*
 Mayflower Hotel 171–72
 Senate Caucus Room *68*
White House 172, 185, *191, 193,* 194–95, *197,* 218, *222, 225,* 247
 Cabinet Room *201*
 Oval Office 185, *187,* 194–95, 221
 Rose Garden 194
Waterbury, Connecticut 155
West Virginia 67, *72, 75, 79,* 82–83, *83,* 171, 205
White, Thomas D. *191*
Wilmette, Illinois *150*
Wisconsin 67, *70, 83*
 University of *139*
Wyoming 85

Acknowledgments

It has been a privilege to work on my father's memoir with so many creative people and without their help it would not have been possible to fulfill my ambition of maintaining his legacy. Making his voice alive again in this way has been a rich and meaningful experience for me.

Firstly, I would like to acknowledge the efforts of Hugo Fleischmann who, in the early days, when this book was just an idea, did the groundwork and then saw the project through at every stage.

My heartfelt thanks go to the staff at Thames & Hudson who have been enthusiastic about the book from the beginning and have given my father a wider audience beyond his photographs. Peter Warner meticulously and conscientiously put together the pieces of the jigsaw from various sources, for which I am grateful. Gavin Forward showed great patience and dedication in transcribing my father's Alsatian tongue.

I very much appreciate the willingness of Frank and Barby Harvey to share in such a public way the photographs by my father that are in their possession. This was a true act of friendship.

Adam Brown, who combines a magic touch with attention to detail, designed this beautiful book and I am indebted to him for that and his commitment to the project as a whole.

Lastly, I would like to dedicate this book to my siblings: Jamie, Victoria, Sacha, and Kristina. I know they will treasure it as much as I will.

Thomasina Lowe

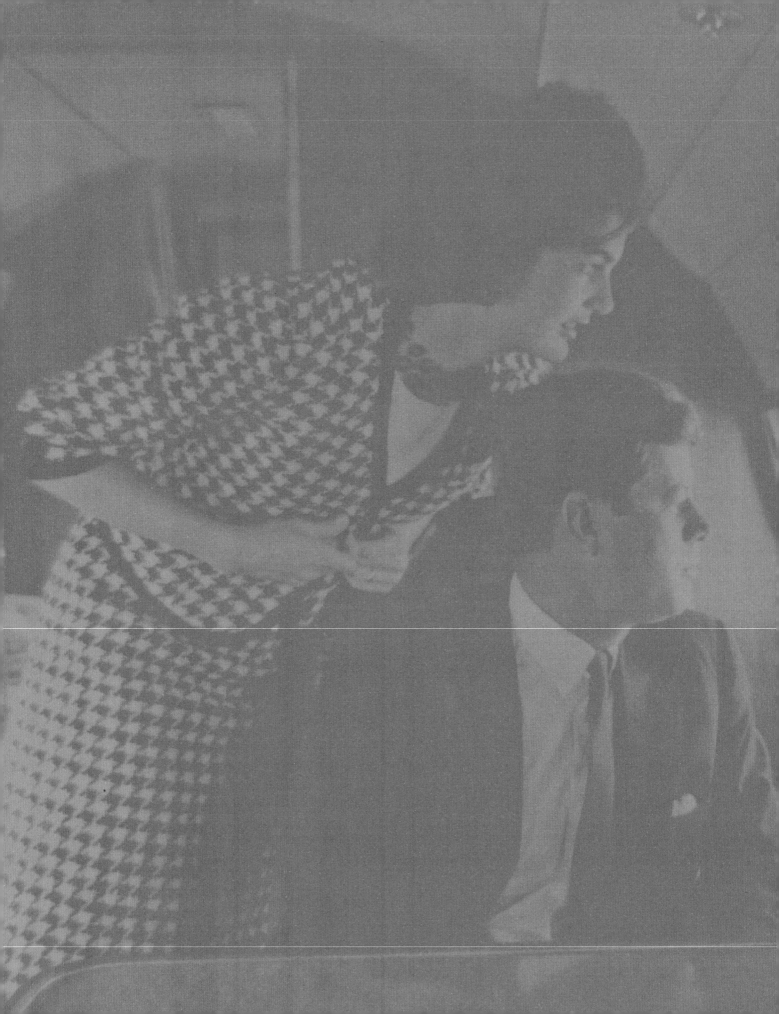